Also by Olivia Laing

The Trip to Echo Spring
To the River

THE LONELY CITY

OLIVIA LAING

The Lonely City

Adventures in the Art of Being Alone

PICADOR

NEW YORK

picadorusa.com • picadorbookroom.tumblr.com
twitter.com/picadorusa • facebook.com/picadorusa

Picador® is a U.S. registered trademark and is used by St. Martin's Press under license from Pan Books Limited.

For book club information, please visit facebook.com/picadorbookclub or e-mail marketing@picadorusa.com.

For permissions acknowledgments, please see the Notes beginning on page 285.

Library of Congress Cataloging-in-Publication Data

Names: Laing, Olivia, author.
Title: The lonely city : adventures in the art of being alone / Olivia Laing.
Description: First U.S. Edition. | New York : Picador, 2016.
Identifiers: LCCN 2015037147| ISBN 9781250039576 (hardcover) | ISBN 9781250039590 (e-book)
Subjects: LCSH: Artists—Psychology. | Loneliness. | City and town life—Psychological aspects. | BISAC: ART / General. | BIOGRAPHY & AUTOBIOGRAPHY / Artists, Architects, Photographers.
Classification: LCC N71 .L24 2016 | DDC 700.1/9—dc23
LC record available at http://lccn.loc.gov/2015037147

Our books may be purchased in bulk for promotional, educational, or business use. Please contact your local bookseller or the Macmillan Corporate and Premium Sales Department at 1-800-221-7945, extension 5442, or by e-mail at MacmillanSpecialMarkets@macmillan.com.

First published in Great Britain by Canongate Books Ltd

First U.S. Edition: March 2016

10 9 8 7 6 5 4 3 2 1

If you're lonely,
this one's for you

and every one members one of another
Romans 12:5

CONTENTS

THE LONELY CITY

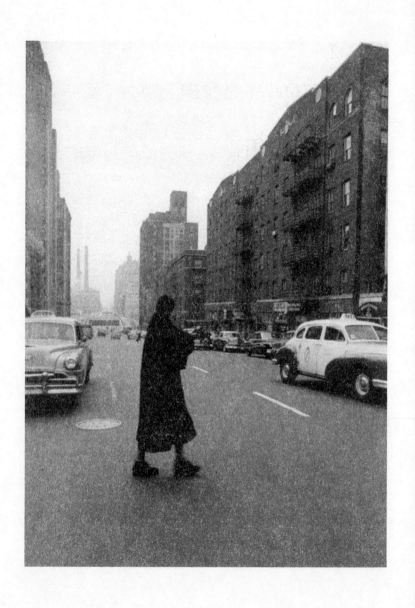

1

THE LONELY CITY

IMAGINE STANDING BY A WINDOW at night, on the sixth or seventeenth or forty-third floor of a building. The city reveals itself as a set of cells, a hundred thousand windows, some darkened and some flooded with green or white or golden light. Inside, strangers swim to and fro, attending to the business of their private hours. You can see them, but you can't reach them, and so this commonplace urban phenomenon, available in any city of the world on any night, conveys to even the most social a tremor of loneliness, its uneasy combination of separation and exposure.

You can be lonely anywhere, but there is a particular flavour to the loneliness that comes from living in a city, surrounded by millions of people. One might think this state was antithetical to urban living, to the massed presence of other human beings, and yet mere physical proximity is not enough to dispel a sense of internal isolation. It's possible – easy, even – to feel desolate and unfrequented in oneself while living cheek by jowl with others. Cities can be lonely places, and in admitting this we see that loneliness doesn't necessarily require physical solitude, but rather an absence or paucity

of connection, closeness, kinship: an inability, for one reason or another, to find as much intimacy as is desired. *Unhappy*, as the dictionary has it, *as a result of being without the companionship of others.* Hardly any wonder, then, that it can reach its apotheosis in a crowd.

Loneliness is difficult to confess; difficult too to categorise. Like depression, a state with which it often intersects, it can run deep in the fabric of a person, as much a part of one's being as laughing easily or having red hair. Then again, it can be transient, lapping in and out in reaction to external circumstance, like the loneliness that follows on the heels of a bereavement, break-up or change in social circles.

Like depression, like melancholy or restlessness, it is subject too to pathologisation, to being considered a disease. It has been said emphatically that loneliness serves no purpose, that it is, as Robert Weiss puts it in his seminal work on the subject, 'a chronic disease without redeeming features'. Statements like this have a more than casual link with the belief that our whole purpose is as coupled creatures, or that happiness can or should be a permanent possession. But not everyone shares that fate. Perhaps I'm wrong, but I don't think any experience so much a part of our common shared lives can be entirely devoid of meaning, without a richness and a value of some kind.

In her diary of 1929, Virginia Woolf described a sense of *inner loneliness* that she thought might be illuminating to analyse, adding: 'If I could catch the feeling, I would: the feeling of the singing of the real world, as one is driven by loneliness and silence from the habitable world.' Interesting, the idea that loneliness might be taking you towards an otherwise unreachable experience of reality.

4

Not so long ago, I spent a period in New York City, that teeming island of gneiss and concrete and glass, inhabiting loneliness on a daily basis. Though it wasn't by any means a comfortable experience, I began to wonder if Woolf wasn't right, if there wasn't more to the experience than meets the eye – if, in fact, it didn't drive one to consider some of the larger questions of what it is to be alive.

There were things that burned away at me, not only as a private individual, but also as a citizen of our century, our pixelated age. What does it mean to be lonely? How do we live, if we're not intimately engaged with another human being? How do we connect with other people, particularly if we don't find speaking easy? Is sex a cure for loneliness, and if it is, what happens if our body or sexuality is considered deviant or damaged, if we are ill or unblessed with beauty? And is technology helping with these things? Does it draw us closer together, or trap us behind screens?

I was by no means the only person who'd puzzled over these questions. All kinds of writers, artists, filmmakers and songwriters have explored the subject of loneliness in one way or another, attempting to gain purchase on it, to tackle the issues that it provokes. But I was at the time beginning to fall in love with images, to find a solace in them that I didn't find elsewhere, and so I conducted the majority of my investigations within the realm of visual art. I was possessed with a desire to find correlates, physical evidence that other people had inhabited my state, and during my time in Manhattan I began to gather up works of art that seemed to articulate or be troubled by loneliness, particularly as it manifests in the modern city and even more particularly as it has manifested in the city of New York over the past seventy or so years.

Initially it was the images themselves that drew me, but as I burrowed in, I began to encounter the people behind them: people who had grappled in their lives as well as work with loneliness and its attendant issues. Of all the many documenters of the lonely city whose work educated or moved me, and who I consider in the pages ahead – among them Alfred Hitchcock, Valerie Solanas, Nan Goldin, Klaus Nomi, Peter Hujar, Billie Holiday, Zoe Leonard and Jean-Michel Basquiat – I became most closely interested in four artists: Edward Hopper, Andy Warhol, Henry Darger and David Wojnarowicz. Not all of them were permanent inhabitants of loneliness, by any means, suggesting instead a diversity of positions and angles of attack. All, however, were hyper-alert to the gulfs between people, to how it can feel to be islanded amid a crowd.

This seems particularly unlikely in the case of Andy Warhol, who was after all famous for his relentless sociability. He was almost never without a glittering entourage and yet his work is surprisingly eloquent on isolation and the problems of attachment, issues he struggled with lifelong. Warhol's art patrols the space between people, conducting a grand philosophical investigation into closeness and distance, intimacy and estrangement. Like many lonely people, he was an inveterate hoarder, making and surrounding himself with objects, barriers against the demands of human intimacy. Terrified of physical contact, he rarely left the house without an armoury of cameras and tape recorders, using them to broker and buffer interactions: behaviour that has light to shed on how we deploy technology in our own century of so-called connectivity.

The janitor and outsider artist Henry Darger inhabited the opposite extreme. He lived alone in a boarding house in the city of Chicago, creating in a near-total void of companionship or audience a fictional universe populated by wonderful and frightening beings. When he gave up his room unwillingly at the age of seventy to die in a Catholic mission home, it was found to be stuffed with hundreds of exquisite and disturbing paintings, work he'd apparently never shown to another human being. Darger's life illuminates the social forces that drive isolation – and the way the imagination can work to resist it.

Just as these artists' lives varied in sociability, so their work handled or moved around the subject of loneliness in a multitude of ways, sometimes tackling it directly and sometimes dealing with subjects – sex, illness, abuse – that were themselves sources of stigma or isolation. Edward Hopper, that rangy, taciturn man, was occupied, though he sometimes denied it, with the expression of urban loneliness in visual terms, its translation into paint. Almost a century on, his images of solitary men and women glimpsed behind glass in deserted cafés, offices and hotel lobbies remain the signature images of isolation in the city.

You can show what loneliness looks like, and you can also take up arms against it, making things that serve explicitly as communication devices, resisting censorship and silence. This was the driving motivation of David Wojnarowicz, a still under-known American artist, photographer, writer and activist, whose courageous, extraordinary body of work did more than anything to release me from the burden of feeling that in my solitude I was shamefully alone.

Loneliness, I began to realise, was a populated place: a city in itself. And when one inhabits a city, even a city as rigorously and logically constructed as Manhattan, one starts by getting lost. Over time, you begin to develop a mental map, a collection of favoured destinations and preferred routes: a labyrinth no other person could ever precisely duplicate or reproduce. What I was building in those years, and what now follows, is a map of loneliness, built out of both need and interest, pieced together from my own experiences and those of others. I wanted to understand what it means to be lonely, and how it has functioned in people's lives, to attempt to chart the complex relationship between loneliness and art.

A long time back, I used to listen to a song by Dennis Wilson. It was from *Pacific Ocean Blue*, the album he made after The Beach Boys fell apart. There was a line in it I loved: *Loneliness is a very special place*. As a teenager, sitting on my bed on autumn evenings, I used to imagine that place as a city, perhaps at dusk, when everyone turns homeward and the neon flickers into life. I recognised myself even then as one of its citizens and I liked how Wilson claimed it; how he made it sound fertile as well as frightening.

Loneliness is a very special place. It isn't always easy to see the truth of Wilson's statement, but over the course of my travels I've come to believe that he was right, that loneliness is by no means a wholly worthless experience, but rather one that cuts right to the heart of what we value and what we need. Many marvellous things have emerged from the lonely city: things forged in loneliness, but also things that function to redeem it.

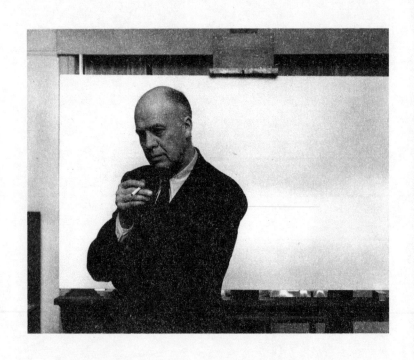

2

WALLS OF GLASS

I NEVER WENT SWIMMING IN New York. I came and went, but never stuck a summer, and so all the outdoor pools I coveted remained empty, their water spirited away for the duration of the long off-season. Mostly, I stayed on the eastern edges of the island, downtown, taking cheap sublets in East Village tenements or in co-ops built for garment workers, where day and night you could hear the hum of traffic crossing the Williamsburg Bridge. Walking home from whatever temporary office I'd found that day, I'd sometimes take a detour by Hamilton Fish Park, where there was a library and a twelve-lane pool, painted a pale flaking blue. I was lonely at the time, lonely and adrift, and this spectral blue space, filling at its corners with blown brown leaves, never failed to tug my heart.

What does it feel like to be lonely? It feels like being hungry: like being hungry when everyone around you is readying for a feast. It feels shameful and alarming, and over time these feelings radiate outwards, making the lonely person increasingly isolated, increasingly estranged. It hurts, in the way that feelings do, and

it also has physical consequences that take place invisibly, inside the closed compartments of the body. It advances, is what I'm trying to say, cold as ice and clear as glass, enclosing and engulfing.

Most of the time, I sublet a friend's apartment on East 2nd Street, in a neighbourhood full of community gardens. It was an unreconstructed tenement, painted arsenic green, with a claw-footed bathtub in the kitchen, concealed behind a moulding curtain. The first night I arrived there, jet-lagged and bleary, I caught a smell of gas that grew increasingly pronounced as I lay unsleeping on the high platform bed. In the end I called 911 and a few minutes later three firemen trooped in, relit the pilot light and then hung about in their big boots, admiring the wooden floor. There was a framed poster above the oven from a 1980s Martha Clarke performance called *Miracolo d'Amore*. It showed two actors dressed in the white suits and pointed hats of the Commedia dell'Arte. One was moving towards a lit doorway, and the other had flung both hands up in a gesture of horrified alarm.

Miracolo d'Amore. I was in the city because I'd fallen in love, headlong and too precipitously, and had tumbled and found myself unexpectedly unhinged. During the false spring of desire, the man and I had cooked up a hare-brained plan in which I would leave England and join him permanently in New York. When he changed his mind, very suddenly, expressing increasingly grave reservations into a series of hotel phones, I found myself adrift, stunned by the swift arrival and even swifter departure of every-thing I thought I lacked.

In the absence of love, I found myself clinging hopelessly to the city itself: the repeating tapestry of psychics and bodegas, the

bump and grind of traffic, the live lobsters on the corner of Ninth Avenue, the steam drifting up from beneath the streets. I didn't want to lose the flat I'd rented in England for almost a decade, but I also had no ties, no work or family commitments to tether me in place. I found a lodger and scrimped the money for a plane ticket, not knowing then that I was entering a maze, a walled city within the island of Manhattan itself.

But already this isn't quite right. The first apartment I had wasn't on the island at all. It was in Brooklyn Heights, a few blocks away from where I would have been living in the alternate reality of accomplished love, the ghostly other life that haunted me for almost two full years. I arrived in September, and at immigration the guard said to me without a trace of friendliness *why are your hands shaking?* The Van Wyck Expressway was the same as ever, bleak, unpromising, and it took several attempts to open the big door with the keys my friend had FedExed me weeks back.

I'd only seen the apartment once before. It was a studio, with a kitchenette and an elegantly masculine bathroom tiled all in black. There was another ironic, unsettling poster on the wall, a vintage advert for some kind of bottled drink. A beaming woman, her lower half a glowing lemon, spritzing a tree hung liberally with fruit. It seemed to epitomise sunny abundance, but the light never really made it past the brownstones opposite, and it was clear that I was tucked up on the wrong side of the house. There was a laundry room downstairs, but I was too new to New York to know what a luxury that was, and went down unwillingly, scared the basement door would slam, trapping me in the dripping, Tide-smelling dark.

Most days I did the same things. Go out for eggs and coffee, walk aimlessly through the exquisite cobbled streets or down to the promenade to gaze at the East River, pushing each day a little further until I reached the park at Dumbo, where on Sundays you'd see the Puerto Rican wedding couples come to have their photos taken, the girls in enormous sculptural lime-green and fuchsia dresses that made everything else look tired and staid. Manhattan across the water, the glittering towers. I was working, but I didn't have anything like enough to do, and the bad times came in the evenings, when I went back to my room, sat on the couch and watched the world outside me going on through glass, a light bulb at a time.

I wanted very much not to be where I was. In fact part of the trouble seemed to be that where I was wasn't anywhere at all. My life felt empty and unreal and I was embarrassed about its thinness, the way one might be embarrassed about wearing a stained or threadbare piece of clothing. I felt like I was in danger of vanishing, though at the same time the feelings I had were so raw and overwhelming that I often wished I could find a way of losing myself altogether, perhaps for a few months, until the intensity diminished. If I could have put what I was feeling into words, the words would have been an infant's wail: *I don't want to be alone. I want someone to want me. I'm lonely. I'm scared. I need to be loved, to be touched, to be held.* It was the sensation of need that frightened me the most, as if I'd lifted the lid on an unappeasable abyss. I stopped eating very much and my hair fell out and lay noticeably on the wooden floor, adding to my disquiet.

I'd been lonely before, but never like this. Loneliness had waxed in childhood, and waned in the more social years that followed. I'd lived by myself since my mid-twenties, often in relationships but sometimes not. Mostly I liked the solitude, or, when I didn't, felt fairly certain I'd sooner or later drift into another liaison, another love. The revelation of loneliness, the omnipresent, unanswerable feeling that I was in a state of lack, that I didn't have what people were supposed to, and that this was down to some grave and no doubt externally unmistakable failing in my person: all this had quickened lately, the unwelcome consequence of being so summarily dismissed. I don't suppose it was unrelated, either, to the fact that I was keeling towards the midpoint of my thirties, an age at which female aloneness is no longer socially sanctioned and carries with it a persistent whiff of strangeness, deviance and failure.

Outside the window, people threw dinner parties. The man upstairs listened to jazz and show tunes at full blast, and filled the hallways with pot smoke, snaking fragrantly down the stairs. Sometimes I spoke to the waiter in my morning café, and once he gave me a poem, typed neatly on thick white paper. But mostly I didn't speak. Mostly I was walled up inside myself, and certainly a very long way from anyone else. I didn't cry often, but once I couldn't get the blinds closed and then I did. It seemed too awful, I suppose, the idea that anyone could peer over and get a glimpse of me, eating cereal standing up or combing over emails, my face illuminated by the laptop's glare.

I knew what I looked like. I looked like a woman in a Hopper painting. The girl in *Automat*, maybe, in a cloche hat

and green coat, gazing into a cup of coffee, the window behind her reflecting two rows of lights, swimming into blackness. Or the one in *Morning Sun,* who sits on her bed, hair twisted into a messy bun, gazing through her window at the city beyond. A pretty morning, light washing the walls, but nonetheless something desolate about her eyes and jaw, her slim wrists crossed over her legs. I often sat just like that, adrift in rumpled sheets, trying not to feel, trying simply to take consecutive breaths.

The one I found most disturbing was *Hotel Window.* Looking at it was like gazing into a fortune teller's mirror, through which you glimpse the future, its spoiled contours, its deficit of promise. This woman is older, tense and unapproachable, sitting on a navy couch in an empty drawing room or lobby. She's dressed to go out, in a smart ruby-coloured hat and cape, and is twisting to look down into the darkening street below, though there's nothing out there save a gleaming portico and the stubborn black window of the building opposite.

Asked about the origins of this painting, Hopper once said in his evasive way: 'It's nothing accurate at all, just an improvisation of things I've seen. It's no particular hotel lobby, but many times I've walked through the Thirties from Broadway to Fifth Avenue and there are a lot of cheesy hotels there. That probably suggested it. Lonely? Yes, I guess it's lonelier than I planned it really.'

What is it about Hopper? Every once in a while an artist comes along who articulates an experience, not necessarily consciously or willingly, but with such prescience and intensity that the association becomes indelible. He never much liked the

idea that his paintings could be pinned down, or that loneliness was his metier, his central theme. 'The loneliness thing is overdone,' he once told his friend Brian O'Doherty, in one of the very few long interviews to which he submitted. And again, in the documentary *Hopper's Silence*, when O'Doherty asks: 'Are your paintings reflective of the isolation of modern life?' A pause, then Hopper says tersely: 'It may be true. It may not be true.' Later, asked what draws him to the dark scenes he favours, he replies opaquely: 'I suppose it's just me.'

Why, then, do we persist in ascribing loneliness to his work? The obvious answer is that his paintings tend to be populated by people alone, or in uneasy, uncommunicative groupings of twos and threes, fastened into poses that seem indicative of distress. But there's something else too; something about the way he contrives his city streets. As the Whitney curator Carter Foster observes in *Hopper's Drawings*, Hopper routinely reproduces in his paintings 'certain kinds of spaces and spatial experiences common in New York that result from being physically close to others but separated from them by a variety of factors, including movement, structures, windows, walls and light or darkness'. This viewpoint is often described as voyeuristic, but what Hopper's urban scenes also replicate is one of the central experiences of being lonely: the way a feeling of separation, of being walled off or penned in, combines with a sense of near-unbearable exposure.

This tension is present in even the most benign of his New York paintings, the ones that testify to a more pleasurable, more equanimous kind of solitude. *Morning in a City*, say, in which a

naked woman stands at a window, holding just a towel, relaxed and at ease with herself, her body composed of lovely flecks of lavender and rose and pale green. The mood is peaceful, and yet the faintest tremor of unease is discernible at the far left of the painting, where the open casement gives way to the buildings beyond, lit by the flannel-pink of a morning sky. In the tenement opposite there are three more windows, their green blinds half-drawn, their interiors rough squares of total black. If windows are to be thought analogous to eyes, as both etymology, *wind-eye*, and function suggests, then there exists around this blockage, this plug of paint, an uncertainty about being seen – looked over, maybe; but maybe also overlooked, as in ignored, unseen, unregarded, undesired.

In the sinister *Night Windows*, these worries bloom into acute disquiet. The painting centres on the upper portion of a building, with three apertures, three slits, giving into a lighted chamber. At the first window a curtain billows outward, and in the second a woman in a pinkish slip bends over a green carpet, her haunches taut. In the third, a lamp is glowing through a layer of fabric, though what it actually looks like is a wall of flames.

There's something odd, too, about the vantage point. It's clearly from above – we see the floor, not the ceiling – but the windows are on at least the second storey, making it seem as if whoever's doing the looking is hanging suspended in the air. The more likely answer is that they're stealing a glimpse from the window of the 'El', the elevator train, which Hopper liked to ride at night, armed with his pads, his fabricated chalk, gazing avidly through the glass for instances of brightness,

moments that fix, unfinished, in the mind's eye. Either way, the viewer – me, I mean, or you – has been co-opted into an estranging act. Privacy has been breached, but it doesn't make the woman any less alone, exposed in her burning chamber.

This is the thing about cities, the way that even indoors you're always at the mercy of a stranger's gaze. Wherever I went – pacing back and forth between the bed and couch; roaming into the kitchen to regard the abandoned boxes of ice cream in the freezer – I could be seen by the people who lived in the Arlington, the vast Queen Anne co-op that dominated the view, its ten brick storeys lagged in scaffolding. At the same time, I could also play the watcher, *Rear Window*-style, peering in on dozens of people with whom I'd never exchange a word, all of them engrossed in the small intimacies of the day. Loading a dishwasher naked; tapping in on heels to cook the children's supper.

Under normal circumstances, I don't suppose any of this would have provoked more than idle curiosity, but that autumn wasn't normal. Almost as soon as I arrived, I was aware of a gathering anxiety around the question of visibility. I wanted to be seen, taken in and accepted, the way one is by a lover's approving gaze. At the same time I felt dangerously exposed, wary of judgement, particularly in situations where being alone felt awkward or wrong, where I was surrounded by couples or groups. While these feelings were undoubtedly heightened by the fact that I was living in New York for the first time – that city of glass, of roving eyes – they arose out of loneliness, which agitates always in two directions, towards intimacy and away from threat.

That autumn, I kept coming back to Hopper's images, drawn to them as if they were blueprints and I was a prisoner; as if they contained some vital clue about my state. Though I went with my eyes over dozens of rooms, I always returned to the same place: to the New York diner of *Nighthawks*, a painting that Joyce Carol Oates once described as 'our most poignant, ceaselessly replicated romantic image of American loneliness'.

I don't suppose there are many people in the western world who haven't peered into the cool green icebox of that painting, who haven't seen a grimy reproduction hanging in a doctor's waiting room or office hallway. It's been disseminated with such profligacy that it has long since acquired the patina that afflicts all too-familiar objects, like dirt over a lens, and yet it retains its eerie power, its potency.

I'd been looking at it on laptop screens for years before I finally saw it in person, at the Whitney one sweltering October afternoon. It was hanging at the very back of the gallery, hidden behind a shoal of people. *The colours are amazing*, a girl said, and then I was drawn to the front of the crowd. Up close, the painting rearranged itself, decomposing into snags and anomalies I'd never seen before. The bright triangle of the diner's ceiling was cracking. A long drip of yellow ran between the coffee urns. The paint was applied very thinly, not quite covering the linen ground, so that the surface was breached by a profusion of barely visible white pinpricks and tiny white threads.

I took a step back. Green shadows were falling in spikes and diamonds on the sidewalk. There is no colour in existence that so powerfully communicates urban alienation, the atomisation

of human beings inside the edifices they create, as this noxious pallid green, which only came into being with the advent of electricity, and which is inextricably associated with the nocturnal city, the city of glass towers, of empty illuminated offices and neon signs.

A tour guide came in then, her dark hair piled on her head, a group of visitors trailing in her wake. She pointed to the painting, saying *do you see, there isn't a door?* and they crowded round, making small noises of exclamation. She was right. The diner was a place of refuge, absolutely, but there was no visible entrance, no way to get in or out. There was a cartoonish, ochre-coloured door at the back of the painting, leading perhaps into a grimy kitchen. But from the street, the room was sealed: an urban aquarium, a glass cell.

Inside, in their livid yellow prison, were the four famous figures. A spivvy couple, a counter-boy in a white uniform, his blond hair raked into a cap, and a man sitting with his back to the window, the open crescent of his jacket pocket the darkest point on the canvas. No one was talking. No one was looking at anyone else. Was the diner a refuge for the isolated, a place of succour, or did it serve to illustrate the disconnection that proliferates in cities? The painting's brilliance derived from its instability, its refusal to commit.

Look, for instance, at the counter-boy, his face maybe affable, maybe cold. He stands at the centre of a series of triangles, presiding over the nocturnal sacrament of coffee. But isn't he also trapped? One of the vertices is cut off by the edge of the canvas, but surely it's narrowing too sharply, leaving no room for the

expected hatch or gangway. This is the kind of subtle geometric disturbance that Hopper was so skilled at, and which he used to kindle emotion in the viewer, to produce feelings of entrapment and wariness, of profound unease.

What else? I leant against the wall, sweaty in my sandals, itemising the diner's contents. Three white coffee cups, two empty glasses rimmed in blue, two napkin dispensers, three salt shakers, one pepper shaker, maybe sugar, maybe ketchup. Yellow light flaring on the ceiling. Livid green tiles (*brilliant streak of jade green*, Hopper's wife Jo had written in the notebook she used to log his paintings), triangular shadows dropping lightly everywhere, the colour of a dollar bill. A hoarding above the diner for Phillies American cigars, *Only 5cs*, illustrated with a crude brown doodle. A green till in the window of the store across the street, not that there was any stock on show. Green on green, glass on glass, a mood that expanded the longer I lingered, breeding disquiet.

The window was the weirdest thing: a bubble of glass that separated the diner from the street, curving sinuously back against itself. This window is unique in Hopper's work. Though he painted hundreds, maybe thousands, in his life, the rest are simply openings, apertures for the eye to gaze through. Some catch reflections, but this was the only time he ever painted glass itself, in all its ambiguous physicality. Simultaneously solid and transparent, material and ephemeral, it brings together what he elsewhere did in parts, fusing in one devastating symbol the twin mechanisms of confinement and exposure. It was impossible to gaze through into the diner's luminous interior without experiencing a swift

apprehension of loneliness, of how it might feel to be shut out, standing alone in the cooling air.

<div align="center">★</div>

The dictionary, that chilly arbiter, defines the word *lonely* as a negative feeling invoked by isolation, the emotional component being what differentiates it from *lone, alone* or *solo. Dejected because of want of company or society; sad at the thought that one is alone; having a feeling of solitariness.* But loneliness doesn't necessarily correlate with an external or objective lack of company; what psychologists term social isolation or social privation. By no means all people who live their lives in the absence of company are lonely, while it is possible to experience acute loneliness while in a relationship or among a group of friends. As Epictetus wrote almost two thousand years ago: 'For because a man is alone, he is not for that reason also solitary; just as though a man is among numbers, he is not therefore not solitary.'

The sensation arises because of a felt absence or insufficiency of closeness, and its feeling tone ranges from discomfort to chronic, unbearable pain. In 1953, the psychiatrist and psychoanalyst Harry Stack Sullivan came up with what still stands as a working definition: 'the exceedingly unpleasant and driving experience connected with inadequate discharge of the need for human intimacy'.

Sullivan only approached loneliness in passing in his work, and as such the real pioneer of loneliness studies is the German psychiatrist Frieda Fromm-Reichmann. Fromm-Reichmann spent

most of her working life in America and is memorialised in popular culture as the therapist Dr Fried in Joanne Greenberg's semi-autobiographical novel about her teenage struggles with schizophrenia, *I Never Promised You a Rose Garden*. When she died in Maryland in 1957, she left on her desk an unfinished pile of notes, which was subsequently edited and published as 'On Loneliness'. This essay represents one of the first attempts by a psychiatrist or psychoanalyst to approach loneliness as an experience in its own right, distinct from and perhaps fundamentally more damaging than depression, anxiety or loss.

Fromm-Reichmann viewed loneliness as an essentially resistant subject, hard to describe, hard to pin down, hard even to broach as a topic, noting dryly:

> The writer who wishes to elaborate on loneliness is faced
> with a serious terminological handicap: Loneliness seems
> to be such a painful, frightening experience that people
> do practically everything to avoid it. This avoidance seems
> to include a strange reluctance on the part of psychiatrists
> to seek scientific clarification on the subject.

She picks through what little material she can find, gathering up scraps from Sigmund Freud and Anna Freud and Rollo May. Many of these, she thinks, muddle together different types of loneliness, conflating that which is temporary or circumstantial – the loneliness of bereavement, say, or the loneliness that stems from insufficient tenderness in childhood – with the deeper and more intractable forms of emotional isolation.

Of these latter, desolating states, she comments: 'Loneliness, in its quintessential form, is of a nature that is incommunicable by the one who suffers it. Nor, unlike other non-communicable emotional experiences, can it be shared via empathy. It may well be that the second person's empathic abilities are obstructed by the anxiety-arousing quality of the mere emanations of the first person's loneliness.'

When I read those lines, I remembered sitting, years back, outside a train station in the south of England, waiting for my father. It was a sunny day, and I had a book I was enjoying. After a while, an elderly man sat down next to me and tried repeatedly to strike up conversation. I didn't want to talk and after a brief exchange of pleasantries I began to respond more tersely until eventually, still smiling, he got up and wandered away. I've never stopped feeling ashamed about my unkindness, and nor have I ever forgotten how it felt to have the force field of his loneliness pressed up against me: an overwhelming, unmeetable need for attention and affection, to be heard and touched and seen.

If it's difficult to respond to people in this state, it is harder still to reach out from it. Loneliness feels like such a shameful experience, so counter to the lives we are supposed to lead, that it becomes increasingly inadmissible, a taboo state whose confession seems destined to cause others to turn and flee. In her essay, Fromm-Reichmann returns repeatedly to this issue of incommunicability, noting how reluctantly even the loneliest of patients approach the subject. One of her case studies concerns a schizophrenic woman who asked to see her psychiatrist specifically in order to discuss her experience of deep and hopeless loneliness.

After several futile attempts, she finally burst out: 'I don't know why people think of hell as a place where there is heat and where warm fires are burning. That is not hell. Hell is if you are frozen in isolation into a block of ice. That is where I have been.'

I first read this essay sitting on my bed, the blinds half-drawn. On my printout, I'd drawn a wavering Biro line under the words *a block of ice*. I was often feeling then like I was encased in ice, or walled up in glass, that I could see out all too clearly but lacked the ability to free myself or to make the kind of contact I desired. Show tunes from upstairs again, cruising Facebook, the white walls tight around me. Hardly any wonder I'd been so fixated on *Nighthawks*, that bubble of greenish glass, the colour of an iceberg.

After Fromm-Reichmann's death, other psychologists slowly began to turn their attention to the subject. In 1975, the social scientist Robert Weiss edited a seminal study, *Loneliness: The Experience of Emotional and Social Isolation*. He too opened by acknowledging the subject's neglect, noting wryly that loneliness is more often commented on by songwriters than social scientists. He felt that in addition to being unnerving in its own right – he writes of it as something that 'possessed' people, that is 'peculiarly insistent'; 'an almost eerie affliction of the spirits' – loneliness inhibits empathy because it induces in its wake a kind of self-protective amnesia, so that when a person is no longer lonely they struggle to remember what the condition is like.

If they had earlier been lonely, they now have no access to the self that experienced the loneliness; furthermore,

they very likely prefer that things remain that way. In consequence they are likely to respond to those who are currently lonely with absence of understanding and perhaps irritation.

Even psychiatrists and psychologists, Weiss thought, were not immune to this near-phobic dislike; they too were liable to be made uneasy 'by the loneliness that is potential in the everyday life of everyone'. As a result, a kind of victim blaming takes place: a tendency to see the rejection of lonely people as justified, or to assume they have brought the condition on themselves by being too timid or unattractive, too self-pitying or self-absorbed. 'Why can't the lonely change?' he imagines both professional and lay observers musing. 'They must find a perverse gratification in loneliness; perhaps loneliness, despite its pain, permits them to continue a self-protective isolation or provides them with an emotional handicap that forces handouts of pity from those with whom they interact.'

In fact, as Weiss goes on to show, loneliness is hallmarked by an intense desire to bring the experience to a close; something which cannot be achieved by sheer willpower or by simply getting out more, but only by developing intimate connections. This is far easier said than done, especially for people whose loneliness arises from a state of loss or exile or prejudice, who have reason to fear or mistrust as well as long for the society of others.

Weiss and Fromm-Reichmann knew that loneliness is painful and alienating, but what they didn't understand was how it generates its effects. Contemporary research has focused particularly on this area, and in attempting to understand what loneliness does

to the human body it has also succeeded in illuminating why it is so appallingly difficult to dislodge. According to work being carried out over the past decade by John Cacioppo and his team at the University of Chicago, loneliness profoundly affects an individual's ability to understand and interpret social interactions, initiating a devastating chain-reaction, the consequence of which is to further estrange them from their fellows.

When people enter into an experience of loneliness, they trigger what psychologists call hypervigilance for social threat, a phenomenon Weiss first postulated back in the 1970s. In this state, which is entered into unknowingly, the individual tends to experience the world in increasingly negative terms, and to both expect and remember instances of rudeness, rejection and abrasion, giving them greater weight and prominence than other, more benign or friendly interactions. This creates, of course, a vicious circle, in which the lonely person grows increasingly more isolated, suspicious and withdrawn. And because the hypervigilance hasn't been consciously perceived, it's by no means easy to recognise, let alone correct, the bias.

What this means is that the lonelier a person gets, the less adept they become at navigating social currents. Loneliness grows around them, like mould or fur, a prophylactic that inhibits contact, no matter how badly contact is desired. Loneliness is accretive, extending and perpetuating itself. Once it becomes impacted, it is by no means easy to dislodge. This is why I was suddenly so hyper-alert to criticism, and why I felt so perpetually exposed, hunching in on myself even as I walked anonymously through the streets, my flip-flops slapping on the ground.

At the same time, the body's state of red alert brings about a series of physiological changes, driven by gathering tides of adrenaline and cortisol. These are the fight or flight hormones, which act to help an organism respond to external stressors. But when the stress is chronic, not acute; when it persists for years and is caused by something that cannot be outrun, then these biochemical alterations wreak havoc on the body. Lonely people are restless sleepers, and experience a reduction in the restorative function of sleep. Loneliness drives up blood pressure, accelerates ageing, weakens the immune system and acts as a precursor to cognitive decline. According to a 2010 study, loneliness predicts increased morbidity and mortality, which is an elegant way of saying that loneliness can prove fatal.

At first it was thought that this increased morbidity occurred because of the practical consequences of being isolated: the lack of care, the potentially diminished ability to feed and nurture oneself. In fact, it seems almost certain now that it is the subjective experience of loneliness that produces the physical consequences, not the simple fact of being alone. It is the feeling itself that is stressful; the feeling that sets the whole grim cascade into motion.

★

Hopper could not possibly have known about any of this, except of course from the inside out, and yet in painting after painting he shows not just what loneliness looks like but also how it feels, communicating with his blank walls and open windows a simu-

lacrum of its paranoid architecture, the way it functions to simultaneously entrap and expose.

It's naive to assume that an artist is personally acquainted with their subject matter, that they are not simply a witness to their age, to the prevailing moods and preoccupations of the times. All the same, the more I looked at *Nighthawks*, the more I wondered about Hopper himself, who had after all once said: 'The man's the work. Something doesn't come out of nothing.' The vantage point the painting makes you enter into is so particular, so estranging. Where did it come from? What was Hopper's own experience of cities, of intimacy, of longing? Was he lonely? Who do you have to be to see the world like that?

Though he disliked interviews, and as such left only a minimal record of his life in words, Hopper was often photographed, and so it's possible to track him through the years, from gawky youth in a straw boater in the 1920s to great man of the arts in the 1950s. What comes across in these mostly black and white images is a quality of intense self-containment, of someone set deep inside himself, leery of contact, emphatically reserved. He stands or sits always a little awkwardly, slightly hunched, as tall men often are, his long limbs uncomfortably arranged, dressed in dark suits and ties or three-piece tweeds, his long face sometimes sullen, sometimes guarded and sometimes showing a small glint of amusement, the deprecating wit that came and went in disarming flashes. A private man, one might conclude, not on easy terms with the world.

All photographs are silent, but some are more silent than others, and these portraits attest to what was by all accounts

Hopper's most striking feature, his gigantic resistance to speech. It's a different thing from quietness, silence; more powerful, more aggressive. In his interviews, it functions as a barrier, preventing the interviewer from opening him up or putting words into his mouth. When he does speak, it's often simply to deflect the question. 'I don't remember,' he says frequently, or 'I don't know why I did that.' He regularly uses the word *unconscious*, as a way of evading or disclaiming whatever meaning the interviewer believes to be seeping from his pictures.

Just before his death in 1967, he gave an unusually long interview to the Brooklyn Museum. He was eighty-four at the time: the foremost realist painter at work in America. As always, his wife was present in the room. Jo was a consummate interrupter, filling in the spaces, jumping in all the gaps. The conversation (which was recorded and transcribed, though never published in full) is illuminating not only in terms of content, but also for what it reveals of the Hoppers' complex dynamic, their intimately adversarial marriage.

The interviewer asks Edward how he comes to choose his subjects. As usual, he seems to find the question painful. He says that the process is complicated, very difficult to explain, but that he has to be very much interested in his subject, and that as such he can only produce perhaps one or two paintings a year. At this, his wife interrupts. 'I'm being very biographic,' she says, 'but when he was twelve years old, he grew, he was six feet tall.' 'Not at twelve. Not at twelve,' Hopper says. 'But that's what your mother said. And you said. Now you're changing it. Oh, you contradict me . . . You know, you'd think we were bitter enemies.' The

interviewer makes some small sound of disavowal and Jo ploughs on, describing her husband as a schoolboy, slim as a blade of grass, no strength in him at all, not wanting to make trouble with the mean kids, the bullies.

> But that made him rather, it would make one shy . . . he had to lead the line at school, you know, the tallest, and oh, he hated that, these bad boys in back of him, and they'd try to push him off in the wrong direction.

'Shy is hereditary,' Hopper says, and she replies: 'Well, I think it's circumstantial too, you know . . . He never has been much on the declaring himself – '. At that he interrupts, saying: 'I declare myself in my paintings.' And again, a little later: 'I don't think I ever tried to paint the American scene. I'm trying to *paint myself.*'

He'd always had a knack for drawing, right from his boyhood in New Jersey at the tail end of the nineteenth century, the only son of cultured and not particularly well-suited parents. A lovely naturalness of line, and at the same time a certain sourness that came out especially in the ugly caricatures he drew right through his life. In these often strikingly unpleasant drawings, which were never exhibited but which can be seen in Gail Levin's biography, Hopper presents himself as a skeletal figure, all long bones and a grimace, often under the thumb of women or hankering silently for something they refuse to supply.

At eighteen, he went to art school in New York, where he was taught by Robert Henri, one of the foremost proponents of the gritty urban realism known as the Ashcan School. Hopper

was an outstanding and much-praised student, and so understandably lingered at college for years, unwilling to cast himself fully into independent adulthood. In 1906 his parents financed a trip to Paris, where he shut himself away, not meeting any of the artists in the city at the time, a lack of interest in prevailing currents or fashions that he maintained lifelong. 'I'd heard of Gertrude Stein,' he remembered later, 'but I don't recall having heard of Picasso at all.' Instead, he spent his days wandering the streets, painting by the river or sketching prostitutes and passers-by, setting down a taxonomy of hairdos and women's legs and nifty feathered hats.

It was in Paris that he learned to open up his paintings, to let light in, following the example of the Impressionists, after the gloomy browns and blacks favoured in his New York training. Learned too to meddle with perspective, to make small impossibilities in his scenes: a bridge reaching where it couldn't, the sun falling from two directions at once. People stretched, buildings shrunk, infinitesimal disturbances in the fabric of reality. This is how you unsettle the viewer, by making a not-rightness, by rendering it in little jabs of white and grey and dirty yellow.

For a few years he went back and forth to Europe, but in 1910 he settled permanently in Manhattan. 'It seemed awfully crude and raw here when I got back,' he remembered decades later. 'It took me ten years to get over Europe.' He was jarred by New York, its frenetic pace, the relentless pursuit of the *long green*. In fact, money quickly became a major problem. For a long time, no one was interested in his paintings at all, and he scraped by as an illustrator, hating the clichéd commissions, the dismal neces-

sity of lugging a portfolio all over town, an unwilling salesman for work he didn't think at all worthwhile.

They weren't exactly rich in relationships either, those first American years. No girlfriend, though there might have been brief liaisons here and there. No intimate friendships, and only occasional contact with his family. Colleagues and acquaintances, yes, but a life notably short on love, though long on independence, long too on that discarded virtue, privacy.

This sense of separation, of being alone in a big city, soon began to surface in his art. By the early 1920s, he was making a name for himself as an authentically American artist, stubbornly sticking with realism despite the fashionable tide of abstraction filtering in from Europe. He was determined to articulate the day-to-day experience of inhabiting the modern, electric city of New York. Working first with etchings and then in paint, Hopper began to produce a distinctive body of images that captured the cramped, anxious, sometimes alluring experience of urban living.

His scenes – of women glimpsed through windows, of disordered bedrooms and tense interiors – were improvised from things he saw or half saw on long walks around Manhattan. 'They are not factual,' he said much later. 'Perhaps there were a very few of them that were. You can't go out and look up at an apartment and stand in the street and paint but many things have been suggested by the city.' And elsewhere: 'The interior itself was my main interest . . . simply a piece of New York, the city that interests me so much.'

None of these drawings show crowds, of course, though the crowd is surely the signature sight of the city. Instead they focus

on the experience of isolation: of people alone or in awkward, uncommunicative couples. It's the same limited and voyeuristic view that Alfred Hitchcock would later subject James Stewart to in the Hopperesque *Rear Window*, a film that is likewise about the dangerous visual intimacy of urban living, of being able to survey strangers inside what were once private chambers.

Among the many people Stewart's character L. B. Jeffries watches over from his Greenwich Village apartment are two female figures who might have walked straight out of a Hopper painting. Miss Torso is a sexy blonde, though her popularity is more superficial than it initially appears, while Miss Lonelyhearts is an unhappy, not quite attractive spinster, consistently displayed in situations that attest to her inability to find either companionship or contentment in solitude. She's seen preparing dinner for an imaginary lover, weeping and consoling herself with alcohol, picking up a stranger, then fighting him off when his advances go too far.

In one excruciating scene, Jeffries watches through a zoom lens as she makes herself up in a mirror, dressed in an emerald green suit, before putting on large black glasses to assess the effect. The act is intensely private, not intended for spectators. Instead of displaying the polished exterior she's so painstakingly produced, what she inadvertently reveals instead is her longing and vulnerability, her desire to be desirable, her fear that she's running short on what remains for women a chief currency of exchange. Hopper's paintings are full of women like her; women who appear to be in the grips of a loneliness that has to do with gender and unattainable standards of appearance, and that gets increasingly toxic and strangulating with age.

But if Jeffries is performing Hopper's characteristic gaze – cool, curious, detached – then Hitchcock is also at pains to show how voyeurism works to isolate the viewer as well as the viewed. In *Rear Window* voyeurism is explicitly presented as an escape from intimacy, a way of side-stepping real emotional demands. Jeffries prefers watching to participating; his obsessive scrutiny is a way of remaining emotionally aloof from both his girlfriend and the neighbours on whom he spies. It's only gradually that he is drawn into investment and commitment, becoming literally as well as figuratively engaged.

A rangy man who likes to spy on others, and who must learn to accommodate a flesh and blood woman in his life: *Rear Window* mimics or mirrors more than just the contents of Hopper's art. It also reflects the contours of his emotional life, the conflict between detachment and need that was lived out in actuality as well as expressed in coloured streaks of paint on canvas, in scenes repeated over many years.

In 1923, he re-encountered a woman with whom he'd studied at art school. Josephine Niveson, known as Jo, was tiny and tempestuous: a talkative, hot-tempered, sociable woman who'd been living alone in the West Village after the death of her parents, doggedly making her way as an artist, though she was crushingly short on funds. They bonded over a shared love of French culture and that summer began haltingly to date. The next year, they married. She was forty-one and still a virgin, and he was almost forty-two. Both must have considered the possibility that they would remain alone for good, having gone so far beyond the then conventional age for marriage.

The Hoppers were only parted when Edward died in the

spring of 1967. But though they were as a couple deeply enmeshed, their personalities, even their physical forms, were so diametrically opposed that they sometimes seemed like caricatures of the gulf between men and women. As soon as Jo gave up her studio and moved into Edward's marginally more salubrious room on Washington Square, her own career, previously much fought for, much defended, dwindled away to almost nothing: a few soft, impressionistic paintings here and there; an occasional group show.

In part this was because Jo poured her considerable energies into tending and nurturing her husband's work: dealing with his correspondence, handling loan requests and needling him into painting. At her insistence, she also posed for all the women in his canvases. From 1923 on, every office worker and city girl was modelled for by Jo, sometimes dressed up and sometimes stripped down, sometimes recognisable and sometimes entirely rebuilt. The tall blonde usherette in 1939's *New York Movie*, leaning pensively against a wall: that was based on her, as was the leggy red-haired burlesque dancer in 1941's *Girlie Show*, for which Jo modelled 'without a stitch on in front of the stove – nothing but high heels in a lottery dance pose'.

A model, yes; a rival, no. The other reason Jo's career foundered is that her husband was profoundly opposed to its existence. Edward didn't just fail to support Jo's painting, but rather worked actively to discourage it, mocking and denigrating the few things she did manage to produce, and acting with great creativity and malice to limit the conditions in which she might paint. One of the most shocking elements of Gail Levin's fascinating and enormously detailed *Edward Hopper: An Intimate Biography*, which draws closely on Jo's unpublished diaries, is the violence into which the

Hoppers' relationship often degenerated. They had frequent rows, particularly over his attitude to her painting and her desire to drive their car, both potent symbols of autonomy and power. Some of these fights were physical: cuffings, slappings and scratchings, undignified struggles on the bedroom floor that left bruises as well as wounded feelings.

As Levin observes, it is almost impossible to form a judgement of Jo Hopper's work, since so little of it has survived. Edward left everything to his wife, asking that she bequeath his art to the Whitney, the institution with which he'd had the closest ties. After his death, she donated both his and the majority of her own artistic estates to the museum, even though she'd felt from the moment of her marriage that she'd been the victim of a boycott by the curators there. Her disquiet was not unwarranted. After her death, the Whitney discarded all her paintings, perhaps because of their calibre and perhaps because of the systematic undervaluing of women's art against which she'd railed so bitterly in her own life.

The silence of Hopper's paintings becomes more toxic after the revelation of how violently he worked to suppress and check his wife. It isn't easy to square the revelation of pettiness and savagery with the image of the suited man in polished shoes, his stately reticence, his immense reserve. Perhaps his own silence was part of it, though: some inability to communicate in ordinary language, some deep resentment around intimacy and need. 'Any talk with me sends his eyes to the clock,' Jo wrote in her diary in 1946. 'It's like taking the attention of an expensive specialist' – behaviour that compounded her feeling of being 'a rather lonely creature', cut off and excluded from the artistic world.

Just before the Hoppers got together, a fellow artist jotted down a pen-portrait of Edward. He started with the visual elements: the prominent masticating muscles, the strong teeth and big, unsensuous mouth, before moving on to the cool static way he painted: blocking things out, retaining control. He noted Hopper's sincerity, his vast inhibitions and his wit, writing: 'Should be married. But can't imagine to what kind of a woman. The hunger of that man.' A few lines on he repeated the phrase: 'But the hunger of him, the hunger of him!'

Hunger is also what's communicated in Hopper's cartoons, in which he abases himself before his primly elevated wife, a starving man, crouching on the floor while she eats at the table or kneeling in pious self-abnegation at the foot of her bed. And it flickers on and off in his paintings too, in the vast space he makes between men and women who share the same small rooms. *Room in New York*, say, which ripples with unexpressed frustration, unmet desire, violent restraint. Perhaps this is why his images are so resistant to entry, and so radiant with feeling. If the statement *I declare myself in my paintings* is to be taken at face value, then what is being declared is barriers and boundaries, wanted things at a distance and unwanted things too close: an erotics of insufficient intimacy, which is of course a synonym for loneliness itself.

★

For a long time, the paintings came steadily enough, but by the mid-1930s the periods between them had started to lengthen. Until

very late in life, Hopper always needed something real to spark his imagination, wandering the city until he saw a scene or space that gripped him, and then letting it settle in his memory; painting, or so he hoped, both the feeling and the thing, 'the most exact transcription possible of my most intimate impressions of nature'. Now he began to complain about a lack of subjects that excited him enough to bother beginning the labour, the tricky business of trying 'to force this unwilling medium of paint and canvas' into a record of emotion, a process he characterised in a famous essay titled 'Notes on Painting' as a struggle against inevitable decay.

> I find in working always the disturbing intrusion of elements not a part of my most interested vision, and the inevitable obliteration and replacement of this vision by the work itself as it proceeds. The struggle to prevent this decay is, I think, the common lot of all painters to whom the invention of arbitrary forms has lesser interest.

While this process meant painting could never be entirely pleasurable, the periods of blockage were far worse. Black moods, long disappointing walks, frequent trips to the cinema, a retreat into wordlessness, plunging downward into a shaft of silence, which led almost inevitably to fights with Jo, who needed to speak as badly as her husband required quiet.

All of these things were at work in the winter of 1941, the period from out of which *Nighthawks* emerged. Hopper had achieved considerable acclaim by then, including the rare honour of a retrospective at the Museum of Modern Art. Ever the New England

puritan, he hadn't let the increase in prestige go to his head. While he and Jo had moved from the cramped back studio at Washington Square to two rooms at the front, they still didn't have central heating or a private bathroom; still had to haul coal up seventy-four steps for the woodburner that kept the place from freezing.

On 7 November they returned from a summer in Truro, where they had recently built a beach house. A canvas was put on the easel, but for weeks it stayed untouched, a painful blankness in the small flat. Hopper went out on his usual outings, trolling for scenes. At last, something came into focus. He started making drawings in coffee shops and on street corners, sketching patrons that caught his eye. He drew a coffee pot and jotted colours next to it: *amber* and *dark brown*. On 7 December, either just before or just after this process started, Pearl Harbor was attacked. The next morning, America entered the Second World War.

In a letter Jo wrote to Edward's sister on 17 December, worries about bombing are interspersed with complaints about her husband, who is finally at work on a new painting. He's banned her from entering the studio, meaning she's effectively imprisoned in half their tiny domain. Hitler has said he intends to destroy New York. They live, she reminds Marion, right under glass skylights, a leaking roof. They don't have blackout shades. Ed, she writes crossly, can't be bothered. A few lines down: 'I haven't gone thru even for things I want in the kitchen.' She packs a knapsack with a chequebook, towels, soap, clothes and keys, 'in case we ran to race out doors in our nighties'. Her husband, she adds, jeers when he sees what she has done. There's nothing new about his slighting tone, nor her habit of passing it on.

In the studio next door, Edward gets a mirror and draws himself, slouching at the counter, establishing the pose for both his male customers. Over the next few weeks he furnishes the café with coffee pots and cherry countertops, the dim reflections in their shined and lacquered surfaces. The painting has started to quicken. He's busy with it, Jo tells Marion a month later, *interested all the time*. Eventually he allows her into the studio to pose. This time he elongates her, reddening her lips and hair. The light strikes her face, bowed to consider the object in her right hand. He finally finishes on 21 January 1942. Collaborating, as they often do, on titles, the Hoppers call it *Nighthawks*, after the beaked profile of the woman's saturnine companion.

There's so much going on in this story, so many potential readings, some personal and some far larger in scope and scale. The glass, the leaking light, look different after reading Jo's letter, her agitation over bombs and blackouts. You could read the painting now as a parable about American isolationism, finding in the diner's fragile refuge a submerged anxiety about the nation's abrupt lurch into conflict, the imperilling of a way of life.

Then there's a more intimate interpretation to be made, about the ongoing struggle with Jo, the need to keep her punishingly distant and then to bring her close, to change her face and body into the sexual, self-contained woman at the counter, lost in thought. Is this Hopper's way of silencing his wife, locking her into the speechless medium of paint, or is it an erotic act, a mode of fertile collaboration? The practice of using her as a model for so many different women invites such questioning, but to settle on a single answer is to miss the point of how emphatically Hopper resists

closure, creating with his ambiguous scenes a testament instead to human isolation, to the essential unknowability of others – something, one must remember, that he achieved in part by ruthlessly refusing his wife the right to her own acts of artistic expression.

In the late 1950s, the curator and art historian Katherine Kuh interviewed Hopper for a book called *The Artist's Voice*. In the course of their conversation, she asked him which of his paintings he liked the best. He named three, one of which was *Nighthawks*, which he said 'seems to be the way I think of a night street'. 'Lonely and empty?' she asks, and he replies: 'I didn't see it as particularly lonely. I simplified the scene a great deal and made the restaurant bigger. Unconsciously, probably, I was painting the loneliness of a large city.' The conversation meanders on to other things, but a few minutes later she returns to the subject, saying: 'Whenever one reads about your work, it is always said that loneliness and nostalgia are your themes.' 'If they are,' Hopper replies cautiously, 'it isn't at all conscious.' And then, reversing again: 'I probably am a lonely one.'

It's an unusual formulation, *a lonely one*; not at all the same thing as admitting one is lonely. Instead, it suggests with that *a*, that unassuming indefinite article, a fact that loneliness by its nature resists. Though it feels entirely isolating, a private burden no one else could possibly experience or share, it is in reality a communal state, inhabited by many people. In fact, current studies suggest that more than a quarter of American adults suffers from loneliness, independent of race, education and ethnicity, while 45 per cent of British adults report feeling lonely either often or sometimes. Marriage and high income serve as mild deterrents, but the

truth is that few of us are absolutely immune to feeling a greater longing for connection than we find ourselves able to satisfy. The lonely ones, a hundred million strong. Hardly any wonder Hopper's paintings remain so popular, and so endlessly reproduced.

Reading his halting confession, one begins to see why his work is not just compelling but also consoling, especially when viewed en masse. It's true that he painted, not once but many times, the loneliness of a large city, where the possibilities of connection are repeatedly defeated by the dehumanising apparatus of urban life. But didn't he also paint loneliness *as* a large city, revealing it as a shared, democratic place, inhabited, whether willingly or not, by many souls? What's more, the technical strategies he uses – the strange perspective, the sites of blockage and exposure – further combat the insularity of loneliness by forcing the viewer to enter imaginatively into an experience that is otherwise notable for its profound impenetrability, its multiple barriers, its walls like windows, its windows like walls.

How had Frieda Fromm-Reichmann put it? 'It may well be that the second person's empathic abilities are obstructed by the anxiety-arousing quality of the mere emanations of the first person's loneliness.' This is what's so terrifying about being lonely: the instinctive sense that it is literally repulsive, inhibiting contact at just the moment contact is most required. And yet what Hopper captures is beautiful as well as frightening. They aren't sentimental, his pictures, but there is an extraordinary attentiveness to them. As if what he saw was as interesting as he kept insisting he needed it to be: worth the labour, the miserable effort of setting it down. As if loneliness was something worth looking at. More than that, as if looking itself was an antidote, a way to defeat loneliness's strange, estranging spell.

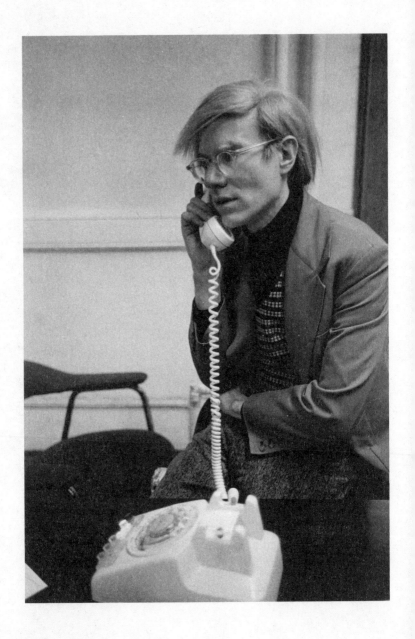

3

MY HEART OPENS TO YOUR VOICE

I DIDN'T STAY IN BROOKLYN long. The friend whose apartment I was staying in came back from L.A. and I moved to the green walk-up in the East Village. The change in habitat marked another phase of loneliness; a period in which speech became an increasingly perilous endeavour.

If you are not being touched at all, then speech is the closest contact it is possible to have with another human being. Almost all city-dwellers are daily participants in a complex part-song of voices, sometimes performing the aria but more often the chorus, the call and response, the passing back and forth of verbal small change with near and total strangers. The irony is that when you are engaged in larger and more satisfactory intimacies, these quotidian exchanges go off smoothly, almost unnoticed, unperceived. It is only when there is a paucity of deeper and more personal connection that they develop a disproportionate importance, and with it a disproportionate risk.

Since coming to America, I was forever botching the ballgame of language: fumbling my catches, bungling my throws. Each morning

I'd walk up through Tompkins Square Park to get my coffee, past the Temperance fountain and the dog run. On East 9th Street there was a café that looked out over a community garden planted with an enormous weeping willow. It was populated almost exclusively by people gazing into the glowing clamshells of their laptops and so it seemed a safe place, in which my solitary status was unlikely to be exposed. Each day, though, the same thing happened. I ordered the nearest thing to filter on the menu: a medium urn brew, which was written in large chalk letters on the board. Each time, without fail, the barista looked mystified and asked me to repeat myself. I might have found it funny in England, or irritating, or I might not have noticed it at all, but that autumn it worked under my skin, depositing little grains of anxiety and shame.

It was such a stupid thing to get upset about: a minor artefact of foreignness, of speaking a shared language with a slightly different inflection, a different slant. Wittgenstein speaks for all exiles when he says: 'The silent adjustments to understand colloquial language are enormously complicated.' I was failing to make those complicated adjustments, those enormous silent shifts, and as such I was exposing myself as a non-native, an outsider, someone who doesn't know the code word is *regular* or *drip*.

In certain circumstances, being outside, not fitting in, can be a source of satisfaction, even pleasure. There are kinds of solitude that provide a respite from loneliness, a holiday if not a cure. Sometimes as I walked, roaming under the stanchions of the Williamsburg Bridge or following the East River all the way to the silvery hulk of the U.N., I could forget my sorry self, becoming instead as porous and borderless as the mist, pleasurably adrift on

the currents of the city. I didn't get this feeling when I was in my apartment; only when I was outside, either entirely alone or submerged in a crowd.

In these situations I felt liberated from the persistent weight of loneliness, the sensation of wrongness, the agitation around stigma and judgement and visibility. But it didn't take much to shatter the illusion of self-forgetfulness, to bring me back not only to myself but to the familiar, excruciating sense of lack. Sometimes the trigger was visual – a couple holding hands, something as trivial and innocuous as that. But more often it had to do with language, with the need to communicate, to understand and make myself understood via the medium of speech.

The intensity of my reaction – sometimes a blush; more often a full-blown blast of panic – testified to hypervigilance, to the way perception around social interaction had begun to warp. Somewhere in my body, a measuring system had identified danger, and now the slightest glitch in communication was registering as a potentially overwhelming threat. It was as if, having been so cataclysmically dismissed, my ears had become attuned to the note of rejection, and when it came, as it inevitably does, in small doses throughout the day, some vital part of me clamped and closed, poised to flee not so much physically as deeper into the interior of the self.

No doubt it was ridiculous to be so sensitive. But there was something almost agonising about speaking and being misunderstood or found unintelligible, something that got right to the heart of all my fears about aloneness. *No one will ever understand you. No one wants to hear what you say. Why can't you fit in, why do*

you have to stick out so much? It wasn't hard to see why someone in this position might come to mistrust language, doubting its ability to bridge the gap between bodies, traumatised by the revealed gulf, the potentially lethal abyss that lurks beneath each carefully proffered sentence. Dumbness in this context might be a way of evading hurt, dodging the pain of failed communication by refusing to participate in it at all. That's how I explained my growing silence, anyway; as an aversion akin to someone wishing to avoid a repeated electric shock.

If anyone would have understood this dilemma, it was Andy Warhol, an artist I'd always dismissed until I became lonely myself. I'd seen the screen-printed cows and Chairman Maos a thousand times, and I thought they were vacuous and empty, disregarding them as we often do with things we've looked at but failed properly to see. My fascination with Warhol did not begin until after I'd moved to New York, when I happened upon a couple of his television interviews one day on YouTube and was struck by how hard he seemed to be struggling with the demands of speech.

The first was a clip from the Merv Griffin show in 1965, when Warhol was thirty-seven, at the height of his Pop Art fame. He came on in a black bomber jacket and sat chewing gum, refusing to speak out loud and instead whispering his answers in Edie Sedgwick's ear. *Do you do your own copies*, Griffin asks and at this ideal question Andy comes to life, nodding his head, putting a finger to his lips and then mumbling the word *yes* to a torrent of amused applause.

In the second interview, recorded two years later, he sits rigid

against a backdrop of his own *Elvis I and II*. Asked if he ever bothers reading interpretations of his work, he gives a campy little wobble of the head. 'Uhhhh,' he says, 'can I just answer *alalalala*?' The camera zooms in, revealing he's by no means as disengaged as the affectless, narcotic voice suggests. He looks almost sick with nerves, his make-up not quite concealing the red nose that was the bane of his existence and which he tried repeatedly to improve with cosmetic surgery. He blinks, swallows, licks his lips; a deer in headlights, at once graceful and terrified.

Warhol is often thought of as being completely subsumed by the glossy carapace of his own celebrity, of having successfully transformed himself into an instantly recognisable avatar, just as his screen-prints of Marilyn and Elvis and Jackie Kennedy convert the actual face into the endlessly reproducible lineaments of the star. But one of the interesting things about his work, once you stop to look, is the way the real, vulnerable, human self remains stubbornly visible, exerting its own submerged pressure, its own mute appeal to the viewer.

He'd had problems with speech from the start. Though passionately fond of gossip and drawn since childhood to dazzling talkers, he was in his own person frequently tongue-tied, especially in younger life, struggling with communication by way of both the spoken and the written word. 'I only know one language,' he once said, conveniently forgetting the Slovak he spoke with his family:

> . . . and sometimes in the middle of a sentence I feel like a foreigner trying to talk it because I have word

spasms where the parts of some words begin to sound peculiar to me and in the middle of saying the word I'll think, 'Oh, this can't be right – this sounds very peculiar, I don't know if I should try to finish up this word or try to make it into something else, because if it comes out good it'll be right, but if it comes out bad it'll sound retarded,' and so in the middle of words that are over one syllable, I sometimes get confused and try to graft other words on top of them . . . I can hardly talk what I already talk.

Despite his own incapacity, Warhol was fascinated by how people talk to one another. 'To me,' he said, 'good talkers are beautiful because good talk is what I love.' His art exists in such a dazzling array of mediums, among them film, photography, painting, drawing and sculpture, that it's easy to miss quite how much of it was devoted to human speech. During his career, Warhol made over 4,000 audio tapes. Some of these he stored away, but others were transcribed by assistants and published as books, including several memoirs, the gargantuan diaries and a novel. His taped works, both published and unpublished, investigate the alarming-ness of language, its range and limits, just as his films explore the borders of the physical body, its boundaries and fleshy openings.

If becoming Warhol was an alchemical process, then the base metal was Andrej, later Andrew, Warhola, born amidst the smelting fires of Pittsburgh on 6 August 1928. He was the youngest of three sons of Andrej, sometimes spelled Ondrej, and Julia Warhola, Ruthenian emigrants from what was then the Austro-Hungarian

Empire and is now Slovakia. This linguistic instability, this parade of changing names, is a staple of the immigrant experience, undermining from the very first the comforting notion that word and object are securely attached. *I come from nowhere*, Warhol once famously said, referring to poverty or Europe or the myth of self-creation, though perhaps also attesting to the linguistic rent from out of which he had emerged.

Andrej had been the first to arrive in America, settling at the beginning of the First World War in a Slovakian slum region of Pittsburgh and finding work as a coal miner. Julia followed in 1921. The next year, their son Pawel was born, anglicised to Paul. None of the family spoke English and Paul was bullied at school for his accent, his mangling of American diction. As a consequence he developed a speech impediment so severe that he cut class whenever he might have to talk in public; a phobia that eventually drove him to drop out of high school altogether (years later, in the diary he dictated each morning down the phone to his secretary Pat Hackett, Andy commented of Paul: 'And my brother speaks better than I do, he always was a good talker').

As for Julia, she never mastered the new language, speaking at home in Ruthenian, itself a blend of Slovak and Ukrainian mixed with Polish and German. In her own tongue she was a strikingly garrulous woman, a magnificent storyteller and ardent letter writer; a genius of communication transplanted to a country where she could not make herself understood beyond a few phrases of broken and garbled English.

Even as a little boy, Andy was notable for his skill at drawing and his painful shyness: a pale, slightly otherworldly child, who

fantasised about renaming himself *Andy Morningstar*. He was passionately close to his mother, particularly when at the age of seven he contracted rheumatic fever, followed by St Vitus's Dance, an alarming disorder characterised by involuntary movements of the limbs. Confined to bed for months, he inaugurated what might in retrospect be termed the first of his Factories, those hubs of production and sociability he would go on to establish in New York. He turned his room into an atelier of scrapbooking, collaging, drawing and colouring in, activities for which Julia served as both rapturous audience and studio assistant.

Sissy, momma's boy, spoilt: this sort of withdrawal can leave a mark on a child, especially if they're temperamentally unsuited to the society of their peers or do not conform to gender roles. It happened to a future friend, Tennessee Williams, who never quite refound his footing in the shifting, sometimes perilous hierarchy of school. As for Andy, though he always had female friends and was never actively bullied, he could not in fairness be described after his re-emergence from the sickroom as socially desirable, a popular presence in the hallways of Schenley High School.

There was his appearance for a start: tiny and homely, with a bulbous nose and ashen hair. The illness had left his strikingly white skin covered in liver-coloured blotches, and as a teenager he suffered from the mortification of acne, earning him the nickname *Spot*. In addition to his physical awkwardness, he spoke English, his second language, with a heavy accent, which instantly marked him as coming from among the lowest of Pittsburgh's immigrant working classes.

Can I just say *alalalala?* According to his biographer, Victor Bockris, Andy had trouble making himself understood right through his teens and into adulthood: saying "'ats" for "that is", "jeetjet" for "did you eat yet?" and "yunz" for "all of you'"; what one of his teachers later described as 'mutilations of the English language'. In fact, his grasp was so poor that even at art school he relied on friends to help him draft essays, assuming he'd even understood what the teachers had assigned.

It's not easy to summon him, the Andy of the 1940s. He lingers at the threshold, slight in his creamy corduroy suit, standing with hands folded prayer-style against his cheek, a pose he'd copied from his idol Shirley Temple. Gay, of course, not that anyone had the terminology or sophistication to vocalise that then. The sort of boy who polarised opinion, with his confident, stylish draw-ings, his flamboyant outfits and awkward, uncomfortable air.

After graduation, he moved in the summer of 1949 to – where else? – New York, renting a slummy walk-up on St Mark's Place, two blocks away from where I had my humiliating morning coffees. There he started, like Hopper before him, the arduous process of building a career as a commercial illustrator. The same rounds of magazine editors, dragging a portfolio, though in Raggedy Andy's case it was a brown paper bag. The same grinding poverty, the same shame at its exposure. He remembered (or claimed he did; like many of Andy's stories, this may actually have happened to a friend) watching in horror as a cockroach crawled out of his drawings as he displayed them to the white-gloved art director at *Harper's Bazaar.*

Over the course of the 1950s he transformed himself by dogged

networking and hard graft into one of the city's best known and best paid commercial artists. In that same period, he established himself within the intersecting worlds of bohemian and gay society. You could see it as a decade of success, of rapid elevation, but it also involved repeated rejection on two fronts. What Warhol most wanted was to be accepted by the art world and to be desired by one of the beautiful boys on whom he developed serial crushes: a breed exemplified by the poised and wickedly glamorous Truman Capote. Adept despite his shyness at manoeuvring himself into social proximity, he was hampered by an absolute belief in his own physical abhorrence. 'He had an enormous inferiority complex,' one of these love objects, Charles Lisanby, later told Bockris. 'He told me he was from another planet. He said he didn't know how he got here. Andy wanted so much to be beautiful, but he wore that terrible wig which didn't fit and only looked awful.' As for Capote, he thought Warhol was 'just a hopeless born loser, the loneliest, most friendless person I'd ever met in my life'.

Born loser or not, he did in the course of the 1950s have several relationships with men, though they had a tendency to fizzle out and were marked by his extreme unwillingness to show his body, preferring always to look than be seen. As for the art world, though he succeeded in having several shows, his drawings were dismissed as being too commercial, too campy, too weightless, too flimsy; too gay altogether for the homophobic, macho climate of the time. This was the age of abstract expressionism, dominated by Jackson Pollock and Willem de Kooning, in which the cardinal virtues were seriousness and feeling, the revealed layers behind the super-ficiality of the image. Beautiful drawings of golden shoes couldn't

be anything but a retrograde step, frivolous and trivial, though in fact they represented the first stage in Warhol's assault on distinction itself, the opposition between depth and surface.

The loneliness of difference, the loneliness of undesirability, the loneliness of not being admitted into the magic circles of connection and acceptance – the social and professional group-ings, the embracing arms. Another thing: he lived with his mother. In the summer of 1952 Julia had arrived in Manhattan (I'd like to say by ice cream van, but that was a previous visit). Andy had recently moved into his own apartment and she was anxious about his ability to care for himself. The two of them shared a bedroom, as they had when he was a sick little boy, sleeping on twin mattresses on the floor and re-establishing the old produc-tion-line of collaboration. Julia's hand is everywhere in Warhol's commercial work; in fact, her beautifully erratic lettering won several awards. Her housekeeping skills were less pronounced. Both that apartment and the larger one that followed quickly degenerated into a state of squalor: a smelly labyrinth filled with wobbling towers of paper, in which as many as twenty Siamese cats made their homes, all but one of them named Sam.

<p style="text-align:center">*</p>

Enough. At the beginning of the 1960s, Warhol reinvented himself. Instead of whimsical drawings of shoes for fashion magazines and department store ad campaigns, he began to produce flat, commod-ified, eerily exact paintings of even more despicable objects, the kind of household goods everyone in America knew and handled

daily. Starting with a series of Coke bottles, he progressed rapidly to Campbell's soup cans, food stamps and dollar bills: things he literally harvested from his mother's cupboards. Ugly things, unwanted things, things that couldn't possibly belong in the sublime white chamber of the gallery.

He wasn't quite the originator of what quickly became known as Pop Art, though he would soon be its most famous and charismatic proponent. Jasper Johns had produced his first encaustic, messy, painterly American flag in 1954, and they were exhibited at the Leo Castelli gallery in New York in 1958. Robert Rauschenberg, Robert Indiana and Jim Dine all had shows planned in the city by the end of 1960, and in 1961 Roy Lichtenstein, another Castelli artist, pushed even further in terms of both content and execution, ditching the human brushstrokes of abstract expressionism altogether to paint the first of his giant primary-coloured Mickey Mouses, *Look Mickey*, a cartoon lovingly replicated (though perhaps, considering the adjustments and clarifications that Lichtenstein made, a better word is purified) in oils, right down to the Ben-Day dots of the printing process, soon to become a signature of his style.

One talks about the shock of the new, but part of the reason Pop Art caused such enormous hostility, such a wringing of hands among artists, gallerists and critics alike, is that it looked on first glance like a category error, a painful collapse of the seemingly unquestionable boundary between high and low culture; good taste and bad. But the questions Warhol was asking with his new work run far deeper than any crude attempt at shock or defiance. He was painting things to which he was sentimentally attached,

even loved; objects whose value derives not because they're rare or individual but because they are reliably the same. As he put it later in his bewitchingly weird autobiography, *The Philosophy of Andy Warhol*, in the lovely Gertrude Steinish cadence at which he was so adept: 'all the Cokes are the same and all the Cokes are good.'

Sameness, especially for the immigrant, the shy boy agonisingly aware of his failures to fit in, is a profoundly desirable state; an antidote against the pain of being singular, alone, *all one*, the medieval root from which the word *lonely* emerges. Difference opens the possibility of wounding; alikeness protects against the smarts and slights of rejection and dismissal. One dollar bill is not more attractive than another; drinking Coke puts the coal miner among the company of presidents and movie stars. It's the same democratic inclusive impulse that made Warhol want to call Pop Art Common Art, or that had him declare: 'If everybody's not a beauty, then nobody is.'

Warhol emphasised the glamour of sameness as well as its potentially unnerving aspect by producing his common objects as multiples; a generative bombardment of repeating images in fluxing palettes. In 1962 he discovered the mechanical, wonderfully chancy process of silk-screening. Now he could dispense with hand-painted images altogether, transforming photographs by way of professionally produced stencils directly into prints. That summer, he filled the living room-cum-studio of his new house on Lexington Avenue with hundreds of Marilyns and Elvises, their faces rolled on to canvases covered in tonal splashes of pink and lavender, scarlet, fuchsia and pale green.

'The reason I'm painting this way is that I want to be a machine, and I feel that whatever I do and do machine-like is what I want to do,' he famously told Gene Swenson in an interview for *Art News* conducted the next year.

AW: I think everybody should be a machine. I think everybody should like everybody.

GS: Is that what Pop Art is all about?

AW: Yes. It's liking things.

GS: And liking things is like being a machine?

AW: Yes, because you do the same thing every time. You do it over and over again.

GS: And you approve of that?

AW: Yes.

To like: to feel attraction. To be like: to be similar or indistinguishable, of a common origin or ilk. *I think everybody should like everybody*: the lonely wish lurking at the heart of this profusion of likeable like objects, each one desirable, each one desirably the same.

The desire to transform himself into a machine didn't end with the production of art. At around the time that he was painting the first Coke bottles, Warhol also redesigned his own image, converting himself into a product. In the 1950s, he'd shuttled between Raggedy Andy and a more dandyish uniform of Brooks Brothers suits and expensive, often identical shirts. Now he codified and refined his appearance; playing not, as is customary, to his strengths, but rather emphasising the elements of himself

about which he felt most self-conscious or insecure. He didn't surrender his own individuality, or try to make himself appear more ordinary. Instead, he consciously developed himself as a replicable entity, exaggerating his physical appearance to create an automaton or simulacrum that he could both shelter behind and send out into the world at large.

Rejected by the galleries for being too camp, too gay, he intensified his swishy way of moving, his mobile wrists and light, bouncing walk. He set his wigs a little askew, to emphasise their presence, and exaggerated his awkward way of talking, speaking in a mumble if he spoke at all. According to the critic John Richardson: 'He made a virtue of his vulnerability, and forestalled or neutralized any possible taunts. Nobody could ever "send him up". He had already done so himself.' Forestalling criticism is something we all do in small ways, but the commitment and thoroughness of Warhol's intensification of his flaws is very rare, attesting both to his courage and his extreme fear of rejection.

The new Andy was immediately recognisable; a caricature that could be cloned at will. In fact, in 1967 he did just that, secretly sending the actor Alan Midgette out in Warhol drag to do a university lecture tour on his behalf. Dressed in a leather jacket, albino wig and Wayfarers and mumbling through his talks, Midgette did not arouse suspicion until he got lazy and stopped applying Andy's signature pancake layer of pallid foundation.

Multiple Andys, like the multiple silk-printed Marilyns and Elvises, raise questions about originals and originality, about the duplicatory process by which celebrity arises. But the desire to turn oneself into a multiple or machine is also a desire to be

liberated from human feeling, human need, which is to say the need to be cherished or loved. 'Machines have less problems. I'd like to be a machine, wouldn't you?' he told *Time* in 1963.

Warhol's mature work, in all its many mediums, from the screen-printed divas to the magically random and quixotic movies, is in perpetual flight from emotion and earnestness; arises, in fact, out of a desire to undermine, undo, do over plodding notions of authenticity and honesty and personal expression. Affectlessness is as much a part of the Warhol look, the gestalt, as the physical props he employed to play himself. In all the eleven years and 806 pages of his vast diaries, the response to scenes of emotion or distress is almost invariably *it was so abstract* or *I was so embarrassed*.

How did this come about? How did Raggedy Andy with his weeping needs become transformed into the anaesthetised high priest of Pop? Becoming a machine also meant having relationships with machines, using physical devices as a way of filling the uncomfortable, sometimes unbearable space between self and world. Warhol could not have achieved his blankness, his enviable detachment, without the use of these charismatic substitutes for human intimacy and love.

In *The Philosophy of Andy Warhol*, he explains in very precise terms how technology liberated him from the burden of needing other people. At the start of this laconic, light-footed and remarkably funny book (which opens with the unnerving declaration: 'B is anybody who helps me kill time. B is anybody and I'm nobody. B and I'), Warhol revisits his early life, recalling the babushkas and Hershey bars, the un-cut-out cut-out dolls stuffed under his pillow.

He wasn't amazingly popular, he says, and though he did have some nice friends, he wasn't especially close to anyone. 'I guess I wanted to be,' he adds sadly, 'because when I would see the kids telling one another their problems, I felt left out. No one confided in me – I wasn't the type they wanted to confide in, I guess.'

This isn't exactly a confession. It floats weightlessly, a play or parody of unburdenment, though it does explicitly conflate loneliness, the desire for closeness, with the desire for more or deeper speech. All the same, on he goes, spilling details next about the early years in Manhattan. He still wanted to be close to people back then, for them to open up their hidden regions, to share those elusive, covetable *problems* with him. He kept thinking his roommates would become good friends, only to discover they were just looking for someone to pay the rent, something that made him feel hurt and left out.

> At the times in my life when I was *feeling* the most gregarious and looking for bosom friendships, I couldn't find any takers so that exactly when I was alone was when I felt the most like not being alone. The moment I decided I'd rather be alone and not have anyone telling me their problems, everybody I'd never even seen before in my life started running after me . . . As soon as I became a loner in my own mind, that's when I got what you might call a 'following.'

But now he had an ironic problem of his own, which was that all these new friends were telling him too much. Instead of

enjoying their problems vicariously, as he had hoped he would, he felt instead that they were spreading themselves on to him, like *germs*. He went to a psychiatrist to talk it over, and on the way back he stopped at Macy's – if in doubt, shop: the Warhol credo – and bought a television, the first he'd ever owned, an RCA 19-inch black and white set.

Who needs a shrink? If he kept it on while people were talking it was just diverting enough to protect him from getting too involved, a process he described as being like *magic*. In fact, it was a buffer in more ways than one. Able to conjure or dismiss company at the touch of a button, he found that it made him stop caring so much about getting close to other people, the process he'd found so hurtful in the past.

This is a strange story, perhaps better understood as a parable, a way of articulating what it's like to inhabit a particular kind of being. It's about wanting and not wanting: about needing people to pour themselves out into you and then needing them to stop, to restore the boundaries of the self, to maintain separation and control. It's about having a personality that both longs for and fears being subsumed into another ego; being swamped or flooded, ingesting or being infected by the mess and drama of someone else's life, as if their words were literally agents of transmission.

This is the push and pull of intimacy, a process Warhol found much more manageable once he realised the mediating capacities of machines, their ability to fill up empty emotional space. That first TV set was both a surrogate for love and a panacea for love's wounds, for the pain of rejection and abandonment. It provided an answer to the conundrum voiced in the very first lines of *The*

Philosophy: 'I need B because I can't be alone. Except when I sleep. Then I can't be with anyone' – a double-edged loneliness, in which a fear of closeness pulls against a terror of solitude. The photographer Stephen Shore remembered being struck in the 1960s by the intimate role it played in Warhol's life, 'finding it stunning and poignant that he's Andy Warhol, who's just come from some all-night party or several of them, and has turned on the television and cried himself to sleep to a Priscilla Lane film, and his mother has come in and turned it off'.

Becoming a machine; hiding behind machines; employing machines as companions or managers of human communication and connection: Andy was as ever at the vanguard, the breaking wave of a change in culture, abandoning himself to what would soon become the driving obsession of our times. His attachment at once prefigures and establishes our own age of automation: our rapturous, narcissistic fixation with screens; the enormous devolution of our emotional and practical lives to technological apparatuses and contraptions of one kind or another.

Though I made myself venture out each day for a walk by the river, I was spending increasing hours sprawled on the orange couch in my apartment, my laptop propped against my legs, sometimes writing emails or talking on Skype, but more often just prowling the endless chambers of the internet, watching music videos from my teenaged years or spending eye-damaging hours scrolling through racks of clothes on the websites of labels I couldn't afford. I would have been lost without my MacBook, which promised to bring connection and in the meantime filled and filled the vacuum left by love.

For Warhol, the Macy's television was the first in a long line of surrogates and intermediaries. Over the years, he employed a range of devices, from the stationary 16mm Bolex on which he recorded the Screen Tests of the 1960s to the Polaroid camera that was his permanent companion at parties in the 1980s. Part of the appeal was undoubtedly having something to hide behind in public. Acting as servant, consort or companion to the machine was another route to invisibility, a mask-cum-prop like the wig and glasses. According to Henry Geldzahler, who met Warhol in the transitional year of 1960, just before he began his transformation:

> He was a little bit franker, but not much. He was always hiding. What became obvious later on, as he used the tape recorder, camera and video, the Polaroid, was the distancing quality of technology for him. It was always keeping people at a slight remove. He always had a frame through which he could see them in a slightly distanced way. But that wasn't what he wanted. What he wanted was to make sure that they couldn't see him too clearly. Basically, all those personality devices he had, all those denials and kind of cagy self-inventions, were about – don't understand me, don't look into me, don't analyze. Don't get too near me, because I'm not sure what's there, I don't want to think about it. I'm not sure I like myself. I don't like where I came from. Take the artifact as I'm giving it.

But unlike the television, which was static and domestic, a transmitter merely, these new machines also allowed him to record the world around him, to capture and hoard the messy, covetable litter of experience. His favourite was the tape-recorder, a device that so radically transformed his need for people that he nicknamed it *my wife*.

> I didn't get married until 1964 when I got my first tape recorder. My wife. My tape recorder and I have been married for ten years now. When I say 'we,' I mean my tape recorder and me. A lot of people don't understand that . . . The acquisition of my tape recorder really finished whatever emotional life I might have had, but I was glad to see it go. Nothing was ever a problem again, because a problem just meant a good tape and when a problem transforms itself into a good tape it's not a problem any more.

The tape machine, which in fact entered his life in 1965 (a gift from the makers, Philips), was the ideal intermediary. It served as a buffer, a way of keeping people at one remove, at once diverting and inoculating the flow of potentially infectious or invasive words that had so agitated him prior to the purchase of the television. Warhol hated waste, and he liked to make art out of what other people considered superfluous, if not actually trash. Now he could capture the social butterflies, the proto-Superstars who'd begun to gather around him, storing their unscripted selves, their charismatic effluvia on the preservative medium of magnetic tape.

By this time he was no longer working at home, painting

pictures with his mother, but had instead moved his studio oper-
ation on to the fifth floor of a dirty, dingy, barely furnished
warehouse on East 47th Street, in that dismal part of Midtown
near the UN, its crumbling walls meticulously covered with silver
foil, silver Mylar and silver paint.

The Silver Factory was the most sociable and least bounded
of all of Warhol's working spaces. It was permanently thronged
with people: people helping out or killing time, people lolling
on the couch or chatting on the phone while Andy laboured in
a corner, making Marilyns or cow wallpaper, frequently pausing
to ask a passer-by what they thought he should do next. Stephen
Shore again: 'My guess is that it helped him in his work to have
people around, to have these other activities around him.' And
Andy himself: 'I don't really feel all these people with me every
day at the Factory are just hanging around me. I'm more hanging
around *them* . . . I think we're in a vacuum here at the Factory:
it's great. I like being in a vacuum; it leaves me alone to work.'

Alone in a crowd; hungry for company but ambivalent about
contact: it's not surprising that in the Silver Factory years Warhol
acquired the nickname *Drella*, a portmanteau of Cinderella, the girl
left behind in the kitchen while everyone else has gone to the ball,
and Dracula, who gains his nourishment from the living essence
of other human beings. He'd always been acquisitive about people,
especially if they were beautiful or famous or powerful or witty;
had always desired proximity, access, a better view. (Mary Woronov,
in her terrifying amphetamine-memoir of the Factory years,
Swimming Underground: 'Andy was the worst . . . He even looked
like a vampire: white, empty, waiting to be filled, incapable of

satisfaction. He was the white worm – always hungry, always cold, never still, always twisting.') Now he had the tools to take possession, ameliorating loneliness without ever having to risk himself.

*

Language is communal. It is not possible to have a wholly private language. This is the theory put forward by Wittgenstein in *Philosophical Investigations*, a rebuttal of Descartes's notion of the lonely self, trapped in the prison of the body, uncertain that anyone else exists. Impossible, says Wittgenstein. We cannot think without language, and language is by its nature a public game, both in terms of acquisition and transmission.

But despite its shared nature, language is also dangerous, a potentially isolating enterprise. Not all players are equal. In fact, Wittgenstein was by no means always a successful participant himself, frequently experiencing extreme difficulty in communication and expression. In an essay on fear and public language, the critic Rei Terada describes a scene repeated throughout Wittgenstein's life, in which he would begin to stammer while attempting to address a group of colleagues. Eventually, his stuttering would give way to a tense silence, during which he would struggle mutely with his thoughts, gesticulating all the while with his hands, as if he was still speaking audibly.

The fear of being misunderstood or failing to generate understanding haunted Wittgenstein. As Terada observes, his 'confidence in the stability and public character of language coexisted, it would seem, with a dreadful expectation that he would himself

69

be unintelligible'. He had a horror of certain kinds of language, in particular 'idle talk and unintelligibility'; talk that lacked substance or failed to produce meaning.

The idea that language is a game at which some players are more skilled than others has a bearing on the vexed relationship between loneliness and speech. Speech failures, communication breakdowns, misunderstandings, mishearings, episodes of muteness, stuttering and stammering, word forgetfulness, even the inability to grasp a joke: all these things invoke loneliness, forcing a reminder of the precarious, imperfect means by which we express our interiors to others. They undermine our footing in the social, casting us as outsiders, poor or non-participants.

Though Warhol shared many of Wittgenstein's problems with speech production, he retained a typically perverse fondness for language errors. He was fascinated by empty or deformed language, by chatter and trash, by glitches and botches in conversation. The films he made in the early 1960s are full of people failing to under-stand or listen to each other, an investigative process that sharpened with the arrival of the tape machine. The first thing he did with his new wife was to make a book, entitled *a, a novel*, composed entirely of recorded speech; a celebratory tour de force of idle and unintel-ligible language, around which loneliness hovers like a sea mist.

Despite the declaration of the title, *a* isn't a novel in any ordi-nary sense. It isn't fictional, for a start. It doesn't have a plot and nor is it a product of creative labour, at least not in the way that term is ordinarily defined. Like Warhol's paintings of inappropriate objects or wholly static films it defies the rules of content, the terms by which categories are assembled and maintained.

It was conceived as an homage to Ondine, Robert Olivo, nicknamed the Pope, the irrepressible speed-queen and greatest of all the Factory's supernaturally gifted talkers. Charming and unstable, he appeared in many of Warhol's films of the period, most notably *Chelsea Girls*, in which he can be seen flying into one of his notorious rages and slapping Rona Page twice around the face for calling him a phoney.

Ondine was a quicksilver presence. A photograph taken around the time of *a*'s taping catches him in a rare moment of stillness, out in the street, head turned to confront the camera – a handsome man in aviators and a black t-shirt, his dark hair falling in a quiff over his eyes, an airline flight bag slung over his shoulder, his mouth in the characteristic pout-cum-smirk that Warhol describes in *POPism* as being 'pure Ondine, a sort of quizzical duck's mouth with deep smile lines around it'.

The original plan was to follow him for twenty-four hours straight. Recording began in the afternoon of Friday, 12 August 1965, but after twelve hours and despite copious consumption of amphetamines Ondine began to flag ('you *have* finished me off'). The remainder was taped later, in three sessions over the summer of 1966 and one in May 1967. The twenty-four cassettes were then transcribed by four different typists, all of them young women. The pool comprised Maureen Tucker, later the drummer in The Velvet Underground, Susan Pile, a student at Barnard, and two high school girls. They approached their task in a variety of ways, some erratically identifying speakers and some failing to distinguish between voices at all. None were professional typists. Tucker refused to transcribe swear words, while one of the girls'

mothers threw away an entire section, horrified by the language.

Warhol insisted that all these errors be preserved, alongside the many infelicities of transcription and spelling. As such, *a* is resistant if not actively antagonistic to the production of understanding. Reading it is confusing, amusing, baffling, alienating, boring, infuriating, thrilling; a crash course in how speech binds and isolates, conjoins and freezes out.

Where are we? Hard to tell. In the street, in a coffee shop, in a cab, on a roof terrace, in a bathtub, on the phone, at a party, surrounded by people popping pills and playing opera at full blast. Everywhere is the same place really: the empire of the Silver Factory. But you have to imagine the interiors. No one describes their location, just as in a conversation one doesn't stop to itemise the elements of the room in which it's taking place.

The effect is like being shipwrecked in a sea of voices, a surf of unattributed speech. Voices in the background, voices vying for space, *voices drowned out by opera*, inconsequential voices, *unintelligible garble*, voices running into one another: an endless barrage of gossip, anecdote, confession, flirtation, plan; language taken to the threshold of meaning, abandoned language, language past the point of caring, language disintegrating into pure sound; *OW-UH-mmmmm. I dunno what the wor dis. Oooooo-mmm-mmm*, through which the voice of Maria Callas perpetually seeps, itself gloriously deformed.

Who's talking? Drella, Taxi, Lucky, Rotten, the Duchess, DoDo, the Sugar Plum Fairy, Billy Name, a parade of cryptic, unstable nicknames and noms de plume. Do you understand or don't you? Are you in or out? Like any game, it's all about belonging. 'The

only way to talk is to talk in games, it's just fabulous,' Ondine says and Edie Sedgwick, disguised as Taxi, replies: 'Ondine has games that no one understands.'

People who can't keep up, who slow the flow, are cast literally to the margins. In one of the most disturbing sequences, Taxi and Ondine are joined by a French actress, whose repeatedly ignored interjections are placed on the far side of the page, away from the main stream of conversation, the text shrunken to denote the tiny tininess of an ignored voice, caught in the echo chamber of exclusion. Elsewhere, the talk is of who deserves to stay inside the charmed circle of the Factory. Elaborate rules are drawn up, protocols of expulsion developed. Society as centrifugal force, separating the elements, policing division.

But speaking, participating, is almost as terrifying as being ignored. Warhol takes the desire for attention – to be looked at and listened to – and sharpens it into an instrument of torture. 'I'm making love to the tape recorder,' Ondine says towards the end of his marathon of speech, but from the very beginning he also keeps begging to stop, asking over and over how many more hours he has to fill. In the john: 'No, oh Della, please, I, I, my . . .' In the bathtub: 'may I ask you in all fairness – this is no private . . .' At Rotten Rita's apartment: 'Don't you hate me Drella, by this time? You must be so disgusted with putting that thing in my face . . . Please shut it off, I'm so horrifying.'

Putting that thing in my face: there's certainly something sexual about Warhol's behaviour: stripping Ondine down, encouraging him to ejaculate a torrent, to spill his secrets, to dish the dirt. What he wants is words – words to fill or kill time, take up empty space,

expose the gaps between people, reveal wounds and hurts. He says very little himself beyond a reticent, repetitive litany of *Oh, Oh really? What?* (In 1981, by which time he'd become considerably more fluent, even chatty, one of his first superstars called him on the phone. He immediately fell back into the old stuttering speech, telling his diary: 'The dialogue was straight from the sixties.')

Towards the end of the book, Ondine escapes for a while and Drella is left with the Sugar Plum Fairy, Joe Campbell, the actor-cum-rent boy who starred with Paul America in his movie *My Hustler* in 1965. Slender, dark and quick-witted, a former boyfriend of Harvey Milk, Campbell was astonishingly skilled at making even the most reluctant people open up. He turns the tables on Warhol, submitting him to the same kind of scrutiny he forced on others. First he examines his body, describing him sweetly as *soft*, not fat. 'How old are you?' he asks. A long pause. 'Very great silence.' 'Yeah, uh talk about Ondine.' 'Nah, why do you avoid this problem?' Warhol repeatedly tries to turn the flow of the conversation. For a minute or two, Joe plays along, and then he returns to the attack.

> SPF—Why do you avoid yourself?　　Huh?
> SPF—Why do you avoid yourself?　　What?
> SPF—I mean you almost refuse your own existence.
> You know-　　Uh—it's just easier　　SPF—No I
> mean I *like*, I like to know you (*talking very quietly*) I
> always think of you as being hurt.　　Well, I've been
> hurt so often I don't even care anymore.　　SPF—Oh
> sure you care.　　Well uh, I don't get hurt anymore

. . . SPF—I mean, it's very nice to feel. You know.
Uh-no, I don't really think so. It's too sad to do (opera)
And I'm always, uh, afraid to feel happy because then
uh . . . just never last . . . SPF—Do you ever, do
you ever do things by yourself? Uh no, I can't do
things by myself.

Talking so much you horrify yourself and those around you;
talking so little that you almost refuse your own existence: *a*
demonstrates that speech is by no means a straightforward route
to connection. If loneliness is to be defined as a desire for inti-
macy, then included within that is the need to express oneself
and to be heard, to share thoughts, experiences and feelings.
Intimacy can't exist if the participants aren't willing to make
themselves known, to be revealed. But gauging the levels is tricky.
Either you don't communicate enough and remain concealed
from other people, or you risk rejection by exposing too much
altogether: the minor and major hurts, the tedious obsessions, the
abscesses and cataracts of need and shame and longing. My own
decision had been to clam up, though sometimes I longed to
grab someone's arm and blurt the whole thing out, to pull an
Ondine, to open everything for inspection.

It's here that Warhol's recording devices take on their magical,
transformative aspect. Plenty of people have over the years felt the
need to portray him as damaged and manipulative, needling confes-
sion out of the vulnerable and drug-addicted as a way of filling
gaping holes in the fabric of his own being. But that isn't the
whole story. His work around speech might be better understood

as a collaboration, a symbiotic exchange between the citizens of too much and not enough, between excess and paucity, expulsion and retention. After all, it's just as painful, just as isolating, to talk into a vacuum as it is to be stoppered in the first place. For the logorrheic, the compulsively communicative, Warhol was the ideal audience, the neutral dream listener as well as the bully with what Ondine called his 'Prussian tactics'.

This is what the filmmaker Jonas Mekas thought was really driving the Factory's grand project of exhibition and exposure. He figured people participated because of Warhol's knack for paying non-judgemental attention to those who were otherwise rejected or ignored.

> Andy was the chief psychiatrist. It's the typical psychiatrist's situation: on the couch, you begin to be totally yourself, hide nothing, this person won't react, just listen to you. Andy was such an open psychiatrist with all those sad, confused people. They used to come and feel at home. There was this person who never disapproved of them – 'Nice, nice, good, oh, beautiful.' They felt very much received, accepted. I have no doubt it helped some not to commit suicide – some committed . . . Also they felt that when Andy put them in front of the camera, they could do and be themselves, thinking that this is what they can contribute, now I'm doing my thing.

The critic Lynne Tillman also felt that the exchange went both ways. In her essay on *a*, 'The Last Words are Andy Warhol', she

weighs the charge of manipulation against the notion that Warhol offered insecure and unhappy people 'something – work or a feeling of significance for that moment or a way to fill time. The tape recorder is on. You are being recorded. Your voice is being heard, and this is history.'

It wasn't just a question of contribution, though. If all of Warhol's work, *a* included, is antagonistic to received notions of value, if it participates in a tearing down of sentiment and seriousness, it is at the same time engaged in a project of building up, of giving status and attention to the deviant and neglected, to the aspects of culture that have become invisible, either because they lurk in shadows or because they've drifted into the blind spot of excessive familiarity.

While *a* is at pains to show that a heartfelt confession has no more intrinsic value than a conversation about 20 milligram bi-phetamine or mouldy Coca-Cola, it simultaneously testifies to the importance, the beauty even, of what people actually say and how they say it: the great jumbled inconsequential endlessly unfinished business of ordinary existence. This is what Warhol liked, and this is what he valued too, a fact attested to by *a*'s closing line, in which Billy Name, summing up the whole chaotic expulsive endeavour, cries 'Out of the garbage, into The Book' – the vessel, that is, by which the transient and trashy will be sanctified and preserved.

★

Of course, all this is assuming that your words are wanted in the first place. In the spring of 1967, the final year of *a*'s taping, a

woman came to see Andy about a play she'd written. He took the meeting, intrigued by the title, *Up Your Ass*, but then got cold feet, worried about the potentially pornographic contents. He thought the woman might be an undercover cop, trying to entrap him. On the contrary, she was as far from the system as it is possible to be, an outlier and anomaly even amidst the flamboyant freak-show of the Factory.

Like Warhol, Valerie Solanas, the woman who once shot him, has been eaten by history, reduced to a single act. The crazy woman, the failed assassin, too angry and unhinged to be worthy of attention. And yet what she had to say is brilliant and prescient as well as brutal and psychotic. The story of her relationship with Andy is all about words – about how much they're valued and what happens if they aren't. In her controversial book, the *SCUM Manifesto*, she considers the problems of isolation not in emotional terms, but structurally, as a social problem that particularly affects women. And yet Solanas's attempt to make contact and build solidarity by way of language ended in tragedy, amplifying rather than relieving the sense of isolation that she and Warhol shared.

The early life of Valerie Solanas is just as you might expect, only more so. A disordered childhood, parcelled between relatives. Sharp as a knife, so sharp you'll cut yourself, a sarcastic, rebellious girl. Abused by her bartender father, sexually active from a young age, first child at fifteen, raised as her sister, second child at sixteen, adopted by friends of the father, a sailor lately back from the Korean War. An out lesbian at school, where she was bullied, then a psychology major at the University of Maryland, where she wrote witty, caustic, proto-feminist columns for the student paper.

What was she like back then? Angry, sometimes physically aggressive, very poor, determined, isolated, radicalised by the circumstances of her own life – the suffocating expectations, the limited options, the galling hypocrisies and ruthless double standards. Unlike Warhol, who combated his exclusion passively, Solanas wanted active change, to smash things up rather than redecorate and rearrange.

After an abortive stint at grad school, she dropped out of the educational system entirely, hitchhiking around the country. She started writing *Up Your Ass* in 1960 and the next year moved to New York, where she drifted between boarding houses and welfare hotels. I have said that both Hopper and Warhol were poor, but Solanas existed in a marginal world that neither of them ever experienced: panhandling, turning tricks, waiting tables; never resting, never taking her eyes off the ball.

In the mid-1960s she started work on what would become the *SCUM Manifesto*. The word *scum* appealed to her. Scum: extraneous matter or impurities; a low, vile or worthless person or group of people. Like Warhol, she was attracted by the excessive and neglected, the rubbished and rubbishy. Both liked turning things upside-down; both were inverts, imaginative upenders of what the culture held dear. As for the SCUM of the manifesto, Solanas's definition describes just the sort of women Warhol liked, at least from the other side of a camera: 'dominant, secure, self-confident, nasty, violent, selfish, independent, proud, thrill-seeking, free-wheeling, arrogant females, who consider themselves fit to rule the universe, who have free-wheeled to the limits of this "society" and are ready to wheel on to something far beyond what it has to offer'.

The *Manifesto* breaks down what's wrong with patriarchy – which is to say, using Solanas's own language, what's wrong with men. It proposes violent solutions, perhaps along the satiric lines of Swift's *A Modest Proposal*, which suggested that Ireland's poor might sell their children as food for the rich, though perhaps not. It's insane and appalling, also insightful and weirdly joyful. It calls in the very first sentence for the overthrow of the government, the elimination of the money system, the institution of complete automation (Valerie shared Warhol's prescience when it came to the liberating or pseudo-liberating qualities of machines) and the destruction of the male sex. Over the next forty-five pages, it slams through the ways in which men are responsible for violence, work, boredom, prejudice, moral systems, isolation, government and war, even death.

Still shockingly violent now, the manifesto was so far in advance of its times politically as to be almost unreadably strange, written in an alien language, a language that is palpably buckling and rupturing, exploding out of silence, splattering itself on to the page. When Solanas wrote *SCUM*, second-wave feminism had barely begun. Betty Friedan's reasoned and reasonable *The Feminine Mystique* was published in 1963. In 1964, the Civil Rights Act barred employment discrimination with regard to race and gender; in addition, the first woman's shelter opened. But a nascent acknowledgement that the lot of women included violence and financial exploitation was still a world away from the systemic, furious, radical upheaval that Solanas was proposing. 'SCUM,' she wrote, 'is against the entire system, the very idea of law and government. SCUM is out to destroy the system, not attain certain rights within it.'

It's not an easy position to inhabit, that of the outlier, the iconoclast. 'Valerie Solanas was a loner,' writes Avital Ronell in her introduction to *SCUM*. 'She had no followers. She arrived too late or too early on every scene.' And Ronell is not the only one to see the manifesto as a text that both arises from and exists in isolation. According to Mary Harron, the writer and director of the biopic *I Shot Andy Warhol*: 'It is a product of a gifted mind working in isolation, with no contact with but also no allegiance to academic structures – isolated and therefore owing nothing to anyone.' As for Breanne Fahs, who wrote the wonderfully restorative biography of Solanas published by the Feminist Press in 2014: '*SCUM Manifesto* was witty, intelligent, and violent, sure, but it was also lonely. Isolation followed Valerie, however much she recruited and connected, attacked and provoked.'

This is not to say, however, that isolation was what Solanas desired. In fact, isolation was one of the things she blamed on men: the way they separated women from each other, hauling them off to the suburbs to form self-absorbed family groups. *SCUM* is deeply opposed to this kind of atomisation. It's not just a lonely document; it's also a document that seeks to identify and remedy the causes of isolation. The deeper dream, beyond that of a world without men, is revealed when the word *community* is defined: 'A true community consists of individuals – not mere species members, not couples – respecting each others individuality and privacy, at the same time interacting with each other mentally and emotionally – free spirits in free relation to each other – and cooperating with each other to achieve common ends' – a statement with which I am in complete accord.

After Valerie finished the manifesto at the beginning of August 1967, she worked frenetically to publicise its existence. She mimeographed 2,000 copies and hand-sold them on the streets, $1 for women, $2 for men. She distributed fliers, conducted forums, posted adverts in the *Village Voice* and made recruiting posters.

One of the recipients of these posters was Andy Warhol. On 1 August, Valerie mailed him three copies, two for the Factory and one 'to keep under your pillow at night'. It was a gift for an ally, not an enemy. They'd met earlier that spring, while she was trying to get *Up Your Ass* produced. At the time, she'd been arranging dozens of meeting with producers and publishers, but they all passed, some expressing anxiety about its pornographic contents (the play is extremely bawdy, centring on the exploits of a hard-boiled dyke called Bongoi).

Valerie hadn't wandered or drifted into the Factory. She'd come deliberately, looking for amplification of her voice, her work. She was focused and intent; 'dead serious' in her own words. That spring she'd sometimes come to sit at Warhol's table in the backroom of Max's Kansas City, braving the stares, the drag queens giving her the once over. She was a fast-talker, a hustler, and he liked that, regularly taping their phone conversations and apparently lifting a number of her lines for later movies.

Their conversations were playful and often very funny. In one of them, reported in Fahs's biography, Solanas asks: 'Andy, will you take seriously your position as head of the men's auxiliary of SCUM? Cause you do realise the immenseness of the position?' Andy: 'What is it? Is it that big?' Valerie: 'Yes, it is.' She pretends to be in the CIA, quizzes him about his sexual practices

and, like the Sugar Plum Fairy, interrogates him about his own silence, his abnormal reticence.

Valerie: Why don't you like to answer questions?
Andy: I really never have anything to say . . .
Valerie: Andy! Did anyone ever tell you you were uptight?
Andy: I'm not uptight.
Valerie: How are you not uptight?
Andy: It's such an old-fashioned word.
Valerie: You're an old-fashioned guy. You really are. I mean, you don't realize it but you really are.

Back in June, she'd given him a bound copy of *Up Your Ass*. He'd expressed interest in producing it; in fact their conversations had progressed as far as suggesting venues and possible double-bills. But some time that summer Warhol lost or discarded it. As a kind of apology, a way of getting her off his back, he cast Valerie in his film, *I, a Man*. In it, she refuses the sinuous femininity of most of the Superstars, male and female alike, performing instead an aggressively anti-sexual androgyny, awkward, jittery and amusingly contemptuous.

Warhol wasn't by any means the only publisher or promoter Valerie was pursuing that summer. At the end of August, a few days after the premiere of *I, a Man*, she signed a contract for $500 for a novel with a notoriously sleazy publisher, Maurice Girodias at the Olympia Press. As soon as the ink was dry, she began to fret. Did the contract mean she had inadvertently signed away the rights to both *Up Your Ass* and *SCUM Manifesto*? Who

actually owned her words? Had she given them away? Worse, had they been stolen from her?

Warhol was sympathetic to Valerie's worries about the Girodias contract, even arranging for his own lawyers to look it over for free. There was no problem, they all agreed; the contract was vaguely worded and in no way binding, but their reassurances did nothing to ameliorate her growing anxiety. Words were what counted for Valerie; they were the flung rope between her and the world. Words were a source of power, the best way of making contact, of reshaping society on her own terms. The idea that she might have lost control over her own writing was devastating. It plunged her into the isolation chamber of paranoia, where the self is necessarily armed and barricaded against incursion and attack.

But as the old adage goes, just because you're paranoid doesn't mean they're not after you. Solanas was not mad in thinking that she could see oppression everywhere she looked, or that society was a system dedicated to excluding and side-lining women (1967, the year in which *SCUM* was first published, was also, one might remember, the year in which Jo Hopper donated her life's work to the Whitney, which subsequently destroyed it). Valerie's growing loneliness and isolation was caused not just by mental illness, but also because she was voicing something about which the community at large was in denial.

Over the course of the next year, Solanas's relationship with Warhol soured. Her attempts to have him produce the play or make a film out of *SCUM* became more aggrieved, more desperate and deranged. She'd been evicted from the Chelsea Hotel for

non-payment of rent, and was drifting around the country, home-less and broke. She sent him hate mail from the road. One addresses him as 'Toad'; another reads: 'Daddy, if I am good will you let Jonas Mekas write about me? Will you let me do a scene in one of your shit movies? Oh, thank you, thank you' – not, one might imagine, a tone or attitude to which Warhol was much accus-tomed.

Things came to a head in the summer of 1968. Back in New York, and more paranoid than ever, she began to ring Andy persis-tently at home, a number almost no one in his entourage even had, let alone used. Eventually, he stopped taking Solanas's calls at all (one of the ongoing threads in *a* is the necessity of establishing this sort of protocol, so that calls to the Factory could be screened and unwanted advances avoided).

On Monday 3 June, Valerie collected a bag from a friend's apartment and then went to visit two producers, Lee Strasberg and Margo Feiden. Strasberg was out but Valerie spent four hours at Feiden's apartment. At the end of an exhausting and exhaustive discussion about her work, she asked if Margo would be willing to produce her play. When Margo refused, she pulled out a gun. After some persuasion, she left, saying she was going to shoot Andy Warhol instead.

She arrived at the Factory just after lunch, carrying a brown paper bag containing two handguns, a Kotex pad and her address book. This was the new Factory: a glossy loft on the sixth floor of 33 Union Square West, at the northernmost tip of the square. The old Silver Factory had been demolished that spring and with the shift in location the personnel too had begun to change, the speed-

heads and drag queens gradually replaced by sleek and suited men, the business-minded associates who would shepherd Warhol into increasingly lucrative pastures from now on.

When Valerie arrived Warhol was out, and so she hung around outside, going up and down in the elevator at least seven times to check she hadn't missed him. He finally appeared at 4.15, encountering both Valerie and his then boyfriend Jed Johnson in the street outside. The three of them took the elevator up together. In *POPism*, his memoir of the 1960s, Warhol recalled that Valerie was wearing lipstick and a heavy coat, though the day was very hot, and that she was bouncing a little on the balls of her feet.

Upstairs, people were working, among them Warhol's collaborator Paul Morrissey and his business manager Fred Hughes. Andy sat down at his desk and took a call from Viva, Susan Bottomley, who was having her hair dyed in Kenneth's Hair Salon. As they chatted, Valerie pulled out the .32 Beretta and fired twice. No one but Andy saw where the shots had come from. He tried to climb under the desk, but she stood over him and shot again, this time hitting him at close range. Blood was gushing through his t-shirt, splattering the white cord of the phone. 'I felt horrible, horrible pain,' he remembered later, 'like a cherry bomb exploding inside me.' Next, Solanas shot the art critic Mario Amaya, wounding him superficially. She was about to fire at a pleading Fred Hughes when the elevator door opened and she was persuaded to step inside. 'There's the elevator, Valerie. Just *take* it.'

By then Warhol was crumpled on the floor in a pool of his own blood. He kept saying he couldn't breathe. When Billy Name bent over him, shaking and heaving, Warhol thought he was

laughing and started to laugh too. 'Don't laugh, oh, please don't make me laugh,' he said, but Billy was crying. The bullet had ricocheted sideways through Andy's abdomen, passing through both his lungs, his oesophagus, gall bladder, liver, intestines and spleen, leaving a gaping exit wound in his right flank. His lungs were punctured and he was fighting for air.

It took a long time to get him out. Everything dragging, everything lagging. The stretcher wouldn't fit in the elevator and so he had to be carried down six flights of steep stairs, a journey so distressing that he lost consciousness. Mario had to tip the ambulance driver $15 to put the siren on, and once Warhol was finally in the operating room, it seemed anyway that they were too late. Both he and Mario distinctly heard the doctors muttering *No chance*. 'Don't you know who this is?' Mario screamed. 'It's Andy Warhol. He's famous. And he's rich. He can afford to pay for an operation. For Christ's sake, do something.'

Inspired perhaps by the mention of fame and riches, the surgeons did decide to operate, but as they opened up Andy's chest his heart stopped beating. Though they managed to resuscitate, Warhol was clinically dead for one and a half minutes, flung out of life altogether by the least regarded of all the voice artists who'd collected around him: a journey he later said he could never be totally certain he had returned from.

<p style="text-align:center">*</p>

Everyone always got Valerie wrong. When she was arrested (giving herself up to a traffic cop in Times Square at around

the time Andy was having his spleen removed), she told the throng of journalists at the Thirteenth Precinct station house that the answer to why she'd shot Andy Warhol would be found in her manifesto. 'Read my manifesto,' she insisted. 'It will tell you what I am.' Evidently no one did, since she was misidentified on the front page of the *Daily News* the next morning. The famous headline ran: *ACTRESS SHOOTS ANDY WARHOL*. Furious, she demanded a retraction, and the evening edition of the story included her correction: 'I'm a writer, not an actress.'

It would become increasingly hard to maintain control of her own story, dismaying considering she claimed she'd shot Warhol because he had too much control over her life. Now she had to contend with the full apparatus of the state; to spend three years shuttling back and forth between courts, mental hospitals and prisons, among them the notoriously filthy and brutal Matteawan State Hospital for the Criminally Insane (where Edie Sedgwick was also a patient at the time), Bellevue Psychiatric Hospital (where Valerie's uterus was removed), and the Women's House of Detention.

Her case became a cause célèbre among feminists, but she quickly fell out with the women who flocked to her defence. She didn't want anyone speaking for her, or co-opting her ideas. Nor did she stop her attacks on Warhol. During the years of her incarceration, she kept sending him letters, some threatening or coercive, some conciliatory, even chummy. Briefly at liberty in the winter of 1968, she reinstituted her campaign of telephone harassment. In *POPism*, Warhol remembered answering the phone to her on Christmas Eve, and almost fainting when he heard her

voice. She threatened, he said, to 'do it again . . . My worst night-mare had come true.'

Instead, she went back to prison. By the time she re-emerged, she was quieter, more subdued, as you might expect from someone who'd been trapped in places where sexual and physical assaults were common, where prisoners were expected to survive on a slice of bread and a single filthy cup of coffee a day, and were frequently locked as punishment into cells devoid of furnishings or light.

Back in New York, Valerie spent much of her time hunting for food and a place to sleep. People who knew her in that period attest to the way she was excluded from communes and women's groups, both of whom had become wary of her hostility, her savage tongue. Strangers avoided her in the street. She was frequently spat at and thrown out of cafés, not because she was recognised as Warhol's putative assassin, but because she gave off a tang of difference, a silent signal of being somehow outcast, undesirable, even blemished. She drifted around the Village, a miserable, skinny figure, huddled in layers of winter clothes. She was still fixated with the idea that people were stealing her words, only now she thought a transmitter had been hidden in her uterus.

The loneliness of the second half of Solanas's life was a product of many factors. The most obvious and frequently stated was her growing loss of touch with consensual reality. Paranoia is isolating in itself, by its own mechanisms of mistrust and withdrawal, but it also carries a stigma, as does time spent in prison. People pick up on these perceived markers of abnormality. They sidestep the

street mutterer and shun the former criminal, isolating them if not submitting them to actual violence. What I am trying to say is that the vicious circle by which loneliness proceeds does not happen in isolation, but rather as an interplay between the individual and the society in which they are embedded, a process perhaps worsened if they are already a sharp critic of that society's inequities.

All the same, there was a period in the 1970s in which Valerie's life improved. She developed a loving relationship (with a man, as it happens) and found an apartment on East 3rd Street. Later, I realised her building had backed directly on to mine, and that she too must have spent her days listening to the bells of the Most Holy Redeemer tolling off the hours. She found work on a feminist magazine, and enjoyed the business of collaboration. A stable, even a pleasant time, until in 1977 she finally succeeded in self-publishing *SCUM*. It was a total failure, a dead and abject loss. Of all the things that happened to Valerie, it was this that finally broke her ability to form relationships with other people: not the imprisonment, not the shooting, but the final, incontrovertible evidence of her failure to make contact by way of words.

From then on, her paranoia became overwhelming. She thought her enemies were trying to communicate with her through her bed-sheets. She gave up her apartment and her relationship, becoming homeless once again. Her abiding, driving fear in her last years was the same old, increasingly ironic one: that her words were going to be stolen. In the end this paranoia isolated her from everyone in her life. She refused to speak, writing in code and mumbling or humming, trying to avoid the necessity of

opening her mouth. Eventually she left New York altogether and drifted west. She died of pneumonia in April 1988, in Room 420 of a welfare hotel in San Francisco. Her body wasn't found for three days, and was crawling with maggots by the time the super noticed her rent was late.

This is about as lonely as death gets. It's the death of someone who has tumbled out of the world of language altogether; who has severed not just the ties of friendship and love but also the many small verbal bonds that hold each person within the social order, tethering them in place. Solanas had pinned her hopes on language, believing implicitly in its capacity for changing the world. Perhaps in the end it was better, safer, less devastating to think of it as a medium in which her own stock was so high, so in demand that she no longer dared participate, rather than accepting that she had simply failed in her expression: that she was unintelligible, Wittgenstein's great fear, or worse, that what she had to say was not wanted at all.

But it wasn't only Valerie who became more isolated in the wake of the shooting. In hospital, on a drip, with his spleen and part of his right lung removed, Andy felt sure that he had already died, that he was occupying a dream space, parked in a corridor between realms. On the third day, he heard on the hospital television that Robert Kennedy had been shot, the eroding surf of the news deposing him from the front page.

Already wary of contact, already uncertain about the virtues of embodiment, he now had to deal with the catastrophic wreckage of his physical form. His abdomen had been carved to pieces and he would spend the rest of his life in surgical corsets (they made

him feel 'glued-together', a term he also used for his wigs, and which attests to how deeply he relied on physical objects for a sense of wholeness and cohesion). He was exhausted, in acute physical pain and suffering from what would now be diagnosed as post-traumatic stress disorder, which came by way of surges of overwhelming anxiety and terror.

He reacted by withdrawing, going numb, retreating inside himself. In an interview conducted two weeks after the shooting he said, as he had to the Sugar Plum Fairy: 'It's too hard to care . . . I don't want to get too involved in other people's lives . . . I don't want to get too close . . . I don't like to touch things . . . That's why my work is so distant from myself.'

He was so weak that he had to stay home for months, nursed by his mother. When he finally returned to the Factory, it was autumn. It was wonderful to be back; it was just that he didn't quite know what he should do there. He hid out in his office, not painting, not making films. The only one of his old occupations he still enjoyed was taping, but even that was a problem now. After the shooting he'd developed a terror of being around the sort of people whose conversation had previously been so entertaining and desirable. 'What I never came right out and confided to anyone in so many words,' he wrote in *POPism*, 'was this: I was afraid that without the crazy, druggy people around jabbering away and doing their insane thing, I'd lose my creativity. After all, they'd been my total inspiration since '64, and I didn't know if I could make it without them.'

The one thing he did find soothing was listening to his old tapes being transcribed. Andy found all mechanical noise reassuring

– shutters and flashbulbs, ringtones and buzzers – but his favourite by far was the click-clack of typewriters accompanied by the sound of sequestered voices released into the air, liberated at last from their dangerous bodies. That autumn, the Factory typists were working on *a*, and so he could sit in his office, glued together by his corset, listening to the manic chatter of Ondine and Taxi, the swell of those old, beloved voices drifting through the room.

Like *SCUM Manifesto*, the publication of *a* would not be a success, either in terms of sales or reviews. All the same, listening to the tapes roll on, Warhol finally got the idea for his next creative venture. He'd make a magazine, entirely comprised of people talking to one another. He called it *Interview*, and it has survived right through to the present day, a symphony of human speech, made by someone who knew exactly how much words cost and what consequences they can have: how they can start but also stop the opened organ of the heart.

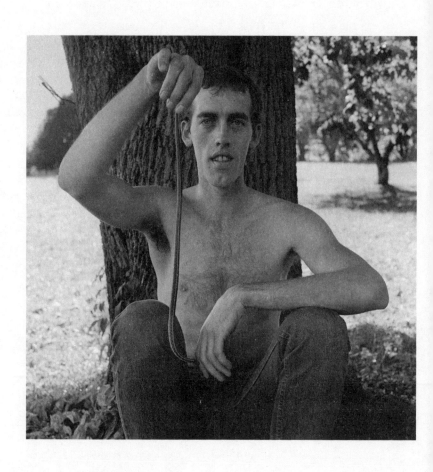

4

IN LOVING HIM

HALLOWEEN. IT HAD BEEN A bad day, I don't know why. At seven I got up from whatever I was or wasn't doing, ringed my eyes in kohl, put on a black dress covered in small black sequins, drank down a glass of bourbon and went out into the night, heading for the parade in the West Village. Cold smoky dark, walking past the big brownstones, their stoops and sills covered in a garish litter of pumpkins, skulls and spun white spider webs. I thought it would be cheering to stand in a crowd, but it wasn't, not really. Looking at my photos from that night I think that what I was in search of was a sensation of smear, of the collapsing boundaries that come with festivity or intoxication. All my pictures are blurred; they all show a whirl of bright objects colliding in space. Giant skeletons, giant eyeballs on stalks, a dozen flashbulbs, a glowing silver suit. A flatbed truck came chugging up Sixth Avenue, bearing a cotillion of zombies snapping and twitching in unison to Michael Jackson's 'Thriller'.

All that evening, I was dogged by the exhausting sense of being too visible, sticking out like a sore thumb among the coupled

and conjoined, the jaunty, tipsy groups of friends. I bitterly regretted not having bought a mask in Party City: a cat face or Spider-Man. I wanted to be anonymous, to pass through the city unseen; not invisible exactly, but concealed, my pained, anxious, all too declarative face hidden from view, relieved from the burden of needing to look unconcerned, or worse, appealing.

What is it about masks and loneliness? The obvious answer is that they offer relief from exposure, from the burden of being seen – what is described in the German as *Maskenfreiheit*, the freedom conveyed by masks. To refuse scrutiny is to dodge the possibility of rejection, though also the possibility of acceptance, the balm of love. This is what makes masks so poignant as well as so uncanny, sinister, unnerving. Think of the Phantom of the Opera or the Man in the Iron Mask; or Michael Jackson himself, for that matter, his exquisite face half-concealed by a black or white surgical veil that begs the question of whether he is the victim or perpetrator of his own disfigurement.

Masks amplify the way in which skin is a barrier or wall, acting as a marker of separation, singularity, distance. They are protective, yes, but a masked face is also frightening. What lies behind it? Something monstrous, something awful beyond bearing. We're known by our faces; they reveal our intentions and betray our emotional weather. All those horror films that feature masked killers – *Texas Chainsaw Massacre*, *Silence of the Lambs*, *Halloween* – play on a terror of facelessness, of not being able to make an appeal, to speak as we say face to face, mortal to mortal.

These films often also articulate the deforming, dehumanising, monster-making horror our culture considers loneliness to be.

Here donning the mask signifies a definitive rejection of the human state, a prelude to wreaking revenge on the community, the mass, the excluding group. (The same message delivered in a lighter envelope week after week on *Scooby-Doo*: the ghoul's mask plucked from the villain to reveal the lonely caretaker, the cantankerous isolate who can't bear those insufferably sunny, agglomerate kids.)

Masks also beg the question of the public self: the set, frozen features of politeness and conformity, behind which real desires writhe and twist. Maintaining a surface, pretending to be someone you are not, living in the closet: these imperatives breed a gangrenous sense of being unknown, of going unregarded. And then of course there are masks as a cover for illegal or deviant activity, and being unmasked, and being surrounded by a masked mob, like the terrifyingly pastoral animal heads worn by the villagers in *The Wicker Man*, or the zombie army in 'Thriller', a video I'd found unwatchably frightening as a child.

Many of these currents circulate through one of the most striking masked images I've ever seen, made by an artist who in the 1980s lived a block away from my apartment on East 2nd. It's a black and white photograph of a man standing outside the 7th Avenue exit of the Times Square subway. He's wearing a sleeveless denim jacket, a white t-shirt and a paper mask of the French poet Arthur Rimbaud, a life-sized Xerox of the famous portrait on the cover of *Illuminations*. Behind him a guy with an Afro is jaywalking in a billowing white shirt and flared black pants. The camera has caught him mid-bounce, one shoe still in the air. Both sides of the street are lined with big old-timey cars and cinemas.

MOONRAKER is on at the New Amsterdam, *AMITYVILLE HORROR* at the Harris, while the sign at the Victory, just above Rimbaud's head, promises in big black letters *RATED X.*

The picture was taken in 1979, when New York was passing through one of its periodic phases of decline. Rimbaud is standing at the sleazy epicentre of the city: on the Deuce, the old name for that stretch of 42nd Street that runs between 6th and 8th Avenue – standing, in fact, right where Valerie Solanas was arrested eleven years before. The street was wild even then, but by the 1970s New York was on the verge of bankruptcy and Times Square was overrun by violence and crime, a teeming haven for prostitutes, dealers, muggers and pimps. The Beaux Arts theatres – the same places Hopper had celebrated in *New York Movie*, his famous painting of a uniformed movie attendant slouched against a wall – had been transformed into porn cinemas and cruising grounds, the old economy of covert glances and desirable images growing more explicit, more flagrant by the day.

What better place for Rimbaud, who was drawn to crime and squalor, who spilled his talent liberally and fast, burning through the precincts of nineteenth-century Paris like a comet? He looks entirely at home there, his paper face expressionless, the gutter glinting at his feet. In other images from the series, which is entitled *Arthur Rimbaud in New York*, he shoots heroin, rides the subway, masturbates in bed, eats in a diner, poses with carcasses at a slaughterhouse and wanders through the wreckage of the Hudson piers, lounging with outstretched arms in front of a wall spray-painted with the words *THE SILENCE OF MARCEL DUCHAMP IS OVERRATED.*

No matter how large the crowd through which he moves, Rimbaud is always on his own; always unlike the people who surround him. Sometimes he's looking for sex, or maybe to sell himself, slouching outside the Port Authority bus terminal, where the hustlers go to display their wares. Sometimes he even has companions, like the one of him standing at night with two laughing homeless men, their arms slung around each other's shoulders, one of them holding a toy pistol, a trashcan fire burning at their feet. All the same, the mask marks him out as separate: a wanderer or voyeur, unable or unwilling to display his real face.

The Rimbaud series was conceived, orchestrated and shot in its entirety by David Wojnarowicz (generally pronounced *Wonna-row-vich*), a then entirely unknown twenty-four-year-old New Yorker who would in a few years become one of the stars of the East Village art scene, alongside contemporaries like Jean-Michel Basquiat, Keith Haring, Nan Goldin and Kiki Smith. His work, which includes paintings, installations, photography, music, films, books and performances, turns on issues of connection and alone-ness, focusing in particular on how an individual can survive within an antagonistic society, a society that might plausibly want them dead rather than tolerate their existence. It's passionately in favour of diversity; acutely aware of how isolating a homogeneous world can be.

The Rimbaud images are often mistaken for self-portraits, but in fact Wojnarowicz stayed behind the camera, using multiple friends and lovers to play the part of mask-wearer. Nonetheless, the work is deeply personal, albeit in a complicated way. The figure of Rimbaud served as a kind of stand-in or proxy for the artist, inserted

into places that mattered to David, places where he'd been or which still exerted a power over him. In an interview carried out much later, he talked about the project and its origins, saying: 'I've periodically found myself in situations that felt desperate and, in those moments, I'd feel that I needed to make certain things . . . I had Rimbaud come through a vague biographical outline of what my past had been – the places I had hung out in as a kid, the places I starved in or haunted on some level.'

He wasn't kidding about the desperate situations. Violence ran through his childhood like a fire, gutting and hollowing, leaving its mark. The story of Wojnarowicz's life is emphatically a story about masks: why you might need them, why you might mistrust them, why they might be necessary for survival; also toxic, also unbearable.

He was born on 14 September 1954 in Red Bank, New Jersey. His first memory wasn't of humans at all, but of horseshoe crabs crawling in the sand, the sort of image his dreamy, collaged films are filled with. His mother was very young, and his father was a merchant seaman, an alcoholic with a vicious temper. The marriage ran into trouble almost as soon as it began, and when David was two years old Ed and Dolores got divorced. For a while he and his siblings – a brother and sister, both older – were left in a boarding house, where they were physically abused: beaten; made to stand to attention or woken in the night and forced to take cold showers. Their mother had custody, but when David was around four the children were kidnapped by their father, who left them on a chicken farm run by an aunt and uncle before taking them to live with his new wife in the suburbs of New

Jersey, in what David later described as The Universe of the Neatly Clipped Lawn – a place where physical and psychic violence against women, gay people and children could be carried out without repercussions.

'In my home,' he wrote in his memoir, *Close to the Knives*, 'one could not laugh, one could not express boredom, one could not cry, one could not play, one could not explore, one could not engage in any activity that showed development or growth that was independent.' Ed was away at sea for weeks at a time, but when he was home he terrorised the children. David was beaten with dog leashes and two-by-fours, and once saw his sister being slammed on the sidewalk until brown liquid oozed from her ears, while neighbours pruned their gardens and mowed their lawns.

Fear contaminates everything. He remembered playing chicken with the trucks that came over the hill by his house, remembered being left in a shopping centre with his siblings just before Christmas, walking miles home in the snow with two turtles in a takeout box. Often he'd spend whole days hiding in the woods, looking for bugs and snakes, an activity he never tired of, even as a grown man.

At some point in the early 1960s he was sent to Catholic school and around that time his father became crueller, more uncontrolled. Once he killed and cooked David's pet rabbit, telling the kids they were eating New York strip. Another time, after a beating, he asked David to play with his penis. When David refused he dropped the subject, though the beating continued. Bad dreams in those days, recurring night images of tidal waves and tornadoes. A better one too, which visited periodically right

to the end. In it, he was walking along a dirt road to a pond. He'd dive in, swimming beneath the surface. There was a cave at the bottom, and he'd duck down into it, going deeper and deeper, lungs bursting, until at the last possible moment he'd emerge into a chamber filled with stalactites and stalagmites, luminous in the dark.

In the mid-1960s the Wojnarowicz children found their mother by looking up her name in a Manhattan phone book: *Dolores Voyna*. They snuck away for a day visit, spending a few hours with her in the Museum of Modern Art. It was there, wandering through the galleries, that David decided to become an artist. More visits were sanctioned, but then out of nowhere Ed decided he was done with the kids he'd fought so hard to get, dumping all three of them on Dolores. It should have been a relief, but her apartment in Hell's Kitchen was tiny and she was unused to playing the part of mother, especially to three by now deeply troubled children. She didn't even like them using the word *mom*, and though she was warm and expressive, it soon transpired that she was also manipulative, erratic and unstable.

New York City: the smell of dog shit and rotting garbage. Rats in the cinema, eating your popcorn. All of a sudden sex was everywhere. Men kept trying to pick David up, kept offering him money. He had a dream about being naked in a stream, ejaculating into water, and after that he said yes to one of the guys, going with him to his apartment on Central Park, though he insisted on travelling separately, by bus. He had sex with the son of one of his mother's friends and then thought frantically about killing him, almost hysterical with panic about his family finding out

and sending him to an asylum, where he'd doubtless be given electric shock therapy. Could it be seen on his face: what he'd done, and worse, how much he'd liked it? It wasn't a good time to be discovering you were queer, a year or two before the Stonewall riots kicked the gay liberation movement into life. He went to the local library to try and find out what a *fag* was. The information was limited, distorted, depressing; a litany of sissies and inverts, self-harm and suicide.

By fifteen he was regularly turning ten-dollar tricks in Times Square. He loved the energy of the place, though he barely ever visited without getting shoved around or having his pockets picked. The slam of the city, the assault of neon and electric light, the roiling mass of people, made up of mixed elements: sailors, tourists, cops, hookers, hustlers and dealers. He wandered through the crowds, fascinated; a skinny boy with big teeth and glasses, his ribs sticking out. At the same time he was drawn to quieter, more inward pursuits. He liked to draw, liked going to the movies on his own or wandering round the dioramas in the Natural History Museum; the dusty smell, the long unpopulated corridors.

A funny habit from those days: hanging by his fingers from the window ledge of his bedroom, his whole weight suspended seven storeys above 8th Avenue. Testing out the limits of his body, maybe, or maybe putting himself at risk as a way of overriding bad feelings, giving himself a series of self-administered shocks, 'testing testing testing how do I control this how much control do I have how much strength do I have'. He was thinking about suicide all the time, thinking about suicide and stealing snakes from pet stores, liberating them in the park. Sometimes he'd ride

the bus to New Jersey and wade into lakes fully dressed, the only time he ever washed (later, he remembered his jeans being so dirty that he could see the reflection of his face when he bent over). Feeling everything around him, all the architectural structures – school, home, family – crumbling, falling apart, the scaffolding struck.

Things came to a head at around the age of seventeen, when he was either thrown out or ran away for good from the apartment in Hell's Kitchen. Dolores had already kicked out both his siblings, after escalating tension, escalating rows. Now David too was on his own, freefalling out of society, crash-landing, as Valerie Solanas had before him, in the slippery, perilous world of the streets.

Time blurred, getting shifty, no longer signifying in the same way. He was almost starving for one thing, eventually getting so emaciated and filthy that he couldn't pick up a decent trick, settling instead for men who often beat him up or ripped him off. A walking skeleton, at the mercy of any vicious creep. He was so malnourished his gums poured with blood every time he smoked a cigarette. In *Fire in the Belly*, Cynthia Carr's extraordinary Wojnarowicz biography, there's a story about him ending up in hospital alone, in agony because of his rotting teeth, after persuading Dolores to lend him her Medicaid card. Push it under the door when you're done, she'd said. She'd be on holiday in Barbados.

He never got enough sleep in those days. Sometimes he'd spend the night on the roof of a building, curled against the heating vents, and in the morning would wake covered in soot,

his eyes and mouth and nose filled with a choking black dust. The same boy, that is, who'd written in his diary a few months earlier of how frightened he was to spend a night alone. Stealing clothes, stealing reptiles from pet shops. Staying in halfway houses, or with a group of transvestites down by the Hudson River, drifting with them between welfare hotels and wretched apartments. Sleeping in boiler rooms or abandoned cars. Sometimes he was raped or drugged by the men who offered him money, but others were kind to him, especially a lawyer called Syd, who used to take him home and feed him, just treat him like a regular, lovable human being.

Eventually, in 1973, he managed to prise himself off the streets. His sister offered him a bed in her apartment, and slowly he worked his way back into something closer to a regular existence: a roof over his head, at any rate, even if things like steady work and steady money weren't exactly easy to secure. In fact, in a covering essay for the book *Rimbaud in New York*, David's boyfriend Tom Rauffenbart remembered that when they first met, David, who had by then become a successful artist, didn't own a real bed and seemed to be subsisting on not much more than coffee and cigarettes. 'I did what I could to change that,' he added, 'but essentially David was a loner. Although he knew many people, he preferred to relate to them one-to-one. Everyone knew a slightly different David.'

You don't emerge from a childhood like that without baggage, without a sense of toxic burdens, which have to be somehow concealed or carried or otherwise disposed of. First there was the legacy of all that abuse and neglect, the feelings of worthlessness

and shame and rage, the sense of difference, of being somehow inferior or marked out. Anger, in particular, and bedded underneath it a deep, maybe unquenchable sense of being unlovable.

As if that wasn't bad enough, there was also the shame of having been on the streets at all, the worry that people would know he'd been a hustler, and judge him for it. He found himself plagued throughout his early twenties by an inability to speak, to acknowledge verbally what he'd been through, the experiences that he'd had. 'There was no way I could relate them to anybody in a room full of people at any party anywhere,' he told his friend Keith Davis in a taped conversation years later. 'The sense of carrying experiences on my shoulder, where I could sit there and look at people and realize there was just no frame of reference that was similar to theirs.' And again in *Close to the Knives*: 'I could barely speak when in the company of other people. There was never a point in conversations at work, parties or gatherings when I could reveal what I'd seen.'

This sense of separation, of being profoundly isolated by his past, was intensified by the old anxiety about sexuality. It had been agonising, growing up in a world in which what he desired to do with his body was considered disgusting, tragic, deviant, deranged. He came out properly in San Francisco in the mid-1970s, on a brief stint away from Manhattan. Living openly for the first time as a gay man, he immediately felt happier, freer and healthier than he ever had before. At the same time he realised forcibly the weight of the antagonism stacked against him, the hatred lurking everywhere for a man who loved men and was not ashamed of the fact. 'My queerness,' he wrote in a biograph-

ical summary titled 'Dateline', 'was a wedge that was slowly separating me from a sick society.'

In *Close to the Knives*, he recalled how it had felt as a child to hear other kids screaming *FAGGOT!* at one another, how 'the sound of it resonated in my shoes, that instant solitude, that breathing glass wall no one else saw'. Reading that sentence made me realise how much of his account reminded me viscerally of scenes from my own life; reminded me, in fact, of the precise sources of my isolation, my sense of difference. Alcoholism, homophobia, the suburbs, the Catholic church. People leaving, people drinking too much, people losing control. I hadn't experienced anything like the violence of David's childhood, but I knew what it was like to feel unsafe, to pass through chaotic and frightening scenes; to have to find a way of coping with a simmering sense of fear and rage. My mother was gay, deep in the closet. In the 1980s she was outed and we ended up running away from the village I'd lived in all my life, shuttling between houses on the south coast as her partner's alcoholism grew more advanced.

This was the era of Section 28, when homophobia was enshrined in Britain's legislation, let alone in any passing bigot's mind, when teachers could not legally promote 'the acceptability of homosexuality as a pretended family relationship'. I'd always found straight society isolating and potentially dangerous. When I read that line in *Knives* I remembered vividly the sick feeling that used to come over me at school when other children talked in their hateful, stupid way about *fags* and *gaylords*, compacting and inflaming my already acute sense of being an alien, of standing

outside. It wasn't just about my mother. I can see myself then, skinny and pale, dressed as a boy, completely incapable of handling the social demands of being at a girls' school, my own sexuality and sense of gender hopelessly out of kilter with the options then on offer. If I was anything, I was a gay boy; in the wrong place, in the wrong body, in the wrong life.

Later, after school, I dropped out altogether, living on protest sites, squatting in semi-derelict buildings in seaside towns. I can remember sleeping in a room of junkies, the backyard filled with ten solid feet of rubbish. Why do you put yourself in unsafe places? Because something in you feels fundamentally devoid of worth. And how do you break out, reclaim your right to difference? One of David's strongest memories of his street years was periodic nights of rage, in which he and a buddy would get so choked up with hunger and frustration that they'd walk almost the length of Manhattan island, smashing the glass in every phone box that they passed. Sometimes you can change the psychic space, the landscape of the emotions, by carrying out actions in the physical world. I suppose in a way that's what art is, certainly the near-magical art that Wojnarowicz would soon begin to make, as he turned increasingly from destruction to creation.

This is the context from out of which *Rimbaud* emerged, the kind of issues with which it struggles. David began taking the photos in the summer of 1979 with a 35mm camera he'd borrowed from a friend. He'd been experimenting previously with images shot at the hip, trying to build up a body of work that would testify to the world in which he'd lived, the expe-

riences he still found it impossible to articulate in speech. He was beginning to understand that art might be a way for him to bear witness, to reveal 'things I'd always felt pressured to keep hidden'. He wanted to make images that somehow told the truth, that acknowledged the people who were left out of history or otherwise disenfranchised, excluded from the record.

There was something very powerful about going back to his old stamping grounds as an adult and inserting Rimbaud into the landscape of his childhood, having him stand impassively by the painted barrier where David used to lean as a boy, waiting for ageing men to buy his skinny, unkempt body. Another self? A sexy, nerveless simulacrum, toughened by experience. Was it a figure he could enter (as later, in his diary: 'I want to create a myth that I can one day become'), or a way of retroactively protecting the goofy, vulnerable little boy that he'd once been? Hard to imagine his Rimbaud being raped or forced to do anything against its will.

Either way, he was using the camera to illuminate an underground world, pouring light into the hidden places of the city, the hustling grounds, the locations where a struggling kid could make a buck or scrounge a meal. Taking a photograph is an act of possession, a way of making something visible while simultaneously freezing it in place, locking it in time. But what of the mood of the pictures, the loneliness that rolls off them in waves, radiating from Rimbaud's uncanny, expressionless figure? It seemed to me that they testified not just to a way of life, but also to the experience of feeling different, cut off, incapable of confessing real feelings: imprisoned, in short, as well as liberated by a mask.

The more I looked at them, the more they tallied with the feelings that David was simultaneously exploring in his diaries ('I found myself walking the streets alone most times, being home alone, and gradually falling into a state of very little communication, all because of the desire to preserve my own sense of life and living'). They express a sense of isolation, a conflict between the desire to make contact, to reach beyond the prison of the self, and to hide, to walk away, to disappear. Something sad about them, despite the toughness, the raw sexuality; a question not yet resolved. As Tom Rauffenbart put it in his essay at the beginning of the *Rimbaud* book: 'Although the Rimbaud mask presents a blank, unchanging face, it seems to always be watching and absorbing sights and experiences. Yet in the end, it remains alone.'

★

I went back to England briefly, and when I returned I began frequenting the Wojnarowicz archive at Fales Library, which is housed inside the big Bobst Library at New York University, right opposite Hopper's old studio in Washington Square. It was just the right distance for a walk and I took a different route each day, crisscrossing the East Village, sometimes dawdling past the little hidden cemetery on East 2nd and sometimes lingering to read the posters outside La Mama and Joe's Pub. It was winter now, the sky bright blue, buckets of copper-coloured chrysanthemums outside the bodegas.

At the library I'd show my pass and take the elevator to the

third floor, deposit my illegal pens in a locker and borrow a pencil to fill out a request sheet. Series I, Journals. Series VIII, Audio. Series IX, Photographs. Series XIII, Objects. Week by week, I worked my way through all of it, unpacking dozens of boxes of the Halloween masks and dollar toys David loved. A red plastic cowboy. A tin ambulance. A devil doll, a Frankenstein. I leafed through diaries, sometimes dislodging old menus and receipts, and watched scratchy VHS tapes of old summer vacations: David swimming in a lake, repeatedly dunking his face beneath the surface as nets of light broke across his chest.

In the evenings, as I walked home past Plantworks or the old Grace Church on Broadway, my head would be filled with images that had surfaced long ago, in the looking glass of someone else's mind. A man shooting heroin in an abandoned pier, tumbling out of consciousness, limp and lovely as a Pietà, spit bubbling from his lips. Dreams of fucking. Dreams of horses. Dreams of dying tarantulas. Dreams of snakes.

So much of Wojnarowicz's life was spent trying to escape solitary confinement of one kind or another, to figure a way out of the prison of the self. There were two things he did, two escape routes that he took, both physical, both risky. Art and sex: the act of making images and the act of making love. Sex is everywhere in David's work, one of the animating forces of his life. It was central among the things he felt driven to write about and depict, to wrestle free from the silence in which he'd felt entrapped as a boy. At the same time, the act itself was also a way − the best way, maybe − of reaching beyond himself, of expressing his feelings via the secret, taboo language of the body. Just as making

art allowed him to communicate his private experience, undoing the paralysing spells of speechlessness, so too sex was a way of making contact, of revealing the wordless, unspeakable things he kept concealed deep inside himself.

During the late 1970s and early 1980s, the same period in which he was making the Rimbaud images, he went out cruising all the time, looking for what some people would describe as casual sex − anonymous and with strangers − but which David almost always both named and viewed as love-making. He recorded these encounters in his diaries and later in his published writing in graphic detail, in both senses of the word: electrically visual, electrically explicit. He also logged his own responses, charting the subtle landscape of the emotions, the instances of longing or paralysing fear.

Almost every night he went out walking, down to the Brooklyn Promenade or over the abandoned West Side Highway to the Chelsea piers, a place that captured both his erotic and creative imagination for many years. The piers ran along the Hudson from Christopher Street to 14th Street and had been rotting ever since the decline of shipping back in the 1960s. As the commercial lines moved their traffic to Brooklyn and New Jersey, most of the Chelsea piers were closed for business and at least three were virtually destroyed by fires. By the middle of the 1970s, the city could no longer afford either to secure or destroy these immense, decaying buildings. Some were squatted by homeless people, who built camps inside the old goods sheds and baggage halls, and others were adopted by gay men as cruising grounds. It was a landscape of decay, of ruined grandeur reclaimed by a dissident, hedonistic population.

David recounted what he saw and did there with an extraordinary mixture of tenderness and brutality. On the one hand, the place was an *outdoor whorehouse*, reeking of piss and shit, where people were regularly murdered and where he once encountered a screaming man with blood pouring from his face who said a stranger in a navy windcheater had knifed him in an empty room. On the other hand, it was a world without inhibitions, where people whose sexuality was elsewhere the subject of intense hostility could find an absolute freedom of encounter and where moments of unexpected intimacy sometimes bloomed amongst the rubble.

In his diaries, he described prowling the Beaux-Arts departure halls at night or during storms. They were vast as football fields, their walls damaged by fire, their floors and ceilings full of holes, through which you could see the river moving, sometimes silver and sometimes a sludgy, toxic brown. He'd sit at the end of the pier with a notebook, his feet dangling over the Hudson, watching the rain falling, the giant illuminated Maxwell House coffee cup pouring its drips of scarlet neon over the Jersey shore. Sometimes a man would join him, or he'd follow a figure down passageways and up flights of stairs into rooms carpeted with grass or filled with boxes of abandoned papers, where you could catch the scent of salt rising from the river. 'So simple,' he wrote, 'the appearance of night in a room full of strangers, the maze of hallways wandered as in films, the fracturing of bodies from darkness into light, sounds of plane engines easing into the distance.'

Wandering the piers, David rarely encountered the same men

twice, though sometimes he looked for them, half in love with an imagined personality, a mythic being he'd conjured out of an accent or a single word. This was part of the pleasure of cruising, the way it allowed him to be sexual and also to stay separate, to maintain a degree of control. You could be alone in the city, could relish the way 'the solitude of two persons passing in opposite directions creates a personal seclusion', knowing that places existed where physical connection was almost assured.

The public nature of what happened on the piers was in itself an antidote to secrecy and shame. He tried to give people a degree of privacy, but there was clearly a two-way dance between voyeurism and exhibitionism going on, part of the pluralistic pleasure of the place. At the same time, the scene invoked his archivist's instinct for recording, for getting down what he saw in words, preserving what might have seemed even then like a transient, impossible utopia. He took photos, his camera at his hip, and carried a razor in case of attack. It all came so fast, anyway, a hail of images, a lovely scrambling assault to the senses. Two men fucking, so hard that one of them fell to his knees. An upside-down couch, scattered office furniture, the carpet pooling with water at every step. Kissing a French man with brilliant white teeth and then staying up all night to make a black and yellow salamander out of paint and clay, a talismanic beast.

Art and sex, the two things bound together. Sometimes he took a can of spray-paint, and scrawled odd scenes from his imagination on to the crumbling walls: stray dreamlike phrases, some by him and some borrowed from artists he admired. *THE SILENCE OF MARCEL DUCHAMP IS OVERRATED*: he'd

written that, in homage to Beuys, then sprayed a version of the Rimbaud face, roughly outlined on a pane of glass. Lines about a Mexican dogfight, a drawing of a headless figure shooting up. Often he incorporated his graffiti into the background of the Rimbaud photos, building up layers of his presence, inscribing himself into the fabric of the place.

He wasn't by any means the only person to be inspired by the wreckage of the piers. Artists had been coming there for almost a decade, drawn by the vast scale of the rooms, the freedom of working without scrutiny or supervision. In the early 1970s, there'd been a series of avant-garde happenings, recorded in weirdly beautiful black and white photos. One shows a man suspended from a loading entrance, dangling from a rope tied to his foot. He teeters above a great heap of trash, from which a single Christmas tree protrudes: the Hanged Man in a post-apocalyptic Tarot deck. The same artist, Gordon Matta-Clark, was also responsible for the most ambitious artistic intervention on the piers. For *Day's End*, he and a team of helpers carved massive geometric shapes out of the floor and walls and ceiling of Pier 52 with chainsaws and blowtorches, letting in a torrent of light and converting the space into what Matta-Clark described as a sun and water temple, built without consultation or permission.

As for the cruising years, they were also documented by dozens of photographers, some amateur and some professional, among them Alvin Baltrop, Frank Hanlon, Leonard Fink, Allen Tannenbaum, Stanley Stellar and Arthur Tress, as well as Peter Hujar, the man who would become the most stabilising and

important figure in David's life. With their cameras, they captured it for posterity: the crowds of naked sunbathers on the dock; the cavernous rooms with their broken windows and damaged girders; the half-dressed men embracing in the shadows.

Others came to paint. Wandering around Pier 46, exploring the stinking labyrinth, David encountered the graffiti artist Tava, born Gustav von Will, who was working on one of his enormous priapic figures, far larger than life. More of them kept appearing, guardians and witnesses to the embracing bodies below. A faun in sunglasses, fucking a bearded man on all fours. Naked muscled torsos with enormous cocks, which David described as caryatids. Images of sexual freedom, licentiousness and pleasure, shocking in their rawness, though as David pointed out later, what was really shocking was that sexuality and the human body were taboo subjects at this late juncture in time, this ebb-end of a violent, image-saturated century.

<p style="text-align:center">★</p>

Reading David's diaries was like coming up for air after being a long time underwater. There is no substitute for touch, no substitute for love, but reading about someone's else's commitment to discovering and admitting their desires was so deeply moving that I sometimes found I was physically shaking as I read. That winter, the piers took on a life of their own in my mind. I pored over all the accounts I could find, fascinated by the spaces, the recklessness of encounter, the freedom and creativity they permitted. They seemed like an ideal world for someone who was struggling

with connection, in that they combined the possibilities of privacy, anonymity and personal expression with the ability to reach out, to find a body, to be touched, to have your doings seen. A utopian, anarchic, sexy version of what the city itself offers, but unsanitised, permissive rather than restrictive – and queer of course, not straight.

I knew this was idealistic, only half the story. I'd read plenty of reports that testified to how dangerous the piers were, and how rejecting and brutal they could be if you didn't look the part or know the code, let alone the bleak consequences that would befall this libidinal haven as AIDS took hold. Still, the piers as they had been gave my mind a place to wander, outside the gleaming factory of monogamy, the pressure to cuddle up, to couple off, to go like Noah's animals two by two into a permanent container, sealed from the world. As Solanas bitterly remarked: 'Our society is not a community but merely a collection of isolated family units.'

I didn't want that any more, if in fact I ever had. I didn't know what I did want, but maybe what I needed was an expansion of erotic space, an extension of my sense of what might be possible or acceptable. This is what reading about the piers was like: it was like those dreams when you push on the wall of a familiar room in a familiar house, and it gives way, opening on to a garden or a pool you never knew was there. I always woke from those dreams flushed with happiness, and it was the same when I read about the piers, as if each time I thought about them I relinquished a little more of the shame that almost every sexual body bears.

One of the things I was reading alongside Wojnarowicz was *The Motion of Light in Water*, a radically candid memoir about living in the Lower East Side in the 1960s by the science fiction writer and social critic Samuel Delany. In it, he described his own nights on the waterfront, 'a space at a libidinal saturation impossible to describe to someone who has not known it. Any number of pornographic filmmakers, gay and straight, have tried to portray something like it – now for homosexuality, now for heterosexuality – and failed because what they were trying to show was wild, abandoned, beyond the edge of control, whereas the actuality of such a situation, with thirty-five, fifty, a hundred all but strangers is hugely ordered, highly social, attentive, silent, and grounded in a certain care, if not community.'

In a later book, *Times Square Red, Times Square Blue*, he returns to this thought about community in greater detail. *Times Square* is a memoir-cum-polemic, in which *come* is the operative word. It chronicles Delany's experiences in the Square, and particularly in the porn cinemas of 42nd Street, like the one that appears with its declarative *X* in the background of the Rimbaud photo. Delany went to these cinemas often daily over a period of thirty years to have sex with multiple strangers, some of whom became deeply familiar to him, though their relationships rarely transcended the location.

Delany was writing in the late 1990s, after the gentrification – the literal Disneyfication, in fact, considering the identity of one of the major investors – of Times Square; which is to say that he was writing in praise and grief at what had already been destroyed. In his thoughtful as well as practised estimation, what

had been lost was not just a place to get your rocks off, but also a zone of contact, and particularly of cross-class and cross-racial contact – a site that facilitated intimacy, albeit transient, between a diverse multitude of citizens, some wealthy and some poor, some homeless, some mentally unsettled, but all soothed by the democratic balm of sex.

His take wasn't so much nostalgic as utopian: a vision of a lubricated city of exchange, in which brief, convivial encounters kept satiated those otherwise nagging and sometimes agonising needs for touch, company, playfulness, eroticism, physical relief. Furthermore, these interactions in stalls and balconies and orchestra pits created as a by-product the kind of weak ties that sociologists believe glue metropolises together, though admittedly they tend to be thinking of repeat encounters with shopkeepers and subway clerks, rather than amiable strangers who might give you a hand job once every three years.

As to whether these places did reduce loneliness, the city itself provided proof of that. Writing of the systemic closures that came in the 1990s, Delany regretfully observed: 'What has happened to Times Square has already made my life, personally, somewhat more lonely and isolated. I have talked with a dozen men whose sexual outlet, like many of mine, were centered on that neighbor-hood. It is the same for them. We need contact.'

We do. But there was a glitch in this utopia, at least as far I was concerned. In the context of the cinemas, the piers, citizens meant men, not women. Once, Delany did bring a female friend with him to the Metropolitan: a small Hispanic woman who worked as an office temp, spending her evenings playing guitar

and singing in nightclubs in the Village. Ana was curious about the scene and so she joined Delany for an afternoon, dressed in boyish clothes, though that didn't stop a kid muttering *fish* as she walked past, or the manager accusing her of being a prostitute. The visit passed off smoothly enough – plenty of easy-going action on the balcony to watch – and yet this anecdote reads more queasily than any of the more graphic encounters elsewhere recorded. What hangs over it, what looms unsaid, is the threat of what could have happened: the potential violence, the all too plausible act of rape, the peculiar mix of disgust, objectification and desire that the female form engenders, particularly when it appears in sexual contexts.

God I was sick of carrying around a woman's body, or rather everything that attaches to it. Maggie Nelson's stunning *The Art of Cruelty* had recently been published and there was a paragraph I'd underscored and ringed in pen, struck by how well it explained my attraction to the world of the piers. 'Of course,' she wrote, 'not all "thingness" is created equal, and one has to live enough of one's life *not* as a thing to know the difference.' In parenthesis, she added: 'This may explain, in part, why the meat-making of gay male porn doesn't produce the same species of anxiety as that of straight porn: since men – or white men, at any rate – don't have the same historical relation to objectification as do women, their meat-making doesn't immediately threaten to come off as cruel redundancy.'

Sometimes you want to be made meat; I mean to surrender to the body, its hungers, its need for contact, but that doesn't mean you necessarily want to be served bloody or braised. And

at other times, like Wojnarowicz's Rimbaud, you want to cruise, to pass unnoticed, to take your pick of the city's sights. This was why I'd been so frantic for a mask at the Halloween parade: because I didn't want to be the thing that was looked at, that could be rejected or disparaged.

I was always walking that winter, up by the Hudson, poking about in the gentrified remnants of the piers, pushing up past the manicured lawns, with their population of glossy couples pushing strollers. Here and there, I found small relics of the past. A set of old wooden pilings, sticking up through the pewter-coloured water like pins from a cushion. Two fallen stone columns, carved with wings. Skinny trees, growing out of rock and rubble, locked gates, layers of graffiti, a poster that read sadly *COST WAS HERE*.

As I wandered, I kept trying to think of an image of a woman that could act as a counterpart to *Rimbaud in New York*: an image of a woman at loose in the city, free-wheeling, to borrow a term from Valerie Solanas (who had her own history with the piers and who was through with the whole business, writing with characteristic bitterness: 'SCUM gets around . . . they've seen the whole show – every bit of it – the fucking scene, the dyke scene – they've covered the whole waterfront, been under every dock and pier – the peter pier, the pussy pier . . . you've got to go through a lot of sex to get to anti-sex').

I hadn't at the time encountered the artist Emily Roysdon's wry photographs of herself re-enacting the Rimbaud images, her face covered by a paper mask of David Wojnarowicz. Instead, I was looking at pictures of Greta Garbo, those tough dreamy

images of her striding around the city in men's shoes and a man's trench coat, taking no shit from anyone, out solely for herself. In *Grand Hotel*, Garbo said she wanted to be alone, that famous line, but what the real Miss Garbo desired was to be *left alone*, a very different thing: as in unbothered, unwatched, unharried. What she longed for was privacy, the experience of drifting unobserved. The sunglasses, the newspaper over the face, even the string of aliases – Jane Smith, Gussie Berger, Joan Gustafsson, Harriet Brown – were ways of avoiding detection, inhibiting recognition; masks that liberated her from the burden of fame.

For most of the years of her retirement, which began in 1941 at the age of thirty-six and lasted for almost five whole decades, Garbo lived in an apartment in the Campanile building on East 54th Street, not far from the Silver Factory, though considerably more salubrious. Every day she went on two walks: long meandering strolls that might take her up to the Museum of Modern Art or the Waldorf; walks for which she shod herself in tan or chocolate or cream suede Hush Puppies, which I once came across for sale on an internet auction. Often she went all the way to Washington Square and back, a loop of six miles, stopping to gaze in the windows of bookstores and delis, walking aimlessly, walking not as a means but as an end, an ideal occupation in and of itself.

'When I stopped working, I preferred other activities, many other activities,' she once said. 'I would rather be outside walking than to sit inside a theater and watch a picture moving. Walking is my greatest pleasure.' And again: 'Often I just go where the man in front of me is going. I couldn't survive here if I didn't

walk. I couldn't be 24 hours in this apartment. I get out and look at the human beings.'

This being New York, the human beings tended to ignore her, though Andy Warhol did confess in his diary in 1985 to passing her in the street and being unable to resist following for a while, taking sneaky photos as he went. She was wearing dark glasses and a big coat, her signature accoutrements, and she went into a Trader Horn store to talk to the counterwoman about TVs. 'Just the kind of thing she would do,' Warhol reported. 'So I took pictures of her until I thought she would get mad and then I walked downtown.' He laughs then, adding ruefully: 'I was alone, too.'

The internet is full of images of her wandering the city. Garbo with an umbrella. Garbo in camel-coloured slacks. Garbo in an overcoat, her hands behind her back. Garbo drifting along Third Avenue, walking calmly between the cabs. In a copy of *Life* from 1955, there's a full-page photograph of her crossing a street, islanded between four lanes of traffic. She cuts a strangely Cubist figure, her head and body completely encased in an enormous black sealskin coat and hat. Only her feet are visible, two skinny legs in blurry boots. She's turned disdainfully from the camera, her attention caught by a gauzy explosion of light at the end of the avenue, into which the buildings seem to dissolve. 'A LONELY FORM', the caption declares: 'Garbo crosses First Avenue near her New York home on a recent afternoon.'

It's an image of refusal, of radical self-possession. But where do these pictures come from? Most were taken by Garbo's stalker, the paparazzo Ted Leyson, who spent the best part of eleven years,

from 1979 to 1990, lurking outside her apartment building. He'd hide, he once explained in an interview, and she'd come out of her front door and look around. Once she was certain she was alone, she'd relax, and then he could sneak after her, ducking from doorway to doorway, ready to snap her out of solitude.

In some of these images you can tell that she's spotted him, whipping a tissue to her mouth to spoil the value of his picture. *Candids*, they called them, a word that once meant pure, fair, sincere, free from malice. It was Leyson who bagged the final photograph, the last before she died. He shot it through the window of the car that was taking her to hospital, her long silver hair down around her shoulders, one veined hand covering the lower portion of her face. She's looking at him through tinted glasses, her expression a queasy combination of fear, scorn and resignation; a gaze that should by rights have cracked the lens.

In two separate interviews, Leyson explained his behaviour as an act of love. 'That's how I express myself – in a strange way – express my regard and admiration for Miss Garbo. It's an overwhelming desire on my part, something I cannot control. It became obsessive,' he told CBS's Connie Chung in 1990. To Garbo's biographer Barry Paris he added in 1992: 'I admire and love her very much. If I caused her any pain, I'm sorry, but I think I did something for her or for posterity. I spent ten years of my life with her – I'm the other "man who shot Garbo", after Clarence Bull.'

I don't want to moralise about desire, be it scopophilia or any other kind. I don't want to moralise about what pleases people or what they do in their private lives, as long as it doesn't cause

harm to others. That said, Leyson's pictures are symptomatic of a kind of gaze that whether given or withheld is dehumanising, a meat-making of a profoundly unliberating kind.

All women are subject to that gaze, subject to having it applied or withheld. I'd been brought up by lesbians, I hadn't been indoctrinated in anything, but lately I'd begun to feel almost cowed by its power. If I was to itemise my loneliness, to categorise its component parts, I would have to admit that some of it at least was to do with anxieties around appearance, about being found insufficiently desirable, and that lodged more deeply beneath that was the growing acknowledgement that in addition to never being able to quite escape the expectations of gender, I was not at all comfortable in the gender box to which I'd been assigned.

Was it that the box was too small, with its preposterous expectations of what women are, or was it that I didn't fit? *Fish*. I'd never been comfortable with the demands of femininity, had always felt more like a boy, a gay boy, that I inhabited a gender position somewhere between the binaries of male and female, some impossible other, some impossible both. Trans, I was starting to realise, which isn't to say I was transitioning from one thing to another, but rather that I inhabited a space in the centre, which didn't exist, except there I was.

That winter, I kept watching Hitchcock's *Vertigo*, a film that is all about masks and femininity and sexual desire. If reading about the piers expanded my sense of possibility about sex, then watching *Vertigo* was a way of repeatedly alerting myself to the danger of conventional gender roles. Its subject is objectification and the way it breeds loneliness, amplifying rather than closing

the gap between people, creating a dangerous abyss – the very chasm, in fact, into which James Stewart as police detective Scottie Ferguson finds himself tumbling, knocked off his feet by craving for a woman who even when alive is more enigma or absence than corporeal, sweating presence.

The most disturbing section takes place after Scottie's breakdown, which itself follows on the heels of his lover Madeleine's suicide. Wandering the precipitous streets of San Francisco, he happens upon Judy, a chubby brunette in a Kelly green sweater who bears a passing resemblance to his lost love, though she possesses none of Madeleine's frosty hauteur or her passivity, her near-catatonic withdrawal from life.

In a grim reworking of the transformations effected in *My Fair Lady* and *Pretty Woman*, he takes this brash, fleshy, vulgar girl to Ransohoff's department store and makes her try on suit after suit until he finds the exact replica of Madeleine's immaculate smoke-grey. 'Scottie, what are you doing?' Judy says. 'You're looking for the suit that she wore, for me. You want me to be dressed like her . . . No, I won't do it!' And she runs to the corner of the room and stands there like a child being punished, her head bowed, her hands clasped behind her back, her face turned to the wall. 'No, I don't want any clothes, I don't want anything, I just want to get out of here,' she whimpers, and he jerks her arm, saying: 'Judy, do this for me.' I watched that scene again and again, wanting to drain it of its power. It's the spectacle of a woman being forced to participate in the perpetual, harrowing, non-consensual beauty pageant of femininity, of being made to confront her status as an object that might or might not be deemed acceptable, capable of arousing the eye.

In the next scene, in a shoe shop, Judy is expressionless. She's absented herself, withdrawing from that place of siege, her body. Later, Scottie drops her off at a hairdresser and goes home to her hotel, where he fiddles with a newspaper, in a state of agonising impatience. She comes towards him along a corridor, white-blonde now, but with her hair still down around her shoulders. 'It should be back from your face and pinned back,' he says furiously. 'I told them that, I told you that.' She tries once again to check him and then capitulates, going into the bathroom to complete the final episode of her transformation.

Scottie walks to the window. Outside, behind net curtains, light is leaking from a neon sign, drenching the room with icy green – the Hopper colour, the colour of urban alienation, inimical to human connection; maybe even to human life. Then Judy-as-Madeleine emerges, and walks towards him, a perfect copy of a copy. They kiss and as the camera circles around them she swoons backward until it seems that he's embracing a dead body, a prefiguration of what will shortly come to pass.

That embrace is one of the loneliest things I've ever seen, though it's hard to tell who's worse off: the man who can only love a hologram, a figment, or the woman who can only be loved by dressing up as someone else – someone who barely exists at all, who is travelling from the moment we first see her towards death. Never mind meat-making: this is corpse-making, objectification taken to its logical extreme.

★

There are better ways of looking at bodies. One of the best antidotes I found, a corrective to Hitchcock's necrophilia and Leyson's stolen images of a beautiful stranger, was the work of the photographer Nan Goldin, one of David Wojnarowicz's closest friends. In her portraits of friends and lovers, the boundaries between bodies, sexualities, genders seem magically to dissolve. This is especially true of her constantly re-edited work *The Ballad of Sexual Dependency*, which she began during the 1970s while living in Boston and continued after her move to New York City in 1978.

These images are almost painfully intimate. 'The instant of photographing, instead of creating distance, is a moment of clarity and emotional connection for me,' Goldin writes in the introduction to the Aperture edition of *Ballad*. 'There is a popular notion that the photographer is by nature a voyeur, the last one invited to the party. But I'm not crashing; this is my party. This is my family, my history.'

It's striking, the difference between observer and participant. What Goldin's photographs show are beloved human bodies, some of which she's known since her teens, regarded with an unaffected tenderness. Many of her images document scenes of decadence – the wild and wasted party-going, the drugs, the baroque outfits. Others are quieter, more gentle. Two men kissing. A boy lying in the milky waters of a bath. A woman's hand on a man's bare back. A couple in bed, on striped sheets, the paleness of their skin emphasized by the lacy white negligées both are wearing.

Naked flesh is everywhere in Goldin's work, sometimes bruised or sweating, the near-translucent white of the professionally

nocturnal. Bodies sleeping, bodies fucking, bodies embracing, estranged bodies, battered bodies, bodies bent on getting high. Her subjects, identified by first names only, are often half-dressed, stripping out of or climbing into clothes, washing or painting a face on in the mirror. Her work is fascinated by people in the act of transition, passing between one thing and another, adapting and refashioning themselves by way of lipstick, lashes, gold lamé, piles of teased hair.

Goldin has explicitly said that she doesn't believe in a single, revelatory portrait of a person, but aims instead to capture a swirl of identities over time. Her people pass through moods, outfits, lovers, states of intoxication. Forget the clunky opposition between masked and authentic selves. Instead there's fluidity, perpetual transition. Many of her subjects, especially early on, were drag queens. She captures the process of transformation, the beautiful boys turning themselves into what she once described as a 'third gender, that made more sense than either of the other two'. Sexual desire is likewise fluid, a matter of connection rather than category. A relief, this non-binary domain, where playing with appearance doesn't automatically necessitate *Vertigo*'s toxic self-extinguishment, but is instead an act of discovery and expression.

That isn't to say that the portraits shy away from showing failures of intimacy: glitches and hiccups, moments of ambivalence or unravelling ties. The subject of *Ballad* is explicitly sexual relationships. As a body of work it traverses the poles of connection and isolation, capturing people as they drift together and apart; moving on the unsteady tides of love. Some sequences – 'Lonely Boys', maybe, or 'Wild Women Don't Get the Blues' or 'Casta

Diva' – show individuals in states of solitude and longing, lounging on beds or gazing through windows, that classic Hopperesque image of the person in a state of paucity and enclosure. The beautiful *Dieter with the tulips*, its powdery grey light, the papery striped flowers, the softness of his face. Tough Sharon, hand thrust into the waistband of her blue jeans, a little square of plaster stuck on to her jaw. Or Brian, lying on the middle one of three double beds in a dingy, barely furnished hotel room in Merida, Mexico, 1982.

Others plunge to the opposite extreme, showing scenes of contact, even congress. A naked boy and a nearly naked girl kissing on a stained mattress on the floor in a New York apartment, their torsos pressed together, their slender legs entwined, one delicate foot cupped upwards, exposing a filthy sole. Or Nan herself in purple ankle boots and maroon socks, her pale legs bare, straddling her lover's chest, his hands just grazing the edge of translucent black knickers. The loveliness of touch, the rush of contact, the high of simply embracing, like Bruce and French Chris on a towel scattered with stars on the beach at Fire Island.

But if sex is a cure for isolation, it is also a source of alienation in its own right, capable of igniting precisely the dangerous forces that swept Scottie off his feet in *Vertigo*. Possessiveness, jealousy, obsession; an inability to tolerate rejection, ambivalence or loss. The most famous image in *Ballad* is a self-portrait of Goldin after her then-boyfriend battered her so badly that she was almost blinded. Her face is bruised and swollen, smashed around the eyes, the skin discoloured to a ruddy purple. Her right iris is clear but the left is suffused with blood, the same scarlet as her painted

lips. She stares into the camera, damaged eye to eye, not so much letting herself be seen as willing herself to look, conducting her own act of remembrance, adding herself to the archive of what goes on between human bodies.

This desire to show what really happened, no matter how shocking, had its roots in childhood experience. Like Wojnarowicz, whom she first met when they were both living in the East Village, Goldin grew up in the suburbs, amidst a climate of silence and denial. When she was eleven, her eighteen-year-old sister killed herself, lying down on a train track outside Washington D.C. 'I saw the role that her sexuality and its repression played in her destruction,' she wrote. 'Because of the times, the early sixties, women who were angry and sexual were frightening, outside the range of acceptable behaviour, beyond control.'

Like Wojnarowicz, she used photography as an act of resistance. In an afterword to Ballad written in 2012, she declared: 'I decided as a young girl I was going to leave a record of my life and experience that no one could rewrite or deny.' It wasn't enough just to take the photos; they also had to be seen, shown back to their subjects. On Twitter, of all places, I'd once come across a handwritten, Xeroxed flier, advertising one of the first of the periodic slideshows she organised of Ballad: 10 p.m. on a May night at 8BC, a club that opened in 1983 in the basement of an old farmhouse, back when the East Village was almost derelict, block after block burned out or converted into shooting galleries.

In 1990, Interview published a conversation between Goldin and Wojnarowicz, one of the wide-ranging, intimate exchanges between artists that Andy Warhol had envisaged when he first

dreamt up the magazine, two decades before. It opens with them in a café in the Lower East Side, joking around over the size of their calamari and struck to discover their birthdays are only a day apart. They talk about their work, discussing anger and violence, sexual desire and their shared wish to leave a record.

Close to the Knives had only recently been published, and towards the end of their conversation Goldin asks David what he'd most like his work to achieve. 'I want to make somebody feel less alienated – that's the most meaningful thing to me,' he says. 'I think part of what informs this book is the pain of having grown up for years and years believing I was from another planet.' A minute later, he adds, 'We can all affect each other, by being open enough to make each other feel less alienated.'

This sums up exactly how I felt about his work. It was the rawness and vulnerability of his expression that proved so healing to my own feelings of isolation: the willingness to admit to failure or grief, to let himself be touched, to acknowledge desire, anger, pain, to be emotionally alive. His self-exposure was in itself a cure for loneliness, dissolving the sense of difference that comes when one believes one's feelings or desires to be uniquely shameful.

In all his writing there is a stepping back and forth between different kinds of material, some very dark and full of disorder, but containing always astonishing spaces of lightness, loveliness, strangeness. He possessed an openness that was in itself beautiful, though he sometimes wondered if he was only capable of reproducing the ugliness he'd seen.

Then too there was his sense of solidarity, his commitment to and interest in people who were different, who stood outside the

norm. 'I always consider myself either anonymous or odd looking,' he once wrote, 'and there is an unspoken bond between people in the world that don't fit in or are not attractive in the general societal sense.' Almost all the sexual encounters that he records – hundreds, if not more – attest to an extraordinary tenderness towards other people's bodies and desires, their weirdnesses, the things they want to do. The only time he sounds truly hostile is when coercion or cruelty of some kind is involved.

If I had to pick a single paragraph, it would be this one, from *Close to the Knives*, about an encounter he had on the pier.

> In loving him, I saw men encouraging each other to lay down their arms. In loving him, I saw small-town laborers creating excavations that other men spend their lives trying to fill. In loving him, I saw moving films of stone buildings; I saw a hand in prison dragging snow in from the sill. In loving him, I saw great houses being erected that would soon slide into the waiting and stirring seas. I saw him freeing me from the silences of the interior life.

I loved that statement, loved especially the final line. *I saw him freeing me from the silences of the interior life.* That's the dream of sex, isn't it? That you will be liberated from the prison of the body by the body itself, at long last desired, its strange tongue understood.

5

THE REALMS OF THE UNREAL

IT'S FUNNY, SUBLETTING, MAKING A life among someone else's things, in a home that someone else has created and long since left. My bed was on a platform, up three wooden steps so steep I had to pick my way down them backwards, like a sailor. There was a boarded-up window at the end that opened on to an air shaft, through which music and conversation would periodically drift and stick. A dumbbell tenement, the kind described in *Low Life*, Luc Sante's incantatory account of Old New York. People had been coming and going through those rooms for years, leaving jars of lip balm and tubes of hand cream in their wake. The kitchen cupboards were filled with half-finished boxes of granola and Yogi tea bags and no one had watered the plants or dusted the shelves in months.

During the day I rarely encountered anyone in the building, but at night I'd hear doors opening and closing, people passing a few feet from my bed. The man who lived in the next apartment was a D.J., and at odd hours of the day and night waves of bass would come surging through the walls, reverberating in my

chest. At two or three in the morning the heat rose clanking through the pipes and just before dawn I'd sometimes be woken by the siren of the ladder truck leaving the East 2nd Street firehouse, which had lost six crew members on 9/11.

Everything felt permeable, silted up, like a room without a lock or a cavern periodically inundated by the sea. I slept shallowly, often getting up to check my email and then sprawling aimlessly on the couch, watching the sky turn from black to inky blue above the fire escape, the Chase bank on the corner. There was a psychic a few doors down and on sunny afternoons she'd sit in the window of her room beside a model skull, sometimes rapping on the glass and beckoning me in, no matter how violently I shook my head. No bad data, no revelations about the future, thanks. I didn't want to know who I might or might not meet, what was lying in wait ahead.

It was becoming increasingly easy to see how people ended up vanishing in cities, disappearing in plain sight, retreating into their apartments because of sickness or bereavement, mental illness or the persistent, unbearable burden of sadness and shyness, of not knowing how to impress themselves into the world. I was getting a taste of it, all right, but what on earth would it be like to live the whole of your life like this, occupying the blind spot in other people's existences, their noisy intimacies?

If anyone can be said to have worked from that place, it's Henry Darger, the Chicago janitor who posthumously achieved fame as one of the world's most celebrated outsider artists, a term coined to describe people on the margins of society, who make work without the benefit of an education in art or art history.

Darger, who was born in the slums of Chicago in 1892, had certainly existed on the margins. His mother had died of puerperal fever when he was four, a few days after giving birth to his sister, who was immediately adopted. His father was crippled, and at the age of eight he was sent away, first to a Catholic boys' home and then to the Illinois Asylum for Feeble-Minded Children, where he received the dreadful news that his father was dead. After running away at seventeen, he found work in the city's Catholic hospitals, in which uncertain refuge he spent nearly six decades rolling bandages and sweeping floors.

In 1932, Darger rented a single room on the second floor of a boarding house at 851 Webster Street, in a run-down, working-class region of the city. There he stayed until 1972, when he became too ill to care for himself and so went unwillingly to the St Augustine Catholic Mission, where coincidentally his father had also died. After he moved out, his landlord, Nathan Lerner, decided to clean the room of forty years of accumulated rubbish. He hired a skip and asked another tenant, David Berglund, to assist him by dragging out piles of newspapers, old shoes, broken eyeglasses and empty bottles, the collected hoardings of a devoted dumpster diver.

At some point during this process, Berglund began to unearth artworks of almost supernatural radiance: beautiful, baffling water-colours of naked little girls with penises, at play in rolling land-scapes. Some had charming, fairy-tale elements: clouds with faces and winged creatures sporting in the sky. Others were of exqui-sitely staged and coloured scenes of mass torture, complete with delicately painted pools of scarlet blood. Berglund showed them

to Lerner, himself an artist, who immediately recognised their value.

Over the next few months, they discovered a vast body of work, including over 300 paintings and thousands of pages of written material. Much of it was set in a coherent otherworld: the Realms of the Unreal, a place Darger inhabited far more dynamically and passionately than he did the everyday city of Chicago. Many people live constricted lives, but what is astonishing about Darger is the compensatory scale as well as richness of his internal sphere. He'd begun writing about the Realms some time between 1910 and 1912, after he escaped from the asylum, though who knows how long he'd been thinking about it, or visiting it in his mind. *The Story of the Vivian Girls, in What is Known as the Realms of the Unreal, of the Glandeco-Angelinian War Storm, Caused by the Child Slave Rebellion* would eventually run to 15,145 pages, making it the longest known work of fiction in existence.

As the unwieldy title suggests, *The Realms of the Unreal* charts the progress of a bloody civil war. It takes place on an imaginary planet, around which our own earth circulates as a moon. Like its American counterpart, this war is being fought over slavery; specifically the slavery of children. In fact, the role of children is among the most striking elements of the work. While gorgeously attired adult men fight on either side, the spiritual leaders of the struggle against the wicked Glandelinians are seven prepubescent sisters, while the victims of their multiple atrocities are small girl children, often stripped of their clothes, revealing the presence of male genitals.

The Vivian Girls are endlessly resilient. Like comic book hero-

ines, they can withstand any amount of violence; escaping every peril. But the other children are not so lucky. As both the written and visual material makes graphically clear, the Realms are a place of infinite cruelty, in which naked little girls are routinely strangled, crucified and disembowelled by uniformed men in gardens filled with luscious outsized flowers. It is this element of the work that would later draw accusations of sexual sadism and paedophilia.

Over the years, Darger also wrote a second enormous novel, *Crazy House: Further Adventures in Chicago*, as well as an autobiography and multiple journals. But despite his astonishing productivity, he apparently never tried to show, promote or even talk about his work, making and containing it within a succession of three small boarding house rooms. As such, it's not perhaps surprising that when Berglund went to the St Augustine Mission to ask about the thrilling find at Webster Street, Darger refused to discuss it, making the enigmatic statement *it's too late now* and asking that the work be destroyed. Later, he contradicted himself, saying that it could be preserved in Lerner's custody.

Either way, when he died on 13 April 1973, at the age of eighty-one, he left behind no explanation for the things he'd made, the art he'd created so painstakingly and over so many years. In the absence of any surviving relatives, it was Lerner and his wife who took on the roles of advocate and champion, coordinating and driving Darger's growing status in the art world, and selling his increasingly costly paintings to private collectors, galleries and museums.

It's rare that a body of work emerges into view so totally severed from its maker, and it's particularly problematic when the

content is both so disturbing and so resistant to interpretation. In the forty years since Darger's death, theories about his intentions and character have proliferated, put forward by an impassioned chorus of art historians, academics, curators, psychologists and journalists. These voices are by no means convergent, but broadly speaking they have established Darger as an outsider artist nonpareil: untutored, ignorant, isolated and almost certainly mentally ill. The extreme violence and physically explicit nature of his work has inevitably drawn lurid readings. Over the years, he's been posthumously diagnosed with autism and schizophrenia, while his first biographer, John MacGregor, explicitly suggested that he possessed the mind of a paedophile or serial killer, an accusation that has proved enduring.

It seemed to me that this second act of Darger's life compounded the isolation of the first; divesting him of dignity and drowning out or speaking over the voice he'd managed to raise against considerable odds. The things he made have served as lightning rods for other people's fears and fantasies about isolation, its potentially pathological aspect. In fact, many of the books and articles written about him seem to shine more light on our cultural anxieties around the effects of loneliness on the psyche than they do on the artist as a real, breathing person.

This process troubled me so much, in fact, that I became obsessed with accessing and reading *The History of My Life*, Darger's own unpublished memoir. Some of its text has been reproduced, but not in its entirety; another form of silencing, particularly when one considers how many volumes have been published on his life.

After some digging, I discovered that the manuscript was in New York, along with all Darger's written work and many of his drawings, part of a collection purchased from the Lerners in the 1990s by the American Folk Art Museum. I wrote to the curator asking if I could visit and she agreed to let me spend a week, the maximum concession, reading through his papers, the words he'd actually used to record his existence in the world.

<div align="center">★</div>

The archive was on the third floor of a huge office building near the Manhattan Bridge, down a maze of shiny white corridors. It doubled as a store for objects not currently on exhibition and so I sat at a desk surrounded by a melancholy zoo of wooden animals draped in white sheets, among them an elephant and a giraffe. Darger's memoir was in a brown leather binder, cracking at the corners and stuffed with grubby sheets of blue-lined paper. It began with page after page of copied passages from the Bible. At last, on page 39: *The History of my life. By Henry Joseph Darger (Dargarius)*; written in 1968, when he was retired and time was hanging heavy on his hands.

Not everyone possesses an instantly distinctive voice, but Darger did. Precise, pedantic, humorous, elliptical and very dry. The memoir opened: 'In the month of April on the 12, in the year of 1892, of what week day I never knew, as I was never told, nor did I seek the information.' What's odd about this sentence is that the first few words seem to be missing, so that one must extrapolate that this is Darger's date of birth. An accident, no doubt,

though it should also serve to make the reader wary, conscious that they are entering into a narrative of gaps.

Darger's account of his very early childhood was more benign than I'd been expecting, partly because he elided the death of his mother, focusing instead on his relationship with his father. They were poor, yes, but their life was not entirely devoid of pleasure, though Henry did have the heavy responsibilities that inevitably fall to children of sick parents. 'My father was a tailor and a kind and easy going man.' 'Oh how good the coffee he could produce by boiling – as he was lame I bought the food coffee milk and other supplies and ran errands.'

His reflections on childhood were interesting. There was never a sense of a *we*, of being part of a merry herd. Rather, an impression of himself as outside, acting first as an aggressor and then protector to those smaller and more vulnerable than himself. The aggression was caused, he thought, because he lacked a brother and had lost his sister to adoption. 'I never knew or seen her, or knew her name. I would as I wrote before shove them down, and once foolishly threw with my fingertips ashes in the eyes of a little girl by the name of Francis Gillow.'

Much has been made of this scene, and another in which he described being 'a meany', pushing a two-year-old to the ground and making it cry: ballast for building an argument about Darger being a sadist or a madman. But who didn't enact some violence on a sibling or stranger when they were small? You only have to sit by a playground for half an hour to see how physically aggressive many small children are.

Later, a shift occurred. He began to experience a deep tender-

ness for children that would persist right through his life. 'Then babies at that were more to me than anything, more than the world. I would fondle them and love them. At that time just any bigger boy or even grown up dare molest or harm them in anyway.' It's this sort of language that gives rise to the suspicion of paedophilia, though Darger certainly saw himself as the counter-opposite of an abuser: the self-styled protector of innocence, alert to vulnerability, to the possibility of harm.

The boy arising from the grubby pages was bright and stubborn, intolerant of irrational adult structures. Precocious of mind, able to grasp the failings of the rote way he was being taught, on one occasion explaining to a teacher the ways in which the histories of the civil war diverged and contradicted one another. But despite his intelligence, Darger wasn't popular at school, due to his habit of making what he described as strange noises with his nose, mouth and throat.

He'd expected his antics to amuse his fellow students, but instead they were annoyed and called him crazy and feeble-minded and sometimes tried to beat him up. He had another odd habit too, a way of throwing with his left hand, 'like pretending it were snowing'. People who saw it thought he was mad and he said if he'd realised why he'd have done it in private, since the accusation of insanity would soon have dreadful consequences for him.

By this time, his father had handed him over to the custody of the nuns at the Mission of Our Lady Home, a place he disliked so much he would have run away, if only he could have thought of how 'to be elsewhere taken care of'. He was eight, a child who despite his ability to shop and run errands was sensible of

his need for adult protection. His father and godmother both came to visit, but there seemed to be no question of him returning home.

In his final year at the Mission, he was because of his strange habits taken several times to see a doctor, who told him eventually that his heart was not in the right place. 'Where was it supposed to be?' he wrote ironically. 'In my belly? Yet I did not receive any kind of medicine or any kind of treatment.' Instead, on a grim November day he was hustled out of Chicago and taken by train to what he described as some kind of home for feeble-minded children. Decades on, he was still enraged. 'I a feeble minded kid. I knew more than the whole shebang in that place.'

In the most recent Darger biography, *Henry Darger, Throwaway Boy*, the writer Jim Elledge summons a powerful array of historical testimony, including a legal case, to prove the appalling conditions at this asylum, where children were routinely raped, choked and beaten, deceased inmates' body parts were used in anatomy lectures, one boy castrated himself and a small girl was scalded to death.

There is no mention of any of these horrors in Darger's own account. 'Sometimes was pleasant and sometimes not so,' he says, and: 'Finally got to like the place.' This doesn't mean, of course, that he was not among the abused. The laconic tone might be the stoicism of no choice, or the numbness that follows on from violence, the isolating, silencing layers of fear and shame. Perhaps not, though. There has been too much speaking into this kind of absence; too strong a desire to fill the holes in Henry's story.

It was a violent place; he was there: those are the facts, the limits of the known.

Here too I must say something about time. As with David Wojnarowicz's account of his childhood, the sense of time in Darger's record is often blurry or uncertain. There are many sentences along the lines of 'I do not remember the number of years I lived with my father' or 'I believe I was at the asylum 7 years'. This temporal unsteadiness is a consequence of too many moves and too little explanation about them, relating too to the absence of a devoted parent, who helps to organise a child's memories by telling their story back to them and keeping them appraised of their chronology, their place. For Henry, there was no one to keep track; no agency and no control. The world he inhabited was a place in which things happen to you, abruptly and without warning, where one's belief in the predictability of the future is severely undermined.

A case in point: when he was 'somewhat older, probably in my early teens', Henry was informed that his father had died, that he was completely at the mercy of the institution, and no longer possessed a family or home. 'I did not cry or weep however,' he writes, his *I*s like shepherd's crooks. 'I had that kind of deep sorrow that bad as you feel I could not. I'd been better off if I could have. I was in that state for weeks, and because of it I was in a state of ugliness of such nature that everyone avoided me, they were so scared . . . During the first of my grief I hardly even ate anything, and was no friend to any one.' Loss after loss, causing withdrawal after withdrawal.

Like time, the subject of home is also a source of puzzlement.

At the *bughouse*, as people called it, the older boys were made to spend their summers working on a state farm. Henry liked the labour, but he hated to leave the asylum. 'I loved it much better than the farm, but yet I loved the work there. Yet the asylum was home to me.' *But* and *yet*: devices for yoking contradictory thoughts together.

In fact, although he enjoyed the meals at the farm, loved to work in the fields and believed the family who ran it were *very good people*, he tried several times to run away. The first escape attempt ended when he was caught by the farm cowboy, who tied his hands to a rope and made him run back behind the horse, a scene vividly animated in Jessica Yu's beautiful documentary about Darger. It's hard to think of a more brutal illustration of being powerless over the course of your life, lashed and dragged in the wake of larger forces.

Undeterred, he tried a second time, hitchhiking a freight train to Chicago. After an alarming storm he lost his nerve, giving himself up to the police. 'What made me run away?' he asked himself in the memoir, answering: 'My protestation at being sent away from the asylum, where I wanted to stay, as for some reason it was home to me.'

*

In my lunch-breaks, I used to walk down to the waterfront and sit by the river. There was a carousel on the promenade, a real beauty, and as I ate I could hear the shouts of children being whirled around on the painted wooden ponies, chestnut, black

and bay. Darger's phrase about the asylum had lodged in my mind, and as I sat there I worried over it.

It was home to me is a statement that cuts to a central issue in loneliness studies: the question of attachment. Attachment theory was developed in the 1950s and 1960s by the British psychoanalyst John Bowlby and the developmental psychologist Mary Ainsworth. It proposes that children need to form secure emotional attachments with a caretaker during infancy and early childhood, a process that contributes to their later emotional and social development and that if ruptured or otherwise insufficient can have lasting consequences.

This sounds like common sense, but at the time of Darger's childhood the consensus among health care providers of all kinds – from psychoanalysts to hospital doctors – was that all children required in the way of nourishment was a germ-free environment and a ready supply of food. The reigning belief was that tenderness and physical affection were actively detrimental to development and could in fact ruin a child.

To modern ears, this seems insane, but it was driven by a genuine desire to improve child survival. In the nineteenth century, child mortality had been enormously high, especially in institutions like hospitals and orphanages. Once germ transmission was understood, the preferred strategy of care was to maintain hygiene by minimising physical contact, moving beds apart and limiting interactions with parents, staff and other patients as much as possible. While this did indeed successfully reduce the spread of disease, it also had an unexpected consequence, which took decades to be properly understood.

In the newly sterile conditions, children failed to thrive. They were physically more healthy, and yet they wasted away, particularly the infants. Isolated and untouched, they went through paroxysms of grief, rage and despair, before eventually submitting passively to their state. Stiff, polite, apathetic and emotionally withdrawn, their behaviour made them easy to neglect, further entrenching them in acute, unspeakable loneliness and isolation.

As a discipline, psychology was at this stage in its infancy, and the majority of practitioners either refused or were unable to see a problem. This was after all the era of the behavioural psychologist B. F. Skinner, who believed babies should be raised in boxes, protected from the contaminating presence of the mother, and of John Watson, president of the American Psychological Association, who mooted bringing up infants in hygienic camps, in accordance with scientific principles and far from the damaging influences of their doting parents.

Nonetheless, a handful of practitioners in America and Europe, among them Bowlby and Ainsworth, Rene Spitz and Harry Harlow, had a strong instinct that what those institutionalised children were suffering from was loneliness, and that what they were pining for was love: in particular affectionate physical contact from a stable and consistent caregiver. They began to carry out research in hospitals and orphanages on both sides of the Atlantic, but these studies were dismissed as being too small, too easily misconstrued. It took Harry Harlow's infamous experiments with rhesus monkeys in the late 1950s to really make the case for love.

Anyone who's seen photographs of Harlow's monkeys clinging to wire models or huddled in isolation chambers will know that

these are deeply disturbing experiments, carried out in an uneasy hinterland between the scientifically valid and the ethically abhorrent. Changing the treatment of human children mattered to Harlow; for him the monkeys were simply collateral damage in a larger battle. Like Bowlby, what he was trying to do was prove the crucial importance of affection and social connection. Many of his findings tally with current research on loneliness, particularly the notion that isolation leads to a decline in social sophistication, which in itself elicits further episodes of rejection.

In the first of his attachment experiments, carried out at the University of Wisconsin in 1957, he separated infant rhesus monkeys from their mothers, providing them with a pair of surrogates, one made of wire and one wrapped in soft cloth. In half the cages, a bottle of milk was attached to the chest of the wire mothers, and in the other half to the cloth mothers. According to the dominant theories of the time, the infant monkeys should have selected whichever surrogate possessed the food, but in fact they exhibited an absolute preference for the cloth mother, clinging to her whether she had milk or not, and only darting to the wire mother to suckle before racing back.

Next, Harlow assessed the reactions of the infants to various kinds of stress. He gave another group access to either a wire or cloth mother, before introducing a barking toy dog and a marching clockwork bear beating a drum. Monkeys who only had access to the wire mothers were far more alarmed by these terrifying apparitions than those provisioned with the more comforting cloth bodies.

These results align with the slightly later work of Mary

Ainsworth, who in the early 1960s explored how children's abilities to handle stressful or threatening situations (the so-called Strange Situation Procedure) depends on how securely they are attached. It was Ainsworth who came up with the categorisation still in use today, formulating a distinction between secure or insecure attachment, the latter of which can be further subdivided into ambivalent and avoidant attachment. An ambivalently attached child is distressed by maternal absence and shows its feeling via a mixture of anger, desire for contact and passivity, while an avoidantly attached child withholds their reactions on the mother's return, masking the intensity of their grief and fear.

Together, these experiments show the intensity of the need an infant has for an attachment figure. Harlow, however, still wasn't satisfied that his work was emphatic enough. For his next experiment, he designed four so-called *monster mothers*. Each possessed a comforting cloth body, but they were also armed respectively with brass spikes, an air-blaster, an ability to fling their charge away or to rock it so violently you could hear the baby monkey's teeth clashing together. Despite the discomfort, the infants kept clinging on, willing to face even pain in their quest for affection, for something soft to cuddle up to.

It was the image of these monster mothers that had come back to me when I read Darger's statement about loving the asylum. The bleak truth Harlow's experiment reveals is that a child's need for attachment far outweighs its capacity for self-protection: something that is also apparent when abused children plead to stay with violent parents. 'I can't say whether I was actually sorry I ran away from the state farm or not but now I believe I was a

sort of fool to have done so,' Darger had written in his memoir. 'My life was like in a sort of Heaven there. Do you think I might be fool enough to run away from heaven if I get there?' Heaven: a place in which during his own time children were regularly beaten, raped and abused.

But the monster mothers wasn't the only experiment of Harlow's to illuminate a key aspect of Darger's life. In the late 1960s, after he won the National Medal of Science, Harlow turned his attention from mothering to what happens to an infant if there is no social interaction whatsoever. He was becoming increasingly aware that it wasn't just attachment to the mother that produced a socially and emotionally healthy infant, but rather a whole mosaic of relationships. He wanted to understand the role of social contact in development, and to see what effects a forced experience of loneliness would produce.

In the first horrifying round of isolation experiments, he placed new-born rhesus monkeys in solitary confinement, some for a month, some for six months and some for an entire year. Even the monkeys with the shortest sentence emerged from their prisons emotionally disturbed, while those who were isolated for a full year were incapable of exploration or sexual relations, engaging instead in repeated patterns of behaviour: huddling, licking and self-clutching. They were aggressive or withdrawn; they rocked or paced back and forth; they sucked their fingers and toes; they froze into fixed positions or repeated strange gestures of the hand and arm. Again, it reminded me of Henry: the compulsive noise-making, the repetitive movements he made with his left hand.

Harlow wanted to see what would happen if these previously isolated individuals were returned to a group environment. The results were devastating. When placed in the shared enclosure they were almost invariably bullied, while some aggressively approached larger individuals in what Harlow termed suicidal aggressions. It was so bad, in fact, that some had to be re-isolated, to keep them from being killed. In Harlow's book, *The Human Model*, the chapter that deals with these experiments is titled 'The Hell of Loneliness'.

If only this were confined to rhesus monkeys. But humans are social creatures too, and also tend to cast out individuals who do not fit easily into the group. People who are not socially fluent, who have not been given a loving training in how to play and engage, how to join in and situate themselves, are far more likely to elicit instances of rejection (one might think here of Valerie Solanas, fresh from prison, being spat at by strangers in the street). For me, this was the most disturbing aspect of Harlow's work: the revelation that after an experience of loneliness both the damaged individual and the healthy society work in concert to maintain separation.

More recent research, particularly with bullied children, suggests that the targets of social rejection are often those who are deemed either too aggressive or too anxious and withdrawn. Unhappily, these are precisely the behaviours that arise from insecure or inadequate attachment or from early episodes of isolation. What this means in practice is that children who have had problematic attachment experiences are far more likely to suffer episodes of rejection than their peers, establishing patterns of loneliness and withdrawal that can continue entrenching well into adulthood.

This pattern too plays out in Darger's life. The lacks and losses he suffered in his childhood are precisely those that shatter attachment, kindling chronic loneliness. What happens next is the grim old cycle of hypervigilance, the growth of defensiveness and suspicion, a note audible everywhere in his memoir. He perpetually revisits old disagreements with people from his past, ways in which they cheated him or let him down. 'I hate my accusers and would have liked to kill them, but did not dare. I never was their friend, and am their enemy yet, even whether they are dead now or not.' The impression is of someone profoundly lacking in social flexibility, someone routinely picked on, ostracised or bullied, locked into the self-defeating circuit of suspicion and mistrust which follows on from any substantial experience of social isolation or shattered bonds.

But what the physiological account of loneliness elides is the part taken by society itself in policing and perpetuating exclusion, rejecting the unwieldy and strange. This is the other driver of loneliness, the reason why certain people – often the most vulnerable and needy of connection – find themselves permanently on the threshold, if not cast entirely beyond the pale.

*

After Darger made it back to Chicago for good, he found employment in the city's Catholic hospitals. Being a janitor was tough, relentless work: long days, no vacations and only Sunday afternoons off – a common enough experience, of course, during the years of the Depression. He kept it up for fifty-four years,

all told, excluding a brief spell in which he was drafted for the army, discharged soon after on account of his poor eyesight. In all that time his duties remained menial: peeling potatoes, washing pots or scraping dishes in the boiling kitchens, which during the brutally hot Chicago summers became so extreme that he was once sick for days with heat exhaustion. An even worse task was carting trash to be burned, *a heck of a job*, especially in winter, when he was often troubled by terrible colds.

What leavened those years, what made them bearable, was the existence of 'a special friend', Whillie (as Darger persistently spelt it, although his name was actually William) Schloeder, who Darger visited every evening in the years that he was working at St Joseph's and Grant Hospital. Darger doesn't say how he met Whillie, who worked as a night-watchman in the city, but over time they got close enough that he knew all the family: the sisters and in-laws, the nieces and nephews. Together, they established a secret club they called the Gemini Society. It was dedicated to the purpose of protecting children, and Darger made various playful items of documentation for it, which undermines the notion that no one ever saw his art.

In 1956, Whillie's mother died and he sold the house and moved with his sister Catherine to San Antonio, where three years later he died of Asian flu. '5 of May, (I forgot the year),' Darger wrote, 'and since that happened I am all alone. Never paled [sic] with anyone since.' The hospital wouldn't give him time off work to go to the funeral and afterwards he could never find out where Catherine had gone, though he thought it might have been Mexico.

A couple of days after reading about Whillie's death in the memoir, I was looking through a slim folder of correspondence – brief notes to priests and neighbours, mainly – when I found a letter Darger had written to Catherine. It was dated 1 June 1959 and it began with a formal expression of sorrow. *My dear friend Miss Catherine, surely did not feel at all good, the very sad news, my dear friend Bill, died May the Second, I feel as if lost in empty space.*

Then there was a long section about a missed phone call, mistaken identities, another Henry in the kitchens at work. 'Why didn't you call where I live?' he asks miserably. 'Then I would have known, and if possible you could have me at the funeral.' Because he was off sick he hadn't got the news for three whole days. He apologises for not writing sooner, 'because I was out of sorts and shaken by the news of his death. He was like a brother to me. Now nothing matters to me at all and I am going to here after live my kind of life.' He promises to have a mass said and asks for a picture or something to remember Whillie by. He expresses the hope that she will receive consolation, adding: 'a loss is hard to take. It sure is to me to lose him for then too I lost all I had and had a hard time to stand it.'

The letter was stamped *RETURNED*. Catherine had already vanished. After the severing of this final bond, Darger never made another friend. Instead, his world became radically unpeopled, which is perhaps what he'd meant by that curious statement *I will here after live my kind of life*. A few years later, in November 1963, he retired from the hospital, at the age of seventy-one. His legs were becoming increasingly painful and he was limping

badly, periodically suffering attacks so bad he couldn't stand. Pain in his side too, so that he sometimes sat and cursed the saints for hours. One might have thought retirement would be a blessing, but he said he hated the *lazy life*, the lack of tasks to fill the empty days. He started going to mass more frequently, and spent many hours combing the neighbourhood for useful pieces of trash, especially string and pairs of men's shoes.

From the outside – and there are plenty of witness statements, mostly collected from the other tenants at Webster Street – he seemed increasingly cranky and withdrawn. He holed up in his room, where he could clearly be heard talking to himself: either the blasphemous rants that he records in the memoir or conversations with people from his past; long, aggrieved arguments in which he would perform both parts.

The History of My Life is not especially forthcoming about this period of Darger's life because on page 206 of 5,084 it segues from an autobiography into an enormously long and rambling story about a tornado called Sweetie Pie and the horrific damage it caused. A more concrete sense of what his retirement involved comes from the journal he kept in his last years. The entries are terse and repetitive, attesting to the outwardly narrow and constricted contours of his life. 'Saturday April 12. My birthday. The same as Friday. Life History. No tantrums.' 'Sunday April 27 1969. Two masses and Communion. Eat Hot dog sandwich. I felt miserable from cold. Went to bed early in the afternoon.' 'Wednesday April 30 1969. Still in bed with a bad cold. Cold today and tonight much worse. Tormented me terribly. No mass or Communion. No Life History.'

Hardly any wonder Father Thomas, the parish priest at St Vincent's, observed anxiously, 'he is more helpless than I presumed'. This is a document of lack, in which there is no mention of friends or social activities beyond the church. It's true that he did sometimes interact with neighbours. There were a few letters in the archive in which he asked David Berglund for small favours: to help with a ladder, or to give him for Christmas *what I need most*, a bar of Ivory soap and a large tube of Palmolive brushless shaving cream, gifts for which he'd thank him with cards printed with sentimental verse. Berglund and his wife also nursed Henry when he was ill, though he doesn't mention this in his own account. But apart from these neighbourly interventions, there is a vast paucity of human interaction, combined with an internal furore of emotion, particularly rage.

The final journal entry comes at the tail end of December, 1971. Darger hasn't been writing for a while, checked by a serious eye infection, which necessitated an operation. During the recovery period he didn't dare go out, stopping instead in bed, the kind of laziness he loathed. Now he sounds miserable and frightened. 'I had a poor a very poor nothing like Christmas. Never had a good Christmas in all my life,' he writes, adding: 'I am very bitter but fortunately not revengeful.' But what, he wonders fretfully, will the future hold for him. 'God only knows. This year was a very bad one. Hope not to repeat.' The final words are 'What will it be?' followed by a dash – an expression of suspension, be it of time or disbelief.

★

My desk at the archive faced a set of metal shelves. On them were piled 114 boxes in varied shades of buff and grey. They looked drab and officey, the sort of thing you might use to store minutes or accounts, but what they actually held was evidence of Darger's secret life: as the artist self, the maker of worlds, an identity he mentioned only in passing in his life history. ('To make matters worse now I'm an artist, been one for years and cannot hardly stand on my feet because of my knee to paint on the top of the long picture.')

As an artist, he was entirely self-taught. Although he possessed a remarkable gift for composition and had loved colouring since very early childhood, he was burdened by the belief that he couldn't draw. Many artists are opposed to or uncomfortable about working free-hand, committing their own lines to the page. Sometimes this is about wanting to avoid determinism, à la Duchamp, who said about one randomised work: 'The intention consisted above all in forgetting the hand.'

This desire resurfaces in the work of Warhol, who though magically gifted at drawing wanted to erase the evidence of the hand, preferring instead the chancy happenstance of machine processes, especially screen printing. Others simply doubted their abilities. Whenever David Wojnarowicz was asked how he got started as an artist, he'd say that as a boy he used to trace pictures – ocean panoramas, say, or images of planets circulating in outer space – presenting them to kids at school as his own work. Eventually a girl confronted him, insisting he draw freehand in front of her. To his surprise he found he could, and from then on the anxiety he'd felt about drawing fell away.

Darger never really experienced a lessening of that fear, but like Warhol he did find elaborate ways of circumventing line drawing, sharing too his pleasure at making art out of actual pieces of the world. How did he do it, though: making painting after painting with no training, a punishing job and only limited resources? The curator at the archive was himself an artist, and in between fetching boxes he explained Darger's career to me, the painstaking way he'd honed and developed a working practice.

He'd started with found images, sometimes backing them on card or doctoring them in subtle ways, especially by painting over them, adding hats or costumes or simply piercing the eyes. Next, he progressed to collages, cutting images out of newspapers and magazines and pasting them into increasingly complex composites. The problem with this technique was that each component image could only be used once, meaning that he had to find more and more raw materials, either at the hospital or by going through the trash. It was wasteful of resources, and also frustrating, having to surrender a favoured image, to commit it to just one picture, just one scenario.

This is where tracing came in. With tracing, he could liberate a figure or object from its past context and reuse it dozens if not hundreds of times, inserting it by way of carbon paper into a diversity of scenes. It was economical, a thrifty process, and it also let him magically possess the image in a way that scissors didn't, transferring it first on to tracing paper and then again through the blue sheets of carbon into the painting proper. One of his favourites was a doleful little girl holding a bucket, one finger in her mouth. Once you've spotted her, she crops up over and again,

a picture of abject misery and desolation. The Coppertone Girl, too: often with horns, or transformed into one of the winged creatures Darger called *blengins*, a world away from where she'd begun.

There were thousands of these source images: folder after folder filled with pictures clipped from colouring books, comics, cartoons, newspapers, adverts and magazines. They attested to an obsessive love of popular culture that reminded me again of Warhol, a hoarding and repurposing of just the kind of ordinary things that would later be embraced by Pop Art, something Darger never mentioned and quite possibly never saw.

Despite the rumours about his disorderly, chaotic habits, Darger had evidently been meticulous in organising this raw material, establishing thematic groupings: sets of clouds and girls, images of the Civil War, of boys, men, butterflies, disasters – all the divergent elements, in fact, that together make up the universe of the Realms. He'd stored them in stacks of filthy envelopes, which were carefully labelled with his own idiosyncratic descriptions: 'Plant and child pictures', 'Clouds to be drawn', 'Special picture Girl bending with stick and another jumping away in terror', 'One girl with some one's finger under chin Maybe sketch maybe not'. Some of these so-called *special images* were further labelled 'to be drawn only once', as if multiple replication would divest or drain them of their uncanny power.

His working practice became even more sophisticated when in 1944 he discovered that he could get images turned into photographic negatives and then enlarged at the drugstore on North Halstead, three blocks away from his house. Enlargement facilitated

the extraordinary complexity of his work, allowing him to play with scale and perspective, to compose elaborate scenes using foreground and background, to create kinetic and receding layers.

One box was stuffed with envelopes from the lab, each containing the original, the negative and the enlargement. The receipts were also preserved; seemingly small sums of $5 and $4 and $3.50, until you remembered that in all Darger's life his salary never exceeded $3,000 a year, and that in the decade of his retirement he lived off social security. Nothing is more declarative of someone's priorities than how they spend their money, particularly when they don't have much of it. Hot dogs for lunch, begging his neighbours for the gift of soap, but 246 enlargements of children, clouds, flowers, soldiers, tornadoes and fires, so that he could incorporate actual beauty and disaster into his unreal world.

All the time that I was working in the archive, I was aware that there was a painting behind me, draped in sheets. It was enormous, at least twelve feet long, so that it was hard to imagine how Darger had stored it, let alone worked on it in his cramped little room. On my final day, I asked if I could see it and so the curator drew back the covers and let me look my fill.

It was made from multiple materials: watercolour, pencil, carbon tracing and collage. A caption had been handwritten on a pasted sheet of plain white paper: *This scene here shows the murderous massacre still going in before the winged blengins arrived from the sky. They came so quick how however that those fastened to the trees, or board, and those on the run escaped the murderist rascals or were rescued, and flown to permanent safty and security.* [sic]

Like many of Darger's paintings, it showed a rural landscape, partially wooded and coloured in a lovely symphony of greens. There was a palm tree, a tree with huge hanging grapes, an apple tree, a pale tree giving forth large white blooms. In the foreground, there was a great profusion of flowers, spreading outward from a clump of crocuses, which rose like snakeheads from the bottom of the canvas.

All the trees bore strange fruit. There were girls tied to them, girls hanging from them, girls lashed to boards and girls running screaming from an army made up of uniformed soldiers and cowboys; one on horseback, the others hurtling through the bush. Some of the girls were naked, especially the ones in the trees, though most of them had managed to keep their socks and Mary Janes, their hair in incongruously neat plaits tied with ribbons. Elaborately coloured butterflies moved among them, drifting through an expanse of rose-pink sky.

The girl with the pail was right at the back, also dressed in pink, her finger in her mouth. 'I have to stop this,' she says by way of a speech bubble. 'But how, by myself?' She's not the only speaker. This is a highly verbal painting. 'We could only get a few. The others would escape. We will signal to our friends flying in the sky,' says a naked girl crouching at the far left of the painting. 'Let's go at the murderers,' her friend replies. Two of the cowboys are arguing nearby, shouting: 'She's mine I tell you. I won't let go' and: 'You let go, will you. She's the one I'm supposed to hang, not you. Yours is on the run.' They're wrestling for control of a rope, which vanishes upward, presumably to an unseen branch. From the other end a girl is hanging, naked but for blue socks and shoes, her tongue protruding from her livid fuchsia face.

I stood by the painting for a long time, writing detailed notes about colour and position. *Three dimensionality by having half of each face/body painted a darker pink. Actual lines drawn in to divide pale from dark. Three naked save for socks and shoes. Girl's throat crushed in crook of elbow, red hair mauve face. Dark purple almost black dress matched to socks. Kicking her legs, knee and hand lost in foliage/flowers. One brighter yellow and with plaits with white ribbons.*

I was starting to feel a little dizzy. There was a squirrel in the tree, a dangling bunch of grapes. Seizing on details was a way of resisting the overwhelming impact of the painting, its orchestrated violence, the way it invited and resisted interpretation in the same field of time. A blond soldier had two girls by the throat, one in each meaty fist. His uniform had gold buttons and his large blue eyes were gazing vacantly into the middle distance, totally disconnected from the actions of his body.

Pain was everywhere in the painting, though not everyone was capable of acknowledging it. In fact, it was a profound investigation into three kinds of gazes: the gaze of agony, the gaze of empathy, and the gaze of disassociation: an account of pain and horror registering on multiple faces. It was hard to know which were the most disturbing, the agonised girls or the blank-faced, wooden men, who didn't understand that they were causing pain, or didn't care; who were unable to register or engage with the harm that they were doing to another body, another sentient being. The result was chaos, a tumult of limbs and mouths and hair, carried out in a landscape of indifference, the blooming ground on which all wars occur.

What was Darger doing, all those years alone in his room? You

might paint something like that once, but imagine doing it again and again, consecrating your life to an analysis of violence and vulnerability in all their many permutations. How does one make sense of it, this work that anyway wasn't meant to be seen? For months now I'd been gathering up responses, different tacks that people had taken.

One in particular had stuck in my mind. It was from John MacGregor's biography, a work that was evidently the product of many years of devoted thought and labour. All the same, there were statements in it I found hard to take. He wanted to dispel the notion that Darger was a conscious artist, was in fact an artist at all, rather than someone mentally ill, making work as a symptom, a compulsion as meaningless as that odd hand gesture that looked like he was throwing snow.

'This endless stream of words and images,' MacGregor wrote:

> . . . was born from his mind with the same inevitability and force as the feces thrown off from day to day by his body. Darger wrote at the urgent prompting of internal necessity . . . At no point was his vision arrived at freely, as a spontaneous, or willed, manifestation of creative choice. His written and pictorial products are the direct and unavoidable expression of a strange, irresistibly powerful, and far from normal, mental state. The unique personal style which we have been examining in the context of his writing is unmistakably the product of psychiatric, perhaps even neurological, anomalies which were present throughout his life.

It was hard to square that statement with the things I'd seen: folder after folder attesting to creative decisions, to choices made and problems solved, though if I'd never read anything by David Wojnarowicz, I might have been more likely to accept it. But the Darger story looks different if you are familiar with Wojnarowicz, which is to say familiar with issues of violence and abuse, of poverty and the devastating effects of shame. Wojnarowicz was a courageous and eloquent advocate for his own work, but the things he said about himself, about his motivations and intentions, also have wider applications. At the very least, they ought to make one ask questions about agency and class and power in the work of vulnerable or socially excluded artists.

You can't think about people like Darger, or Solanas, for that matter, without thinking too about the damage society wreaks upon individuals: the role that structures like families and schools and governments play in any single person's experience of isolation. It's not only factually incorrect to assume mental illness can entirely explain Darger; it's also morally wrong, an act of cruelty as well as misreading. One of the saddest and most telling things in all his work is the declaration of child independence he wrote for the Realms. Among the rights he chose are: 'to play, to be happy, and to dream, the right to normal sleep of the night's season, the right to an education, that we may have an equality of opportunity for developing all that are in us of mind and heart'.

How many of those rights had he actually been granted in his own life? The one that really got me was *the right to an education*. It underscored the brutal, careless way that he'd been treated. You can destroy a person without resorting to the graphic

violence of the Realms; can crush hopes and squander dreams, waste talent, refuse to train and educate an able mind, but rather keep a person in a prison of work, without praise or prospects, and certainly unable to develop what is in them *of mind and heart*. Extraordinary, in this light, that Darger managed to create so much, to leave such luminous traces in his wake.

What MacGregor saw in Darger's work was a compulsive and sexualised desire to cause pain. He believed that his identification was with the men who choked and hung and slaughtered the defenceless, naked girls. Other critics have suggested that on the contrary he was compulsively replicating traumatic scenes of his own abuse. Perhaps both are true, since it is very rare that any single act occurs for just one motive. At the same time, what this leaves out is the possibility that Darger was actually carrying out a conscious and courageous investigation into violence: what it looks like; who its victims and perpetrators are. Bigger questions, too: like what it means to suffer, and whether anyone can truly understand the existence of another person's internal world.

For me, they were paintings made by someone who'd mustered the resolve to look again and again at all the multiple forms of damage committed in the world. This possibility was first given serious weight in 2001, when the touring exhibition *Disasters of War*, curated by Klaus Biesenbach, brought Darger's paintings together with work by the Chapman Brothers and Goya. The show contextualised him within art history, not as a maddened outsider, but as a diligent practitioner of a kind of imaginative reportage of violence, a subject that has always been within the purview of the artist.

While I was in the Darger archive, there were multiple child abuse cases in the news, images of massacres, of people murdering their neighbours: all the component elements of the Realms, the accesses of cruelty and brutality that never seem to end. In fact, there's a way in which his work is the opposite of imaginative, being composed entirely from things that actually existed: from newspaper reports or adverts; the desirable as well as loathsome elements of our own elaborate social world. Ours is the culture of sexualised little girls and armed men. Darger simply thought to put them together, to let them freely interact.

★

Even Darger's hoarding changes aspect when considered in terms of larger social forces. A few weeks after my stint in the archive, I went briefly to Chicago to see the replica of his room at Webster Street in INTUIT, the museum of outsider art. It was smaller than I'd expected, cordoned behind a scarlet rope. I thought the attendant would stay to supervise while I craned on tiptoes, but to my surprise they unhooked the clip and left me there alone.

It was very dark inside. Everything was covered in a fine black powder, maybe charcoal dust or grime. The walls were painted an oily brown and covered in Darger's pictures, including many hand-coloured portraits of the Vivian Girls. There were stacks of scrap books and magazines, boxes of cutting blades, brushes, buttons, pen knives and coloured pens. But what really caught my attention were two things: a table piled high with paints and crayons, many

of them designed for children, and a laundry basket filled with dirty balls of brown and silver string.

People who hoard are often socially withdrawn. Sometimes the hoarding causes isolation, and sometimes it is a palliative to loneliness, a way of comforting oneself. Not everyone is susceptible to the companionship of objects; to the desire to keep and sort them; to employ them as barricades or to play back and forth between expulsion and retention. On an autism website, I'd come across a discussion on the subject, in which someone had encapsulated the desire beautifully, writing: 'Yes, very much a problem for me and while I'm not sure if I personify objects I do tend to develop some weird sort of loyalty to them and it's difficult to dispose of them.'

Something of this sort was clearly going on with Darger, and yet the place of poverty must also be considered: both in terms of the need to be thrifty with resources and the physically confined space in which he lived. Despite the dirt, despite the staring portraits of the Vivian Girls, their pupils scratched out, it didn't feel like the room of a mad person. It felt like the room of someone poor, creative and resourceful, someone who must be wholly self-reliant, who knows they won't be getting anything from anyone else, but must instead gather it for themself from among the discards, the leavings of the city.

He worked his pencils down to stubs, fashioning lengthening devices out of syringes to eke the last inch out. He hoarded rubber bands in old chocolate boxes, mending them with tape rather than throwing them away. He made his paints by pouring tempura into lids, often keeping great heaps of them unused: a

symbol of wealth, perhaps; a gesture of ownership and plenty. They were neatly hand-labelled, sometimes conventionally – *Rose Madder, Oriental Turquoise Blue, Mauve, Cadmium Medium Red* – and sometimes with more personal or punning titles: *Storm Cloud Purple* or *Seven not heaven dark green colours*.

The issue of space was also significant. The same pathologising rhetoric that affects Darger is also active around the Chicago photographer and nanny Vivian Maier. Like him, she worked in isolation, never showing her photographs to anyone and often not even developing her film. In her seventies, she was forced to go into hospital and could no longer afford the upkeep on the locker where her possessions were stored. As is customary in such cases, the contents were auctioned off, falling into the hands of at least two collectors who understood the value of a street photography archive of this quality and scale. Gradually, her 15,000 photographs are being developed, exhibited and sold, commanding, like Darger's work, increasingly high prices, a queasy spectacle when the artists themselves were so poor. Two documentaries have been made, piecing her life together by interviewing the families for whom she worked.

All these people talk about her hoarding, the pack-rat way she went through life. Watching, I couldn't help but feel their reactions were at least partly about money and social status; about who has the right to ownership and what happens when people exceed the number of possessions that their circumstance and standing would ordinarily allow. I don't know about you but if I was asked to put everything I own in a small room in someone else's house, I might well look like a hoarder. Although neither

extreme poverty nor wealth makes one immune to craving an excess of possessions, it's worth asking of any behaviour presented as weird or freakish whether the boundary being transgressed is class, not sanity at all.

All the same, it would be foolish to suggest that Darger was not undamaged by his past, not the subject of some kind of breach with the external world. One of the strangest items I'd come across in the archive was a medium sized notebook which had been labelled *Predictions, June 1911 – December 1917*. It looked like an account book, with vertical pink columns filled with a tiny, cramped hand. As I deciphered the entries, I realised it represented an attempt to bargain with God, to make desired events take place in the real world by threatening violence against the Christian Angelinian forces in the Realms of the Unreal. These threats mostly concerned lost manuscripts and pictures, which if not returned would be avenged by dreadful losses in Darger's imaginary war. Sometimes, though, they involved more practical problems, which one might have thought entirely divorced from the world of the Realms.

> Grahams bank went to smash. Great sums of savings lost or threatening to be lost. Loss inescapable . . . Either Vivian girls or Christian nations shall suffer if money is not returned within January 1 1919. No mercy will be shown.

Or:

Christians will be saved now only if God permits me to gain the means of owning property so that I can adopt children without suffering them the dangers of unsupport. Only chance now left there will be no others under any condition – conditions so serious that progress on manu-script is delayed.

The threat-making began when Darger lost a newspaper photograph of a murdered child, Elsie Paroubek. In the wake of this apparently cataclysmic loss, Darger began his campaign against God. Some of his protests were carried out in the real world of Chicago – refusing, for example, to attend mass for four full years. The majority of his struggle, however, took place in the counter-world of the Realms. He sent avatars of himself, alter-egos like General Henry Joseph Darger, into the war on the side of the wicked Glandelinians. Worse, he tipped the scales of the conflict, making the Glandelinians win battle after battle, torturing and killing hundreds of thousands of child slaves, before cutting their bodies to pieces, so that the ground for miles around was covered in a hellish array of human organs: hearts, livers, stomachs and intestines.

Was God watching? How could he look away? But perhaps he didn't exist at all or was already dead – a nightmarish, blasphemous thought that Darger had one of the pious Vivian Girls put into words, sobbing over the desolating notion of arriving to an empty heaven, of inhabiting a universe devoid of other beings. If there was no God, then Darger really was completely alone. Commit atrocities, become a windmill of slaughter: anything to

get the attention of the divine eye, to prove that at least one being was aware of him, and felt his presence to be significant.

It's not easy to make sense of this material, not just because of its extreme violence, but also because of the blurring of the distinction between the real and unreal, the sense that the two have become conflated or fused. Was the war in the Realms a way of letting violent impulses spill over without harming any actual human beings? If so, this would suggest that it was safely fictional, a contained place. On the other hand, does the book of threats reveal a genuine belief that what happened in the Realms counted in the universe at large; that it could in fact alter the heart of God?

It seems to be the latter, judging from a document Darger made in 1930. On a piece of paper, he'd typed a kind of self-interview about why his desire to adopt a child had been unsuccessful, despite praying consistently for thirteen years. It was apparent from his questions that he hadn't done anything practical to achieve his aim. Instead, he was trying to force God's hand by his behaviour in the Realms. 'Is his threat about making the Christians lose the war if it is not answered anything to do with it?' he asked himself, though the only answer given is an enigmatic letter C.

This is obviously not what one could call sane behaviour. It suggests a breach in object relations, an inability to understand the proper workings of the world, to be able to differentiate reliably between the internal and the external, the boundaries between self and other, imaginary and actual. At the same time it seemed to me entirely understandable that someone so wholly impotent and isolated in their own life might begin to construct a compensatory universe, populated by powerful figures, in which all the

disordered and tumultuous feelings – the grief and longing, the terrible rage – could be permitted range and scope.

Was it possible that creating the Realms could be a healthy urge, a way of containing and controlling the disorderliness, the threatening psychic disarray? I couldn't stop thinking about the way Darger had ended his memoir, the history of his life, by talking for thousands of pages about the destruction caused by a tornado: a great gout of words that attested simply to monumental destruction, to things smashed to smithereens by wild forces, the pieces scattered far and wide.

The notion of a psyche that is broken into bits is central to the psychoanalyst Melanie Klein's theory of loneliness. Klein is often misunderstood or mocked by the too literal-minded, with her talk of good and bad breasts, but of all Freud's heirs, she is the most adept at conjuring the dark world of the psyche, its competing impulses and sometimes damaging defence mechanisms. In 1963, while Harlow was locking monkeys into isolation chambers, Klein published the paper 'On the Sense of Loneliness'. In it, she applied her theories of ego development to the condition of loneliness, particularly 'the sense of being alone regardless of external circumstances'.

Klein believed that loneliness was not just a desire for external sources of love, but also for an experience of wholeness, what she termed 'an unattainable perfect internal state'. It was unattainable in part because it was based on the lost loveliness of the infantile experience of gratification, of being understood without the need for words, and in part because the internal landscape of everyone will always be comprised to some degree of warring

objects, of unintegrated fantasies of destruction and despair.

In Klein's model of development the infantile ego is dominated by splitting mechanisms, dividing its impulses into good and bad and projecting them outward into the world, separating it too into good and bad objects. This splitting derives from a desire for security, preserving the good ego from destructive impulses. In ideal conditions, the infant moves towards integration (*towards* being the operative word: in Klein's seasoned vision full and permanent integration is never a possibility), but conditions are not always ideal for the painful process of reuniting the warring impulses of love and hatred. A weak or damaged ego cannot integrate, because it is too afraid of being overwhelmed by destructive feelings, which threaten to endanger or annihilate the prized and carefully preserved good object.

To get stuck in what Klein termed the paranoid-schizoid position (itself a normal stage of childhood development) is to experience the world in irreconcilable pieces, and to find oneself likewise in bits. In the most extreme manifestations of this state, such as one might see in schizophrenia, a grave co-mingling takes place, so that needful parts of the psyche are lost or scattered and unwanted or despised parts of the world forcefully injected into the self.

'It is generally supposed,' Klein writes:

> . . . that loneliness can derive from the conviction that there is no person or group to which one belongs. This not belonging can be seen to have a much deeper meaning. However much integration proceeds, it cannot do away with the feeling that certain components of the self are

not available because they are split off and cannot be regained. Some of these split-off parts . . . are projected into other people, contributing to the feeling that one is not in full possession of one's self, that one does not fully belong to oneself or, therefore, to anybody else. The lost parts too, are felt to be lonely.

Loneliness here is a longing not just for acceptance but also for integration. It arises out of an understanding, however deeply buried or defended against, that the self has been broken into fragments, some of which are missing, cast out into the world. But how do you put the broken pieces back together? Isn't that where art comes in (yes, says Klein), and in particular the art of collage, the repetitive task, day by day and year by year, of soldering torn or sundered images together?

I was thinking a lot at the time about glue, how it functions as a material. Glue is powerful. It holds fragile structures together and stops things getting lost. It allows the depiction of images that are illicit or hard to access, like the homemade pornography David Wojnarowicz used to make as a child from Archie cartoons, taking a razor and turning Jughead's nose into a penis; that sort of thing. Later, he used to wheatpaste discarded supermarket ads on walls and hoardings in the East Village, on to which he'd spray-painted stencils of his own design, making his visions adhere to the skin of the city, its outward shell. Later still, he worked intensely with collage, bringing together disparate images – fragments of maps, pictures of animals and flowers, scenes from pornographic magazines, scraps of text, the haloed head of Jean

Cocteau – to construct the complicated and densely symbolic paintings of his maturity.

But collage can also be dangerous work. In 1960s London, the playwright Joe Orton and his boyfriend Kenneth Halliwell started stealing library books and giving them weird new covers: a tattooed man on John Betjeman's poems; a leering monkey's face grimacing from a flower on the *Collins Guide to Roses*. For this crime of aesthetic transgression they were sent to prison for six months.

Like Wojnarowicz, they understood the rebellious power of glue, the way it lets you reconstruct the world. In their tiny bedsit in Islington, Halliwell painstakingly covered all the walls in a fantastically elaborate and sophisticated collage, cutting up Renaissance art books to create surreal friezes, face after regarding face rising above the bookcase, the desk and the gas fire. It was in this room that he beat Orton to death with a hammer on 9 August 1967, in a frenzy of loneliness and fear of abandonment, splattering the collaged wall with blood before killing himself by drinking grapefruit juice laced with sleeping pills.

Halliwell's act demonstrates just how potent and destructive the forces Klein identified can be, and what it means to be truly overwhelmed by them. But this is not what happened to Henry Darger. He didn't hurt another person, not in actuality. What he did instead was dedicate his life to making images in which the forces of good and evil could be brought together, into a single field, a single frame. It mattered to him, this act of integration, of devoted labour, of taken care. The reparative impulse, Klein called it: a process that she believed involved enjoyment, gratitude, generosity; perhaps even love.

6

AT THE BEGINNING OF THE END OF THE WORLD

SOMETIMES, ALL YOU NEED IS permission to feel. Sometimes, what causes the most pain is actually the attempt to resist feeling, or the shame that grows up like thorns around it. During my lowest period in New York, almost the only thing I found consoling was watching music videos on YouTube, curled on the sofa with my headphones on, listening again and again to the same voices finding the register for their distress. Antony and the Johnsons' miraculous, grieving 'Fistful of Love', Billie Holiday's 'Strange Fruit', Justin Vivian Bond's triumphant 'In the End', Arthur Russell singing 'Love Comes Back', with its lovely permissive refrain, *being sad is not a crime.*

It was during this period that I first came across Klaus Nomi, *mutant chantant*, who made an art of being an alien, like no one else on earth. He had one of the most extraordinary voices I'd ever heard, soaring through the registers, a counter-tenor assaulting electro-pop. *Do you know me*, he sings. *Do you know me now.* His appearance was as bewitching as his voice: small, with an elfin face, his delicate features accentuated by make-up, his skin

powdered white, his widow's peak sharply delineated into a boot-black fin, his lips painted in a black cupid's bow. He didn't look like a man or a woman but something else entirely, and in his music he seemed to give voice to absolute difference, to what it is like to be the only one of your kind.

I watched his videos repeatedly. There were five of them: 1980s New Wave fantasias with their crudely magical effects. A hyper-stylised cover of 'Lightning Strikes', in which he was dressed as a space-age Weimar puppet, all set for a cabaret on Mars. The same wonderful falsetto, the same strangely touching artificiality: the face now deadpan, now mystified, now sinister, now emphatic, a robot trying human emotions on for size. In 'Simple Man', he prowls the city as a private detective, then walks into a cocktail party in his alien getup, clinking glasses with glamorous women, singing all the while a refrain about never being lonely again.

Who was he? What was he? His real name, I discovered, was Klaus Sperber, and he was a German immigrant to New York City who became a star of the downtown scene and then briefly the world in the late 1970s and early 1980s. 'I might as well look as alien as possible,' he once said of his idiosyncratic appearance, 'because it reinforces a point I am making. My whole thing is that I approach everything as an absolute outsider. It's the only way I can break so many rules.'

Sperber was an outsider par excellence, a gay immigrant who didn't quite fit even in the world of fabulous misfits that was the East Village. He was born in January 1944 in Immenstadt, near the border with Lichtenstein, during the final throes of the Second World War. He learned to sing by listening to records of Maria

Callas and Elvis, but his beautiful voice was against him. He was a counter-tenor at a period when there was no place for male counter-tenors within the closed, conservative world of opera. For a while, he worked as an usher at the Deutsche Oper in West Berlin, and then in 1972 he moved to New York, settling on St Mark's Place, just as Warhol had before him.

In another YouTube video, a snippet from a French television interview, he lists all the menial jobs he did back then: dishwashing, delivery boy, delivering flowers, cooking, chopping vegetables. Eventually he became a pastry chef at the World Trade Center, work at which he was exceptionally skilled. At the same time he began performing his idiosyncratic fusion of opera and electro-pop in downtown clubs.

The film I liked best was of his very first appearance, at Irving Plaza on 15th Street in 1978, performing at a night called New Wave Vaudeville. He appears on stage in a see-through plastic cape, with wings painted around his eyes. A science-fiction figure, gender indeterminate, he opens his mouth and out comes 'Mon cœur s'ouvre à ta voix', my heart opens to your voice, from Saint-Saëns' *Samson et Dalila*. His voice is almost inhuman, climbing higher and higher. *La flèche est moins rapide à porter le trépas, que ne l'est ton amante à voler dans tes bras. The arrow is less rapid in bringing death, than is your lover to fly into your arms.*

'Holy shit', someone shouts. There is a barrage of stray claps and cheers from the audience, then total silence, total attention. He gazes unseeing, that theatrical entranced Kabuki stare (the gaze that can cure epidemics, the gaze, *nirami*, that makes the invisible visible), the sound pouring from him. *Verse-moi, verse-moi l'ivresse. Fill me,*

fill me with ecstasy. Then there is a series of bangs and the stage fills with smoke. 'I still get goose pimples when I think about it,' his friend and collaborator Joey Arias remembered. 'It was like he was from a different planet and his parents were calling him home. When the smoke cleared, he was gone.'

Nomi's career exploded from that moment. At first, his shows were put together by a group of friends, who collaborated on writing songs, making videos and creating costumes, developing together the Nomi universe, the New Wave alien aesthetic. On 15 September 1979 he appeared with Arias as backing singers for David Bowie on *Saturday Night Live*, both dressed in robes by Thierry Mugler. There was an elaborate live show, growing crowds, a tour of America.

Nomi wanted success, but he didn't find it quite as fulfilling as he'd expected. According to the testimony of Andrew Horn's affecting 2004 documentary, *The Nomi Song*, the alien act arose in part from a refined and hypermodern theatrical sensibility – that post-punk, Cold War infused infatuation with the apocalypse and outer space – and in part from a genuine sense of being freakishly other. As his friend, the painter Kenny Scharf, says in the film: 'Everyone was a freak, but he was a freak among the freaks. But at the same time, he was a human being as well and I think he longed to have a boyfriend, relationship, more like love.' His manager Ray Johnson put it even more strongly, observing that despite the sell-out shows, the crowds of fans, it was apparent 'you were witnessing one of the loneliest persons on the earth'.

In the 1980s Nomi's career shifted up a gear. He got a record deal, and made two albums, *Klaus Nomi* and *Simple Man*, recorded

with session musicians, his old friends sidelined. *Simple Man* went gold in France and in 1982 he toured Europe, culminating in December with his last recorded performance, at Eberhard Schoener's Classic Rock Night in Munich, with a full orchestra, in front of an audience of thousands.

Again, you can conjure it from the vaults. He walks with his stiff puppet's gait up the steps to the stage, dressed in a scarlet doublet and white ruff, his legs very thin in black stockings and black heeled shoes, his face dead white, even the palms of his hands unnaturally pale: an uncanny figure, stepping straight from the court of King James II. He looks around him like a sleep-walker, like someone beholding an apparition, his eyes staring from his head. And then he starts to sing, of all things, the aria of the Cold Genius from Purcell's *King Arthur*, the song of a winter spirit summoned unwillingly to life. Hands raised, his voice climbs stutteringly upward to the accompaniment of strings, a weird mixture of dissonance and harmony.

> What power art thou, who from below
> Hast made me rise unwillingly and slow
> From beds of everlasting snow?
> See'st thou not how stiff, how stiff and wondrous old,
> Far, far unfit to bear the bitter cold,
> I can scarcely move or draw my breath?
> Let me, let me freeze again to death.

I am not the first person to observe that there was a prophetic quality to these words, or a depth of feeling to the performance

that went far beyond Nomi's always sophisticated stagecraft. He sings the last line three times, and then, as the orchestra plays the final bars, he descends from the stage, a small, very upright figure, moving almost painfully in his gorgeous, anachronistic clothes.

It was evident that something was very wrong when he returned to New York at the beginning of 1983. In an interview with *Attitude* magazine Joey Arias describes his appearance. 'He was always thin. But I remember him walking into a party looking like a skeleton. He was complaining of flu and exhaustion, and the doctors couldn't diagnose what was wrong with him. Later he had breathing difficulties and collapsed, and he was taken into hospital.'

At the hospital, Nomi's immune system was found to be practically non-functioning, making him susceptible to a myriad of normally uncommon infections. His skin was covered in sore and unsightly purple lesions – the reason he'd worn the ruff in Munich. It was diagnosed as Kaposi's sarcoma, a rare and usually indolent skin cancer. Rare, that is, until 1981, when doctors in California and New York began seeing virulent cases among young gay men. Like Nomi, these men were suffering from an underlying immune disease so new that it had only been named the previous summer, on 27 July 1982: Acquired Immune Deficiency Syndrome, or AIDS, also known at the time as GRID, Gay-Related Immune Deficiency.

Gay cancer, most people were calling it, or else gay plague, though it was increasingly being observed in other populations too. There was no treatment, and the cause, the Human-Immunodeficiency Virus, wouldn't be identified until 1986. AIDS

wasn't fatal in itself, but left the person susceptible to opportunistic infections, many of them previously unusual or mild in humans. Candidiasis, cytomegalovirus, herpes simplex, mycobacterium, pneumocystis, salmonella, toxoplasmosis, cryptococcosis, bringing with them blindness, wasting, pneumonia, sickness.

Nomi was prescribed Interferon for the Kaposi's sarcoma, but it didn't help. He went on a macrobiotic diet and spent much of that spring at home in his apartment on St Mark's Place, watching his own old videos on repeat. *If they saw my face*, he sings in 'Nomi Song', *would they still know me now* – another line that shifts its meaning. In the summer he went back into Memorial Sloan Kettering Cancer Center. Arias again:

> He began to look like a monster: his eyes were just purple slits, he was covered in spots and his body was totally wasted. I had a dream that he'd recover his strength and go back on stage, but that he'd have to veil himself like the Phantom of the Opera. He laughed, he liked that idea, and he actually seemed to be getting better for a while. That was on a Friday night. I was going to go and see him again on the Saturday morning, but they called me and told me that Klaus had passed away in the night.

The story of Nomi's short life haunted me. To resist loneliness, to make a joyous art of difference, and then to die in such profoundly isolating circumstances seemed brutally unfair, though it would soon be a common experience in the world he had inhabited. What did it mean to have AIDS at that time, when

diagnosis was an almost certain death sentence? It meant being perceived as a monster, an object of terror even to medical personnel. It meant being trapped in a body that was regarded as repellent, toxic, unpredictable and dangerous. It meant being shunned by society, subject to pity, disgust and horrified fear.

In *The Nomi Song*, there is a distressing section in which Klaus's friends discuss the climate that surrounded his diagnosis. Man Parrish, his long-term collaborator: 'A lot of people took off. They didn't know how to deal with it. I didn't know how to deal with it. Is this something I could catch? Does he have typhoid or the plague? You heard rumours. You heard stuff in the underground. No one knew what was going on.' Page Wood, the art director of Nomi's stage shows: 'I remember seeing him at dinner and usually I'd go over and give Klaus a hug, and give him a European kiss on each cheek. And, I was just afraid to. I didn't know if this was contagious . . . I sort of went up to him and I hesitated, and he just put his hand on my chest and said "It's alright, don't worry about it," which made me start to tear up and I think that was the last time that I saw him.'

These responses were by no means uncommon. The intense fear generated by AIDS was in part an understandable reaction to a new and rapidly fatal disease. This is especially true of the very early years, in which both cause and mode of transmission were undetermined. Could it be spread by saliva? What about surfaces on the subway? Was it safe to hug a friend? Could you breathe the same air as a sick colleague? These are reasonable questions to ask, but fear of infection rapidly became entangled with more insidious concerns.

Between 1981 and 1996, when combination therapy became available, over 66,000 people died of AIDS in New York City alone, many of them gay men, in conditions of the most horrifying isolation. People were sacked from jobs and rejected by their families. Patients were left to die on gurneys in hospital corridors, assuming they'd managed to get admitted in the first place. Nurses refused to treat them, funeral parlours to bury their bodies, while politicians and religious leaders persistently blocked funding and education.

What was happening was a consequence of stigmatisation, the brutal process by which society works to dehumanise and exclude people who are perceived not to fit, who exhibit unwanted behaviours, attributes and traits. As Erving Goffman explains in his landmark 1963 study, *Stigma: Notes on the Management of Spoiled Identity*, the word *stigma* derives from the Greek and was originally coined to describe a system of 'bodily signs designed to expose something unusual and bad about the moral status of the signifier'. These marks, which were burnt or cut into the flesh, at once advertised and confirmed the bearer's status as an outcast, with whom contact must be avoided for fear of infection or pollution.

Over time, usage expanded to refer to any signifier of unwanted difference – unwanted, that is, by society at large. A source of stigma might be visible or invisible, but once identified it acts to discredit and devalue the person in others' eyes, revealing them not only as different but as actively inferior, 'reduced . . . from a whole and usual person to a tainted, discounted one'. You can see this process at work in the way that Henry Darger's eccentric behaviours led to his institutionalisation, or in the treatment

received by Valerie Solanas after she was released from prison; even in the way that Warhol was excluded from galleries for seeming too camp, too gay.

AIDS, especially in the early years, primarily affected three groups: gay men, Haitians and intravenous drug users. As such, it served to inflame existing stigma, amplifying already entrenched homophobia, racism and contempt for addicts. As these previously discountable populations became simultaneously hyper-visible, outed by the ravages of AIDS-related infections, and apparently lethal, the carriers of a potentially fatal disease, they were confirmed as people to be protected from, rather than people who required care and treatment.

Then there was the matter of sickness itself. Stigma frequently attaches to disorders of the physical body, especially if they affect or draw attention to regions that are already considered shameful, or that are required to be in pristine condition. As Susan Sontag observes in her 1989 book *AIDS and Its Metaphors*, stigma tends to accompany conditions that alter physical appearance, particularly the face, the signifier of identity – one of the reasons that leprosy, though notably hard to transmit, has been regarded almost universally with such unconcealed horror, and that the lesions spreading over Nomi's face had been so devastating.

Stigma is also at work around sexually transmitted diseases, particularly those that spread via what a society has designated as deviant or shameful sexual practices. In America of the 1980s, this chiefly meant sex between men, especially if it involved promiscuity or anal sex, a practice that Reagan's Health Secretary throughout the AIDS years, Margaret Heckler, was shocked to discover existed, and which the White House press secretary found

hysterically amusing to contemplate whenever a journalist did succeed in raising the subject.

With this dismal material in mind, it's not hard to see why people with AIDS were the target of so much fear and hatred, such irradiating dislike. Objects of stigma are always understood to be somehow polluting or contaminating, and these fears fuelled AIDS panic, with its fantasies around quarantine and exclusion, its anxieties about contact and spread.

Then there's the issue of blame. In the grip of this peculiarly malign kind of magical thinking, there is a tendency to believe that the stigmatised condition isn't random, a matter of chance, but is instead somehow deserved or earned, a consequence of moral failing in the bearer. This is particularly marked when it results from volitional behaviour, from what is construed as individual choice, be it taking drugs, engaging in illicit activities or having non-sanctioned sex.

With AIDS, this manifested as a widespread tendency to see the disease as a moral judgement, a punishment for deviancy (something that is especially visible in the rhetoric around its so-called innocent or blameless victims, the haemophiliacs, and later the babies born of HIV-positive women). 'There is one, only one, cause of the AIDS crisis,' Reagan's former director of communications Pat Buchanan announced in his syndicated column in 1987: 'the wilful refusal of homosexuals to cease indulging in the immoral, unnatural, unsanitary, unhealthy, and suicidal practice of anal intercourse, which is the primary means by which the AIDS virus is being spread through the "gay" community, and, thence, into the needles of IV drug abusers.'

Considering that stigmatisation is a process designed to deny contact, to separate and shun; considering that it always serves to dehumanise and deindividualise, reducing a person from a human being to the bearer of an unwanted attribute or trait, it is not surprising that one of its main consequences is loneliness, which is further accelerated by shame, the two things amplifying and driving one another. Appalling enough to be critically ill, to be exhausted, in pain and with limited mobility, without also becoming literally untouchable, a monstrous body that should be quarantined, islanded away from what is inevitably designated the normal population.

Added to this is the fact that AIDS stigmatised and made potentially lethal habits of sexual practice that had themselves been the source of intimacy and contact, antidotes to shame and isolation: the world that Wojnarowicz had documented so lovingly in *Close to the Knives*. Now the piers, which Nomi had also frequented, were increasingly being regarded as a site of danger, a place of contact in the sense not of touch but of infection and transmission. As the critic Bruce Benderson puts it in the essay 'Towards the New Degeneracy', in his collection *Sex and Isolation*:

> Then came the sledgehammer. AIDS simultaneously ruined my momentary escape from a decent curtailed identity and smashed the idea I had of promiscuity as an effortless expander of social consciousness. In the early eighties, before it was known exactly how AIDS spread – before safer sex – I was catapulted into a panicked loss of a principal means of self-expression and contact with

other humans. Now fucking casually meant more than a flouting of middle-class standards and a mockery of middle class hygiene. It meant illness and death – deterioration . . . Being part of the AIDS risk group made me feel unclean, expendable and marginalized.

Bearing in mind that both loneliness and rejection are stressful experiences, which have ravaging effects on the body, it's shocking but not exactly surprising to discover that being subject to stigma has a powerful physical effect. In fact, psychologists at UCLA working on the relationship between stigma and AIDS discovered that HIV-positive people who suffer social rejection also experience accelerated HIV progression, both proceeding to full-blown AIDS faster and dying more quickly from AIDS-related infections that those who are not exposed to or who are protected from social rejection.

The mechanism here is broadly the same as in loneliness itself – a decline in immune function due to ongoing exposure to the stress of being isolated or rejected by the group. To make matters worse, the act of being closeted, of needing to conceal a stigmatized identity, is also stressful and isolating, and is likewise associated with a lower T cell count and consequently a greater susceptibility to AIDS-related infections. In short, being stigmatised is not just lonely, or humiliating, or shameful; it also kills.

Klaus Nomi died on 6 August 1983, a few weeks shy of his fortieth birthday. Six weeks earlier, on 20 June, *New York Magazine* had run its first AIDS cover story, 'AIDS Anxiety' by Michael Daly. It described the climate of the time, the kind of reactions

occurring across the city. A woman whose husband had been diagnosed, and whose child was being shunned at school. People who were asking if they should wear plastic gloves on the subway, or avoid public swimming pools. Among these anecdotes is a description of a police officer who 'found herself frightened as she assisted a homosexual who had injured his head in a fall'.

> She remembers, 'At first, you feel itchy. The blood was the same color red, but I thought, "Oh, wow, I wonder if this guy's got it." Then I thought, "Oh well, I can't let this guy bleed to death." It was like a leper or something. You don't treat people like that, but the fear is there. I found myself scrubbing with peroxide.'

This was not, to reiterate, a person with AIDS, but rather a person from a population that had become doubly suspect; a member, as Sontag put it, of 'a community of pariahs'. In the same article another woman described the death of the male model Joe MacDonald: how he'd wasted away, how all the gay men she knew were thinking of going straight, how her model friends planned to avoid contact with brushes belonging to make-up artists they knew to be gay.

Fear is contagious, converting latent prejudice into something more dangerous. That same week, Andy Warhol recorded in his diary that at a photo shoot, 'I used my own make up after reading the AIDS piece in *New York*.' He'd known Joe personally, though their acquaintance hadn't helped to dispel the gathering frost, the outcast status. Back in February 1982, Andy had avoided Joe at a party, telling the Diary: 'I didn't want to be near him and talk

to him because he just had gay cancer' – the past tense a painful reminder of the brief period in which no one even knew that the infection was permanent, the disease incurable.

Warhol's diaries of the 1980s are full of scenes like this, manifestations of the poisonous currents of paranoia that were circling the city. Always a mirror of society's concerns, his entries reflect back the ways in which homophobia and hypochondria had begun to intertwine.

11 May, 1982:

The New York Times had a big article about gay cancer, and how they don't know what to do with it. That it's epidemic proportions and they say that these kids who have sex all the time have it in their semen and they've already had every kind of disease there is – hepatitis one, two, and three, and mononucleosis, and I'm worried that I could get it by drinking out of the same water glass or just being around these kids who go to the Baths.

24 June, 1984:

We went and watched the Gay Day parade . . . And there were guys in wheelchairs being pushed by their lovers. I'm serious! It looked like Halloween but without the costumes.

4 November 1985:

You know, I wouldn't be surprised if they started putting gays in concentration camps. All the fags will have to get married so they won't have to go away to camps. It'll be like for a green card.

2 February, 1987:

Then they picked me up for the black-tie dinner at the Saint . . . And we were all afraid to eat anything because the Saint has the gay taint from when it used to be a gay disco. It was so dark there and they were serving the food on *black plates*.

Lest it be forgotten, Warhol was himself a gay man, and in addition a major supporter of AIDS charities. But his personal reactions demonstrate the ways in which stigma spreads and gathers momentum, affecting even fellow members of a stigmatised population.

Warhol was particularly susceptible to this process because of his lifelong terror of sickness and disease, his obsession with contaminating bodies and the dangers they present. In the grips of this peculiarly paralysing hypochondria, he acted in ways that seem actively cruel, refusing to see or even contact acquaintances, friends and former lovers who had or might have AIDS. When he was told on the phone about the death of Mario Amaya, the critic who was with him when he was shot and who insisted that the doctors at the hospital restart his heart, he tried to make light of the news. And when his own former boyfriend Jon Gould died of AIDS-related pneumonia in September 1986, he absolutely refused to discuss the subject in the Diary, announcing only that he would not comment on 'the other news from L.A.'

In some ways his reaction is unique, a product of a fear of death so intense that he didn't attend his own mother's funeral or tell even his closest friends that she had died, saying instead

whenever he was asked about her that she was shopping in Bloomingdale's. But it also encapsulates the way that stigma functions to isolate and separate, especially when death comes out of the dark and begins to serve its black plates.

<div align="center">★</div>

Klaus Nomi was the first famous person to die of AIDS, but within a handful of years the disease was running like wildfire through the community he came from: the close-knit world of downtown New York, composed of artists, composers, writers, performers, musicians. As the writer and activist Sarah Schulman puts it in *Gentrification of the Mind*, her trenchant history of AIDS and its consequences, the disease, at least in the early years, disproportionately affected 'risk-taking individuals living in oppositional subcultures, creating new ideas about sexuality, art and social justice'. Many were queer or otherwise antagonistic to the family values promoted by conservative politicians, and though their work varies wildly, much of it, even before the AIDS crisis, existed in resistance to the isolation that comes from being marginalised or legislated against, made to feel not just different but unwanted and irrelevant.

One of these people was the photographer Peter Hujar, who was diagnosed with full-blown AIDS on 3 January 1987. Hujar was an old acquaintance of Warhol's, and had appeared in several of his Screen Tests, as well as his film *Thirteen Most Beautiful Boys*. He was an exceptionally talented photographer in his own right. Working always in black and white, and moving fluidly between

landscapes, portraits, nudes, animals and ruins, his images possess a graveness, a formal perfection that is very rarely attained.

As such, he was much in demand for fashion and studio work. He was friends with the *Vogue* editor Diana Vreeland, and his subjects included William Burroughs and Susan Sontag, the famous portrait of her lying on a couch in a ribbed sweater, her hands behind her head. He was also responsible for the picture of the Warhol Superstar Candy Darling on her deathbed, surrounded by white roses, later the cover of Antony and the Johnsons' second album, *I Am a Bird Now*.

Hujar's own work patrols something of the same milieu as that of another friend, Diane Arbus. Both were drawn to drag queens and street people, to those whose bodies and experiences were outside the norm. But while Arbus's work is sometimes alienating and estranging, Hujar looked at his subjects with the eye of an equal, a fellow citizen. His gaze is just as steady, but it has a deeper capacity for contact – the tenderness of an insider, rather than the chilliness of a voyeur.

Despite his talent, Hujar was perpetually indigent, living on the very edge of destitution in his loft on Second Avenue, above what is now the Village East cinema, where I sometimes went to while away Saturday afternoons. And despite his capacity for intimacy, his exceptional gifts at both listening and speaking, let alone his promiscuous genius for sex, he was also profoundly isolated, separate from the people around him. He'd flared up at almost every magazine editor and gallerist in the city and fought with most if not all of his wide and varied circle of friends, exploding into paroxysms of terrifying anger. According to

Stephen Koch, a close friend and later Hujar's executor, 'Peter was probably the loneliest person I've ever met. He lived in isolation, but it was a highly populated isolation. There was a circle drawn around him that no one crossed.'

If anyone did manage to make it inside that circle, it was David Wojnarowicz. Hujar was one of the most important people in David's world: first as a lover, and then as best friend, surrogate father, surrogate brother, soulmate, mentor and muse. They'd met in a bar on Second Avenue back in the winter of 1980, or perhaps early in 1981. The sexual aspect of their relationship hadn't lasted long, but the intensity of their connection never slackened, though Hujar was almost twenty years older. Like David, he'd had an abusive childhood in New Jersey, and like David he carried around a reservoir of bitterness and rage.

Somehow, they got through each other's defences (Stephen Koch again: 'David became part of the circle. He was in it'). It was because of Hujar's interest and belief that David started to take himself seriously as an artist. Hujar persuaded him to take up painting, insisting too that he stop dabbling with heroin. His protection and love helped David step aside at least a little from the burdens of his childhood.

Though they took multiple portraits of each other, the only image I've ever seen of them together is by Nan Goldin, their mutual friend. They're in the corner of a dark room, standing side by side, their shirts flaring white in the flash. David is smiling, his eyes closed behind big glasses, like a happy, gawky kid. Peter is smiling too, his head tilted conspiratorially. They look at ease, these two men who often weren't.

In September 1987, Hujar went as he often did to a restaurant on 12th Street, right next to his apartment. While he was eating, the owner came over and asked if he was ready to pay. Sure, Peter said, but why? Bruno held out a paper bag, saying: 'You know why . . . just put your money in here.' A minute later he brought the change back in another paper bag, which he tossed on Peter's table.

This story comes from *Close to the Knives*, which in addition to documenting the magical pre-AIDS world of the piers records the gathering horror of the epidemic as it began to annihilate David's world. When he heard what had happened to Hujar, his first impulse was to go to the restaurant and pour ten gallons of cow blood over the grill. Instead, he went in at lunchtime, when the place was packed, and screamed at Bruno, demanding an explanation, until 'every knife and fork in the place stopped moving. But even that wasn't enough to erase this rage.'

It wasn't just one intolerant restaurant owner that was making him feel almost insane with fury. It was the way the sick were being dehumanised in the eyes of others, reduced to infectious bodies against which people sought to protect themselves. It was the politicians getting up bills to quarantine the HIV positive in camps, and the newspaper columnists suggesting people be tattooed with their infection status. It was the massive surge in homophobic attacks, 'the rabid strangers parading against AIDS clinics in nightly news suburbs'. It was the governor of Texas saying, 'If you want to stop AIDS shoot the queers,' and the mayor of New York running to a sink to wash his hands after distributing cookies to children who had AIDS. It was your best friend dying

in front of your eyes, without a cure in sight, taking typhoid shots made from human shit prescribed by a quack on Long Island to try and shock his failing immune system into life.

Peter was terrified by the prospect of dying, and his terror made him furious, livid at everyone and everything. After his diagnosis, David saw him almost every day, visiting him at the loft or in hospital rooms high above the city. He went with him on quixotic, exhausting errands to find faith healers and doctors who promised miracle cures. He was there when Peter was ill, and he was there at the Cabrini Medical Center when Peter died on 26 November 1987, at the age of fifty-three, only nine months after he'd received his diagnosis.

After everyone left the room David closed the door, picked up his Super 8 camera and filmed Peter's emaciated body, lying in a spotted gown on the hospital bed. After he finished sweeping up and down, he got his camera and took twenty-three photographs of Peter's body, his feet and face, 'that beautiful hand with the hint of gauze at the wrist that held the i.v. needle, the color of his hand like marble'.

Peter was here. Peter is gone. How to configure the transition or translation, the monumental change? In the suddenly empty room he tried to speak to whatever spirit was hovering, perhaps afraid, but found himself unable to find the right words or make the needful gesture, saying at last helplessly, 'I want some kind of grace.'

In the reeling weeks that followed, he drove out to the Bronx Zoo to film the Beluga whales in their tanks. The first time he went, the glass case had been emptied for cleaning. Too much,

this sign of absence. He got in his car immediately and drove away, coming back later to capture the image that he wanted: the whales rolling and drifting in circles, the light falling through the water in grains and sheaves.

Later, he made a film for Hujar that was never finished, inter-cutting the whales with the footage of Peter's dead body on the hospital bed. I'd watched it on a monitor in Fales Library, tears streaming down my face. The camera moved tenderly, grievingly over Peter's open eyes and mouth, his bony, elegant hands and feet, a hospital bracelet looped around his skinny wrist. Then white birds by a bridge, a moon behind clouds, a shoal of some-thing white moving very fast in the dark. The fragment ended with a re-enactment of a dream: a shirtless man being passed through a chain of shirtless men, his supine body slipping gently from hand to tender hand. Peter held by his community, conducted between realms. David cut it with footage of baggage on a carousel: movement again, but this time beyond the domain of the human.

Peter's was one death in a matrix of thousands of deaths; one loss among thousands of losses. It makes no sense to consider it in isolation. It wasn't just individuals; it was a whole community that was under attack, subject to an apocalypse that no one outside even seemed to notice, except to demonise the dying. Klaus Nomi, yes, but also the musician and composer Arthur Russell, the artist Keith Haring, the actress and writer Cookie Mueller, the performance artist Ethyl Eichelberger, the artist and writer Joe Brainard, the filmmaker Jack Smith, the photographer Robert Mapplethorpe, the artist Félix González-Torres: these and thou-sands of others, all gone before their time. 'The beginning of the

end of the world', Sarah Schulman called it in the opening sentence of her 1990 novel about AIDS, *People in Trouble*. No wonder David described being filled with rage like a blood-filled egg, or fantasised about growing to superhuman size and wreaking vengeance on the people who considered his life and the lives of those he loved expendable.

A few weeks after Peter's death, David's partner, Tom Rauffenbart, found out that he too had AIDS and in the spring of 1988 David was also diagnosed. His immediate reaction was of intense loneliness. Love, he wrote that day: love wasn't enough to connect you, to 'merge one's body with a society, tribe, lover, security. You're on your own in the most confrontational manner.' He'd moved by then into Hujar's loft on Second Avenue, was sleeping in Hujar's bed.

During the AIDS years he kept painting a repeating image of creatures attached to one another by pipes or cords or roots, a foetus to a soldier, a heart to a clock. His friends were sick, his friends were dying; he was in deep grief, thrust face to face with his own mortality. Again and again with his brush, painting the cords that tethered creatures together. Connection, attachment, love: those increasingly imperilled possibilities. Later, he'd express this urge in words, writing: 'If I could attach our blood vessels so we could become each other I would. If I could attach our blood vessels in order to anchor you to the earth to this present time I would. If I could open up your body and slip inside your skin and look out your eyes and forever have my lips fused with yours I would.'

Though David's first reaction was loneliness, how he chose to deal with that feeling was to join forces, to make alliances and

to fight for change; to resist the silencing and isolation he'd suffered from lifelong; and to do it not alone but in the company of others. In the plague years, he became deeply involved in non-violent resistance, part of a community that was combining art and activism into an astonishingly creative and potent force. There wasn't much to find inspiring about the AIDS crisis, except the way that it was combated not by people contracting into couples or family groupings, but by communal direct action.

Fight back: the idea was beginning to gain currency in the city that year. *Act up! Fight back! Fight AIDS!* was one of the rallying cries of the direct action group ACT UP, the AIDS Coalition to Unleash Power, which had been established in New York in the spring of 1987, a few weeks, as it happened, after Hujar's diagnosis. Or *I'll never be silent again*, which I remember shouting on London Bridge during Gay Prides of my own childhood, perhaps two or three years later.

David started attending ACT UP meetings in 1988, shortly after his diagnosis. At its height, the group had thousands of members, and spawned chapters across the globe. One of its greatest strengths was its diversity. You don't have to spend long reading the interviews in the ACT UP Oral History Project to realise how complex it was, in terms of both membership and agenda. It was emphatically heterogeneous, mixing gender, race, class and sexuality, and organised not hierarchically but by consensus. Many of the members were artists, among them Keith Haring, Todd Haynes, Zoe Leonard and Gregg Bordowitz.

During the late 1980s and early 1990s, this group of people at the very margins of society succeeded in forcing their country

to change its treatment of them: a reminder of how powerful collective action is as a force for resisting the processes of isolation and stigmatisation. Among its many successes, ACT UP persuaded the Food and Drug Administration, the F.D.A., to change the approval process for new drugs and to alter the protocols of clinical trials so that they became accessible to addicts and women (who couldn't otherwise legitimately access experimental drugs, vital in an era in which the only approved treatment was AZT, a drug so toxic many people couldn't tolerate it). It used sit-ins to force pharmaceutical companies to lower the price of AZT, initially the most expensive drug ever launched; organised a die-in of thousands during mass at St Patrick's Church to draw attention to the Catholic Church's stand against safe sex education in New York public schools; and lobbied the Center for Disease Control to change their definition of AIDS so that women as well as men were eligible for Social Security benefits.

David attended many of these protests, including the October 1988 demonstration at the F.D.A., where he and fellow affinity group members staged a die-in, clutching the styrofoam tombstones that would swiftly become a staple at AIDS actions. In *United in Anger*, a documentary about ACT UP made by two surviving members, Sarah Schulman and the filmmaker Jim Hubbard, he can periodically be seen standing amongst a crowd, identifiable by his height and by the jacket that he wore, on the back of which was printed a pink triangle and the words *IF I DIE OF AIDS – FORGET BURIAL – JUST DROP MY BODY ON THE STEPS OF THE F.D.A.*

Making even the clothes on your back communicate: during

those years, David fused language and image, using every means at his disposal – photography, writing, painting and performance – as a way of bearing witness to his times. In April 1989, he was featured in *Silence = Death*, a documentary about activism in New York in the early years of the epidemic made by the German filmmaker Rosa von Praunheim. He appears repeatedly: a tall, rangy man in glasses, wearing a white t-shirt hand-painted with the words *FUCK ME SAFE*. He stands in his apartment, talking in a deep agitated voice about how it feels to live with homophobia and hypocritical politicians, to watch your friends die and to know that your own body contains the virus that will kill you.

What's striking about this film is not just the intensity of his anger, but the depth of his analysis. In an era in which people with AIDS tended to be portrayed as helpless and isolated, dying wasted and alone, he refuses the identity of victim. Instead, he sets about explaining, in rapid, lucid sentences, how the virus reveals another kind of sickness, at work inside the system of America itself.

David's work had always been political. Even before AIDS, he'd dealt with sexuality and difference: with what it's like to live in a world that despises you, to be subject every single day of your life to hatred and contempt, enacted not just by individuals but by the supposedly protective structures of society itself. AIDS confirmed his suspicions. As he put it in both the film and *Close to the Knives*: 'My rage is really about the fact that when I was told that I'd contracted this virus it didn't take me long to realise that I'd contracted a diseased society as well.'

One of the strongest of his explicitly political art works is 'One

Day This Kid', which he made in 1990. It shows David at the age of eight, a reproduction of the only childhood photograph he had. He's grinning, a little all-American boy in a check shirt, jug-eared, his teeth enormous. Running either side of his head are two columns of text. 'One day politicians will enact legislation against this kid,' it begins:

> One day families will give false information to their children and each child will pass that information down generationally to their families and that information will be designed to make existence intolerable for this kid . . . This kid will be faced with electro-shock, drugs, and conditioning therapies in laboratories . . . He will be subject to loss of home, civil rights, jobs, and all conceivable freedoms. All this will begin to happen in one or two years when he discovers he desires to place his naked body on the naked body of another boy.

It was his story, but it was also the story of his community, of a whole strata of America, of the world itself. The piece's power derives from the way it scrapes away at the accretions of stigma, the poisonous mess civilisation has made out of sex. It returns to basics, to the first small flowering of adolescent desire, to what I am tempted to spell as innocence or purity, had those words not been so thoroughly co-opted by conservatives. All that isolation, all that violence and fear and pain: it was the consequence of wishing to make contact by way of the body. The body, the naked body, burdened and miraculous, all too soon food for flies. Raised

Catholic, David placed what faith he had in redemption here. As
he said elsewhere, smell the flowers while you can.

★

Innocence, what a joke. In 1989, David got caught up in one of
the most gruelling and public battles of the culture wars, when
some of his collages, which contained miniature photographs of
sexual activity, were used by the American Family Association, a
right-wing, fundamental Christian lobbying group, in an attempt
to discredit the funding decisions of the National Endowment
of the Arts. In the end, he took the A.F.A. to court for using his
images out of context, winning a landmark case about how an
artist's work can be reproduced and used.

In his testimony from the trial, which I'd read at Fales, he
talked with an intense eloquence about his paintings, explaining
the context and meaning of all their intricate parts. In addition,
he addressed the use of explicit imagery in his work, telling the
judge:

> I use images of sexuality . . . to deal with what I have
> experienced, and the fact that I think sexuality and the
> human body should not be a taboo subject this late in
> the 20th century. I also use images of sexuality to portray
> the diversity of people, and their sexual orientations, and
> one of the biggest reasons I feel uncomfortable about the
> idea of the human body being a taboo subject is that,
> had the human body not been a taboo subject in this

decade, I might have gotten the information from the Health Department, from elected representatives, that would have spared me having contracted this virus.

After the trial, after that gruelling and stressful brush with censorship, he made a book about sex. *Memories That Smell Like Gasoline* combines fragments of memoir with watercolour drawings and sketches of people in porn cinemas. He wanted to celebrate the old wildness before it vanished altogether, though he was also adamant about the need for safer sex.

In fact, sometimes the recklessness of people in the cinemas appalled him. In one essay he talked about going in immediately after visiting a friend in hospital, and being shocked by the riskiness of the behaviour on display. He fantasised then about filming his friend's face, covered in lesions, his newly blind eyes, dragging in a projector and hooking it up with copper cables to a car battery and projecting the film on to the dark wall above everybody's heads. 'I didn't want to ruin their evening,' he wrote, 'just wanted maybe to keep their worlds from narrowing down too far.' Denial was always David's target, whether that meant right-wing preachers who couldn't abide talk of sex or hedonists who didn't want to admit to the possibility of death.

Memories was packed tight with his own sexual experiences, among them the story of how he'd been violently raped as a boy. The memory of this terrifying afternoon had come back to him when he'd happened to pass the guy in a cinema. It was decades later, but he was still instantly recognisable, his skin somehow greyish, like something manufactured, something dead. The incident

had happened when he was hitching back from swimming in a lake in New Jersey, his clothes still drenched. The man had tied him up and raped him in the back of a red pick-up truck, shoving a wad of mud and sand in his mouth and battering him repeatedly. He thought he was going to die: saw in a flash his own body drenched in lighter fuel and seared like a side of beef, to be found by hikers tossed in a ditch. Seeing the man again, he was so overcome that he felt like he was being bled, like he'd been shrunk back to the size of a boy, like he'd lost the faculty of speech.

And yet, despite holding dozens of these experiences inside himself, he could still celebrate the act of sex, the act of opening consensually to another body, another psyche. He was nauseous a lot the year that he worked on *Memories*, sitting at his cluttered kitchen table, chain-smoking, thinking over all those anonymous acts. But sex wasn't responsible for his sickness. It was the route of transmission, yes, but as he kept on saying, the virus didn't have a moral code, unlike the decision makers who wilfully blocked education and funding, who kept allowing the disease to spread.

As he got sicker, as he felt increasingly more weary and more ill, he began to cut himself off from people, to hole up in Hujar's loft, as he still called it, hiding away from the world. He'd started writing in his diary again, logging dreams about machinery gone wrong, about abandoned animals that needed to be rescued and cared for. Two baby birds left on a sidewalk in Times Square. A tarantula that someone was dropping from a great height, not realising they die if they're subjected to a fall. He dreamt of kissing a guy with Kaposi's, and of finding an apartment full of natural history books, their pages richly embellished with pictures of snakes

and turtles. He wished he'd known the man who lived there, who shared his interests but also had money and a family. 'He's loved,' he wrote in his journal the next day, and underlined the words.

The overwhelming sensation in that period was loneliness: the same loneliness he'd felt at the moment of his diagnosis, the same loneliness he'd felt as a kid, abandoned into one perilous situation or another. No one could touch the burdens he was lugging around; no one could help him with his feelings of need or paralysing fear. 'David has a problem,' he wrote bitterly in his journal, 'he feels pain being alone but can't stand most people. How the fuck do you solve that?'

In his final piece of published writing, the essay that ends *Memories*, he wrote about how he was feeling increasingly invisible, how he was starting to hate people for being unable to see where he was, beyond the blunt fact of his body, which still looked healthy enough from the outside. He'd gone, he thought; he'd ceased to exist. There was a vaguely familiar shell, but inside there was nothing: a stranger people kept thinking they recognised or knew.

He'd always hated the way AIDS activism insisted on positivity, on refusing to admit the possibility of death. Now he poured it all out: the absolute isolation of being terminally ill. He was thirty-six that year. He was a deeply gregarious man, an inveterate collaborator whose letters, diaries, packed phone logs and answering machine tapes attest to how deeply loved he was, how committed to friendship, how embedded in his community. And yet:

I am glass, clear empty glass . . . No gesture can touch me. I've been dropped into all this from another world

and I can't speak your language any longer . . . I feel like
a window, maybe a broken window. I am a glass human.
I am a glass human disappearing in the rain. I am standing
among all of you waving my invisible arms and hands. I
am shouting my invisible words . . . I am disappearing. I
am disappearing but not fast enough.

Invisibility and speechlessness, ice and glass: the classic imagery
of loneliness, of being cut off. Later, these extraordinary words
appeared again on the final spread of 7 *Miles a Second*, a graphic
novel about David's life made in collaboration with his friends,
the artists James Romberger and Marguerite Van Cook.

The image on the facing page shows Hujar's loft from the street
outside, a Hopperesque perspective. It's evening. The sky, in Van
Cook's exquisitely lurid watercolours, is turning navy, the side of
the building going up in flames of rose and gold. A mailbox, sheets
of newspaper blowing down the street. The windows of the loft
are glowing, but there's no one visible behind the glass. *NYC
1993*, it says at the bottom of the page, which is to say at least
six months after David died up there, on 22 July 1992, in the
company of his lover, his family and friends, one of the 194,476
people killed by AIDS-related infections in America that year.

<div align="center">★</div>

I'd been haunting the Wojnarowicz archive at NYU ever since I first
saw the Rimbaud photograph. Some weeks I went in every day to
look through his diaries or listen to his audio journals. Everything

David made was touching, but those tapes articulated feelings of such rawness that it was devastating to hear them. And yet, as with Nomi's singing, I found the act of listening somehow alleviated my own sense of loneliness, simply because I could hear someone voicing their pain, giving space to their difficult and humiliating feelings.

Many were recorded on waking, or in the middle stretches of the night. Often you can hear car horns and sirens, people talking on the street outside. Then David's deep voice, struggling upward out of sleep. He talks about his work and his sexuality and some-times he walks to the window, opens the curtains, and reports on what he sees there. A man in the apartment opposite, combing his hair beneath a bare bulb. A dark-haired stranger standing outside the Chinese laundry, who meets his eyes and doesn't look away. He talks about what dying will feel like, about whether it will be frightening or painful. He says he hopes it will be like slipping into warm water and then on the crackling tape he starts to sing: low plaintive notes, rising and falling over the surf of morning traffic.

One night, he wakes after a bad dream and switches on the machine to talk it out. He's dreamt about a horse being caught in some train tracks, its spine broken, unable to escape. 'It was very much alive,' he says, 'and it was just so fucking upsetting to see this thing.' He describes how he tried to free it, and how instead it was dragged into a wall and skinned alive. 'I haven't the faintest idea what it means for me. And I feel horror and a very deep sadness about something. Whatever the tone of the dream carries it was just so sad and so shocking.' He says goodbye then, and shuts off the machine.

Something alive, something alive and lovely caught and damaged in the mechanisms, the gears and rails of society. When I thought about AIDS, when I thought about the people who have died, and the conditions they experienced; when I thought about those who have survived and who carry inside themselves a decade of mourning, a decade of missing people, I thought of David's dream. When I cried while listening to the tapes, which I did periodically, surreptitiously wiping my eyes on my sleeve, it wasn't just out of sadness, or pity. It was out of rage that this courageous, sexy, radical, difficult, immensely talented man died at the age of thirty-seven, that I lived in a world in which this kind of mass death had been permitted, in which nobody in a position of power had stopped the train and freed the horse in time.

Wojnarowicz articulated a sense of being not just outside society, but actively antagonistic to its strictures, its intolerance of different life-forms. 'The pre-invented world', he'd started calling it, the pre-invented existence of mainstream experience, which seems benign, even banal, its walls almost invisible until you are crushed against them. All his work was an act of resistance against this dominating force, driven by a desire to contact and inhabit a deeper, wilder mode of being. The best way he'd found to fight was to make public the truths of his own life, to create work that resisted invisibility and silence; the loneliness that comes from having your existence denied, from being written out of history, which after all belongs to the normal and not to the stigmatised.

In *Close to the Knives*, he set out very clearly what he thought a work of art could do, writing:

To place an object or writing that contains what is invisible because of legislation or social taboo into an environment outside myself makes me feel not so alone; it keeps me company by virtue of its existence. It is kind of like a ventriloquist's dummy – the only difference is that the work can speak by itself or act like that 'magnet' to attract others who carried this enforced silence.

These feelings about the public and the private informed his thinking about death, too. He didn't want a memorial, his friends weeping or too numb to weep in another anonymous room. He didn't want his or anyone's death to be abstract, to pass by unnoticed in the world at large. At the memorials he'd been attending with increasing frequency over the past few years, he'd sometimes felt the urge to run screaming into the streets, to force every single passing stranger to see the destruction that was taking place.

He wanted to find a way to make each loss tangible, to make death count. The essay in which he first set down these ideas ends with a fantasy that whenever a person died of AIDS their body would be taken by their friends and lovers and loaded into a car and driven to Washington and dumped on the front steps of the White House. It was a vision of accountability, of breaking down the divide between private grief and state responsibility, a divide that had permitted so much suffering to go by unseen.

As such, it's fitting that his memorial was the first political funeral of the AIDS epidemic, the first of many memorials in the form of protest marches. At 8 p.m. on Wednesday 29 July 1992 a crowd of mourners gathered in the street outside Hujar's loft.

Hundreds of people processed in near silence through the East Village, forcing the traffic to a standstill. Down Avenue A, passing over the tarmac where David had once painted a giant cow's head to amuse Hujar. Along East Houston and back up the Bowery, walking behind a black banner that announced in big white letters:

DAVID WOJNAROWICZ
1954–1992
DIED OF AIDS
DUE TO
GOVERNMENT NEGLECT

In a parking lot opposite Cooper Union some of his work was read out loud, and some of it was projected on a wall, just as years before he'd stencilled his own images on to the surfaces of the city. One of the phrases read was: 'To make the *private* into something *public* is an action that has terrific repercussions on the pre-invented world.' Then the banner was burned in the street: a funeral pyre for someone who had fought lifelong simply for the right to be seen, to coexist, to live his life without the threat of violence or arrest, to enjoy desire in the way he pleased.

A few months later, on 11 October, ACT UP organised the Ashes Action, a march on Washington that was a kind of political funeral on a vast scale. It was a crushingly bleak time. There was still no cure for AIDS, no reliable treatment. People were in a state of exhaustion, of grief and gathering despair. Hundreds met on the steps of the Capitol building at 1 p.m., bringing with them the ashes of their loved ones. Then they marched on George

Bush's White House. When they got there, they began to empty the ashes on the lawn, upending caskets and plastic bags and pouring them through the chain-link fence. David Wojnarowicz's ashes were among them, scattered by his lover Tom.

Years before, David used to buy grass seed from a store on Canal Street and roam the piers scattering it in handfuls, Johnny Appleseed in sneakers, wanting to make something beautiful from the rubble. My favourite picture of him showed him lounging on a meadow he'd planted in one of the abandoned baggage or departure halls: grass scattered with debris, grass growing out of disintegrating plaster and particles of soil. Anonymous art, unsignable art, art that was about transformation, about alchemising what was otherwise only waste.

I was reminded of that picture when I first watched the footage on YouTube of the ashes falling, the clouds of greyish dust, the last remains of dozens, perhaps hundreds of people, a tiny proportion of the hundreds of thousands, now millions, lost. It was one of the most heart-breaking things I'd ever seen, a gesture of absolute despair. At the same time, it was an act of intense symbolic power. Where is David now? Like Klaus Nomi, like all the artists who have died of AIDS, he lives on in his work, and in everyone who sees that work, as he suggested years before, when he told Nan Goldin in the conversation recorded in *Interview*, 'once this body drops, I'd like some of my experience to live on'. And he is also scattered across the White House lawn, which is to say at the absolute heart of America, resisting exclusion to the end.

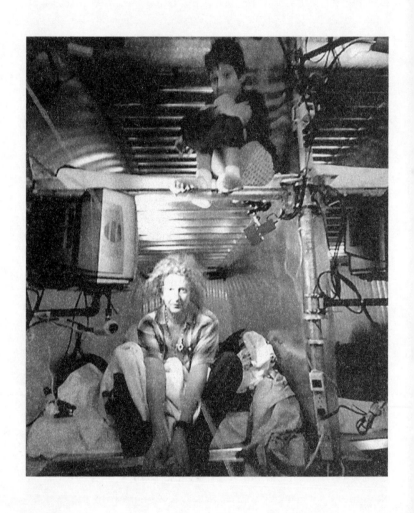

7

RENDER GHOSTS

'TO MAKE THE PRIVATE INTO something public is an act that has terrific repercussions on the pre-invented world,' Wojnarowicz had said, but it hasn't worked out quite like he imagined, not by any means.

In the early spring my sublet in the East Village came to an end and I moved instead to a temporary room on the corner of West 43rd Street and Eighth Avenue, on the tenth floor of what had once been the Times Square Hotel. If I looked south, I could see the mirrored windows of the Westin. The gym was at eye level, and at odd hours of the day or night I'd sometimes catch a figure churning circles on an exercise bike. The other window looked down on to a run of camera stores, bodegas, peep shows and lap-dancing clubs, *PLAYPEN* and *LACE*, a stream of men in backpacks and baseball caps passing through the doors.

It never gets dark in Times Square. It was a paradise of artificial light, in which the older technologies, the neon extravagances in the shape of whisky glasses and dancing girls, were in the process of being made obsolete by the unremitting flawlessness of light-

emitting diodes and liquid crystals. Often I'd wake at two or three or four in the morning and watch waves of neon pass through my room. During these unwanted apertures of the night, I'd get out of bed and yank the useless curtain open. Outside, there was a jumbotron, a giant electronic screen cycling perpetually through six or seven ads. One had gunfire, and one expelled a cold blue pulse of light, insistent as a metronome.

I'd found the new apartment the way I always did: by putting an ad on Facebook. It belonged to an acquaintance of an acquaintance, a woman I'd never met. In an email she told me that the room was very small, with a kitchenette and bathroom, warning me too about the traffic and the neon ads. What she didn't mention was that the building was a refuge: a flagship development run by the charity Common Ground, which rented cheap single rooms to working professionals in addition to housing a more or less permanent population of the long-term homeless, particularly those with AIDS and serious mental health problems. This was explained to me by one of the two security guards on the front desk, who gave me the white electronic card I needed to enter and exit the lobby and took me up to the room to show me how to operate the locks. He'd just started the job, and in the elevator he told me about the building's population, saying of things I might or might not see *if we're not worried about it you don't need to be.*

The halls were painted hospital green, flushed red and white by wall lights, ceiling lights and *EXIT* signs. My room was just big enough to fit a futon and a desk, a microwave, a sink and a small fridge. There were Mardi Gras beads hanging in the bath-

room, and the walls were lined with books and cuddly toys. The sound of stereos and televisions seeped through the walls, and outside crowds of people surged intermittently up from the subway at Port Authority.

It was the epicentre of the twenty-first century, and I lived in it accordingly. Every day I'd wake up and before my eyes were even properly open I'd drag my laptop into bed and lurch seamlessly into Twitter. It was the first thing I looked at and the last, this descending scroll from mostly strangers, institutions, friends, this ephemeral community in which I was a disembodied and inconstant presence. Picking through the litany, the domestic and the civic: lens solution, book cover, news of a death, protest picture, art opening, joke about Derrida, refugees in the forests of Macedonia, hashtag shame, hashtag lazy, climate change, lost scarf, joke about Daleks: a stream of information, sentiment and opinion that some days, most days maybe, received more attention than anything actual in my life.

And Twitter was only the gateway, the portal into the endless city of the internet. Whole days went by on clicking, my attention snared over and over by pockets and ladders of information; an absent, ardent witness to the world, the Lady of Shallot with her back to the window, watching the shadows of the real appear in the lent blue glass of her magic mirror. I used to read like that, back in the age of paper, the finished century, to bury myself in a book, and now I gazed at the screen, my cathected silver lover.

It was like being a spy, carrying out perpetual surveillance. It was like becoming a teenager again, plunging into pools of obses-

sion, moving on, riding the rocking swells, the changing surf. Reading about hoarding or torture or true crime or the iniquities of the state; reading misspelled chatroom conversations about what happened to Samantha Mathis after River Phoenix died, *sorry to sound partonizing but are you sure you WATCHED this interview?* The plunge through, the drift, the awful k-hole of recessive links, clicking deeper and deeper into the past, stumbling out into the horrors of the present. Courtney Love and Kurt Cobain getting married on a beach, a child's bloodied body on the sand: images that generated emotion, overlapping the pointless, the appalling and the desirable.

What did I want? What was I looking for? What was I doing there, hour after hour? Contradictory things. I wanted to know what was going on. I wanted to be stimulated. I wanted to be in contact and I wanted to retain my privacy, my private space. I wanted to click and click and click until my synapses exploded, until I was flooded by superfluity. I wanted to hypnotise myself with data, with coloured pixels, to become vacant, to overwhelm any creeping anxious sense of who I actually was, to annihilate my feelings. At the same time I wanted to wake up, to be politically and socially engaged. And then again I wanted to declare my presence, to list my interests and objections, to notify the world that I was still there, thinking with my fingers, even if I'd almost lost the art of speech. I wanted to look and I wanted to be seen, and somehow it was easier to do both via the mediating screen.

It's easy to see how the network might appeal to someone in the throes of chronic loneliness, with its pledge of connection,

its beautiful, slippery promises of anonymity and control. You can look for company without the danger of being revealed or exposed, discovered wanting, seen in a state of need or lack. You can reach out or you can hide; you can lurk and you can reveal yourself, curated and refined.

In many ways, the internet made me feel safe. I liked the contact I got from it: the small accumulation of positive regard, the favouriting on Twitter, the Facebook likes, the little devices designed and coded for maintaining attention and boosting client egos. I was willing enough to be the sucker, to disseminate my information, to leave the electronic snail-trail of my interests and allegiances for future corporations to convert into whatever currency it is they use. Sometimes, in fact, it seemed like the exchange was working in my favour, especially on Twitter, with its knack for facilitating conversation between strangers along shared lines of interest and allegiance.

In the first year or two that I was there it felt like a community, a joyful place; a lifeline, in fact, considering how cut off I otherwise was. At other times, though, the whole thing seemed insane, a trading-off of time against nothing tangible at all: a yellow star, a magic bean, a simulacrum of intimacy, for which I was surrendering all the pieces of my identity, every element except the physical carcass in which I was supposedly contained. And it only took a few missed connections or lack of likes for the loneliness to resurface, to be flooded with the bleak sense of having failed to make contact.

Loneliness triggered by virtual exclusion is just as painful as that which arises out of real life encounters: a miserable rush of emotion

that almost every person on the internet has experienced at one time or another. In fact, one of the tools psychologists use to assess the effects of ostracism and social rejection is a virtual game called Cyberball, in which the participant plays catch with two computer-generated players, who are programmed to pass the ball normally for the first few tosses, before throwing it exclusively between themselves – an experience identical to the minute smart of having a conversation in which your @self, your avatar, is abruptly excised.

But what did I care, when I could drift away from conversation, and be succoured instead by the addictive act of looking itself? The computer facilitated a pleasurably fluid, risk-free gaze, since nothing I looked at was precisely aware of my observing presence, my fluctuating regard, though I left a trail of cookies to mark my path. Strolling the lit boulevards of the internet, pausing to glance at the exhibitions people have made of their taste, their lives, their bodies, I could feel myself becoming a kind of cousin to Baudelaire, who in the prose-poem 'Crowds' sets out a manifesto for the flâneur, the uncommitted apolitical wanderer of the city, writing dreamily:

> The poet enjoys the incomparable privilege of being able
> to be himself or someone else, as he chooses. Like those
> wandering souls who go looking for a body, he enters as
> he likes into each man's personality. For him alone every-
> thing is vacant.

I walked all the time, but I'd never walked through a city like that. I found the idea abhorrent, in fact, a dandyish disinclination

to engage with the reality of other people. But on the internet, it was hard to remember that there were fleshy, feeling selves behind the avatars. Other people had a tendency to become increasingly abstract, increasingly unreal, their identities blurring and reforming.

Or perhaps it was Edward Hopper I was morphing into. Like him, I found myself becoming a peeper, a creeper, a connoisseur of open windows, patrolling in search of stimulating sights. Like him, my attention was often caught by the erotic. I wandered around the personal ads on Craigslist in just the same way that I wandered around the delis on Eighth Avenue, gazing blankly into the lit racks of sushi, yoghurt, ice cream, Blue Moon and Brooklyn beer, wondering what it was that I wanted, what it was that would satisfy or settle me, eating with my eyes.

No one I knew would admit to liking Craigslist, but I always found it weirdly cheering. The unashamed display of need, the sheer range and specificity of things that people wanted was far more reassuring and democratic than the preening, exacting profiles that appeared on the more sanitised dating sites. If the internet was a city, Craigslist was its Times Square, a site of cross-class, cross-racial contact, temporarily levelled by sexual desire. Cross-entity too, considering how hard it sometimes was to distinguish the human from the bot. *We can both get what we want out of this. I just want a tan Asian girl! I love eaten. Drinks and conversation with a Harvard grad. LET ME SHOVE MY COC IN U long-term 420 sweet princess Chelsea Midtown Midtown West cuddle kitty licked submissive BUSTY game-players tons of baggage plant flowers in my front yard type REAL in the subject of your response.*

Sprawled on the futon in my apartment I spent hours scrolling through the ads, encouraged by how many other people were going frantic with longings of every possible dimension and heft.

But the looking didn't only go one way. Part of the allure of the computer was that I could be seen through the screen, could put myself out for virtual inspection and validation while remaining in control, remote from the possibility of physical rejection. The latter was an illusion, of course. Twice, I put ads on Craigslist. The first, written while I was still in Brooklyn Heights, was hyper-specific and drew mostly angry men or men who quickly became angry. *Ignorant cunt go burn bitch beg to be raped*, one responder wrote, an email that felt like a punch to the chest, a minor explosion of hostility in the larger war enacted on the internet against women. I didn't reply. I logged out of the email account, itself in an assumed name, and never went back, withdrawing this time not because of hypervigilance to social rejection but because of the opposite – because the screen permitted people to make threats and use language that most of them would – I'm guessing here – never countenance in real life.

This is the thing about screens: you can never be sure how clear they are. The disinhibition throwawayemayl@gmail.com evidently felt was a darker aspect of the same freedom I often experienced in my nocturnal journeys, my frictionless hauntings: a freedom that arose because of the way screens facilitate projection and encourage individual expression while at the same time dehumanising the countless others concealed or embedded behind their own more or less lifelike avatars. What's hard to know, though, is whether this means that what emerges is magnified or

distorted, or if anonymity and consequenceless speech (seemingly consequenceless, anyway) simply permits real feelings to seep into the light.

In the second ad, I was vague to the point of absurdity. 479 replies. *Grew up on a farm, you need a strong black man in your life, 6'3 shaved head, care to chat a little, please please no headgames.* These messages were often accompanied or supplanted altogether by pictures of men under trees, men reflected in mirrors, men sometimes whole and sometimes in parts, cropped down to naked chests and engorged penises, one of which was paired with a perplexing picture of its owner standing on a bed, a striped comforter hanging from his shoulders like a superhero's cape.

Some of those emails made my skin crawl, but the majority were touching, with their intimations of loneliness as well as horniness, their hopes for contact. I wrote back to a few, and went nervously on a handful of dates, but none of it went anywhere. Though I wasn't exactly heartbroken any more, something in me – some structure of confidence or esteem – had crumbled. I didn't see anyone a second time. Instead, I stayed indoors and carried on patrolling, looking for connection of an easier, less exposing kind.

Sometimes, as I was scrolling pages, I'd catch my face in the mirror, pallid, absent, glowing. Inside, I might be fascinated or agitated or absolutely enraged, but from the outside I looked half-dead, a solitary body enraptured by a machine. A few years later, watching Spike Jonze's *Her*, I saw the exact replica of this face on Joaquin Phoenix's Theodore Twombly, a man so bruised and leery of actual intimacy that he falls in love with his operating

system, a reboot of Warhol marrying his tape recorder. It wasn't his incredulous joy I recognised, the scenes of him spinning in circles with his phone. It was a scene right at the beginning, in which he gets home from work, sits down in the dark and begins to play a videogame, manically jiggling his fingers to propel an avatar up a slope, his face pathetically engaged, his slumped body dwarfed by the giant screen. He looked hopeless, ridiculous, absolutely divorced from life, and I recognised him immediately as my twin: an icon of twenty-first-century isolation and data dependency.

It no longer seemed absurd by then that someone might have a romantic relationship with an operating system. Digital culture was undergoing hyper-acceleration, moving so fast it was hard to keep track. One minute something was sci-fi, palpably ridiculous; the next a casual ritual, part of the everyday texture of life. The first year that I was in New York, I read Jennifer Egan's *A Visit from the Goon Squad*. Part of it is set a little in the future, and involves a business meeting between a young woman and an older man. After talking a while, the girl becomes agitated by the demands of speech and asks the man if she can 'T' him instead, though they are sitting side by side. As information silently flushes between their two handsets, she looks 'almost sleepy with relief', describing the exchange as *pure*. Reading it, I can distinctly remember thinking that it was appalling, shocking, wonderfully far-fetched. Within a matter of months it seemed instead merely plausible, a little gauche, but entirely understandable as an urge. Now it's just what we do: texting in company, emailing colleagues at the same desk, avoiding encounters, DMing instead.

The relief of virtual space, of being plugged in, of having control. Everywhere I went in New York, on the subway, in cafés, walking down the street, people were locked into their own network. The miracle of laptops and smartphones is that they divorce contact from the physical, allowing people to remain sealed into a private bubble while they are nominally in public and to interact with others while they are nominally alone. Only the homeless and the dispossessed seemed exempt, though that's not counting the street kids who spent every day hanging out in the Apple store on Broadway, keeping up on Facebook even – especially, maybe – if they didn't have anywhere to sleep that night.

Everyone knows this. Everyone knows what it looks like. I can't count how many pieces I've read about how alienated we've become, tethered to our devices, leery of real contact; how we are heading for a crisis of intimacy, as our ability to socialise withers and atrophies. But this is like looking through the wrong end of a telescope. We haven't just become alienated because we've subcontracted so many elements of our social and emotional lives to machines. It's no doubt a self-perpetuating cycle, but part of the impetus for inventing as well as buying these things is that contact is difficult, frightening, sometimes intolerably dangerous. Despite an advert then prevalent on the subway that declared *Your favourite part of having a smartphone is never having to call anyone again*, the source of the gadget's pernicious appeal is not that it will absolve its owner of the need for people but that it will provide connection to them – connection, furthermore, of a risk-free kind, in which the communicator need never be rejected,

misunderstood or overwhelmed, asked to supply more attention, closeness or time than they are willing to offer up.

According to the psychologist Sherry Turkle, a professor at MIT who has been writing about human-technology interactions for the past three decades and who has become increasingly wary of the ability of computers to nourish us in the ways we seem to want them to, part of the screen's allure is that it facilitates a dangerously pleasurable self-forgetfulness in something of the same manner as the analyst's couch. Both spaces offer up a complicated set of possibilities, an alluring oscillation between the dyad of hidden and seen. Lying on their back, witnessed by but unable to glimpse the observer who watches over them, the analysand dreamily narrates their life story. 'Likewise, at a screen,' Turkle writes in *Alone Together*:

. . . you feel protected and less burdened by expectation. And, although you are alone, the potential for almost instantaneous contact gives an encouraging feeling of already being together. In this curious relational space, even sophisticated users who know that electronic communications can be saved, shared, and show up in court, succumb to its illusion of privacy. Alone with your thoughts, yet in touch with an almost tangible fantasy of the other, you feel free to play. At the screen, you have a chance to write yourself into the person you want to be and to imagine others as you wish them to be, constructing them for your purposes. It's a seductive but dangerous habit of mind.

Alone Together was published in 2011. The third in a trilogy about relationships between humans and computers, it's the result of years of research projects, of observing and discussing how technology is used and feels with many different kinds of people, from school children nervously mothering Tamagotchis and teenagers struggling with the demands of virtual and real social lives to isolated seniors coddling therapeutic robots in nursing homes.

In Turkle's first two books, *The Second Self* (1984) and *Life on the Screen* (1992), computers are presented as primarily positive objects. The first, written before the advent of the internet, considers the computer itself as other, ally, even friend, while the second explores the way that networked devices facilitate entry into a liberating zone of exploration and identity play, where anonymous individuals can reinvent themselves, forming connections with people all over the world, no matter how niche their interests and proclivities.

Alone Together is different. Subtitled *Why We Expect More from Technology and Less from Each Other*, it's a frightening book, conveying an oncoming dystopia in which no one talks or touches, in which robots take on the role of caregivers and people's identities become increasingly imperilled and unstable as they are simultaneously succoured and surveilled by machines. Privacy, concentration, intimacy: all are lost, worn away by our fixation with the world inside the screen.

How far ahead can you see? For most of us, committed Luddites aside, these more sinister aspects of virtual existence are only just beginning to crest into visibility, two decades after the public launch of the world wide web. But there have been warnings,

both by scientists and psychologists and broadcast through the prescient medium of art. One of the strangest in this latter category was made over fifteen years ago – and not even by an artist but by a dotcom millionaire with money to burn. Prophecy is a strong word, but the things Josh Harris created at the turn of the new millennium have something of the quality of predictive text, capturing not just the shape of the future but also the urges that brought it into being.

<p style="text-align:center">*</p>

Josh Harris was an internet entrepreneur, the cigar-chomping poster-boy for the excesses of Silicon Alley, the nickname for the digital industries that burgeoned in New York towards the end of the twentieth century. In 1986, at the age of twenty-six, he'd set up Jupiter Communications, the first internet market research company. It went public in 1988, making him a millionaire. Six years later, he founded a pioneering internet television network, Pseudo, which produced multiple channels of entertainment, each catering for and made by different subcultures, from hip hop and gaming to erotica – the same panoply of communities, in fact, that still colonise the web today.

Years before social media, before Facebook (2004) and Twitter (2006), before Grindr (2009), ChatRoulette (2009), Snapchat (2011) and Tinder (2012), before even Friends Reunited (2000), Friendster (2002), MySpace (2003) and Second Life (2003), not to mention the broadband that made them viable, Harris understood that the internet's most powerful appeal was not going to

be as a way of sharing information, but rather as a space in which people could connect with others. He foresaw from the beginning that there would be an appetite for interactive entertainment and he also foresaw that people would be willing to pay a good deal in order to participate, to have a presence in the virtual world.

What I am trying to say is that Harris predicted the internet's social function, and that he did so in part by intuiting the power of loneliness as a driving force. He understood the strength of people's longing for contact and attention and he also grasped the counterweight of their fear of intimacy, their need for screens of every kind. As he put it in the documentary *We Live in Public*: 'If I'm in a certain mood and stuck with my family or friends, the alleviation to that are virtual worlds' – a statement that seems obvious now but that in the 1990s was met with amused bafflement, if not outright ridicule.

It seems he knew all this not just instinctively, but because his own early experiences had shaped him into an exceptionally ideal tenant of unreal spaces. There are at present two documentaries about Harris's strange and turbulent life: *We Live in Public*, which was directed by Harris's long-term collaborator Ondi Timoner, and *Harvesting Me*, an episode of Errol Morris's First Person series. There is also a book, *Totally Wired* by Andrew Smith, which charts the rise and fall of the dotcom bubble by way of a wonderfully forensic account of Harris's exploits over the years. All of these works contain scenes in which Harris describes his childhood, in characteristically aphoristic (also confusing, paranoid and unfinished) sentences, as notably unpeopled and friendless, his emotional

support provided more by television sets than human beings.

He grew up in California, though there was also a stint in Ethiopia: the youngest child in a family of seven, his brothers already well into high school while he toiled through elementary. His father often disappeared, once for so long that the family home was repossessed. His mother worked with delinquent children, drank heavily and was not, by his own or his siblings' accounts, a nourishing, warm or even very present presence. He grew up semi-feral, foraging for himself and spending most of his time alone, glued to the TV, *Gilligan's Island* a particular fixation. 'I think,' he said in *We Live in Public*:

> . . . that I love my mother virtually and not physically. I was bred by her to sit in front of a TV set for hours on end. That's how I've been trained. You know the most important friend to me growing up was in fact the television . . . My emotionality is not derived from other humans . . . I was emotionally neglected but virtually I could absorb the electronic calories from the world inside the television.

It's the sort of thing you can imagine Warhol saying – not so much the neglect, but the sense of kinship with machines, the craving for electronic calories, the desire to enter into an artificial, looking-glass world. Both men maybe saw it as something like an equation, in which the need for intimacy and the fear of it create a stalemate, paralysis, and that rather than struggling in this lonely maze one might simply co-opt devices – cameras, tape

recorders, televisions — using them as shields, distractions, safe zones.

In fact, the two were frequently compared. In the 1990s, the press dubbed Harris the Warhol of the Web, though at the time this was more to do with his penchant for throwing parties and surrounding himself with downtown characters, particularly performance artists, than because he actually produced art himself. All the same, the lineaments of his childhood meant that, like Warhol, he understood the weirdly protective quality of screens, the sense that participating in virtual spaces might be a way of medicating a sense of isolation, a feeling of being left out or going unregarded, without requiring the subtle social skills necessary for IRL interactions. And after all, what better antidote to being alone, all one, than entering the replication machine of the internet, by which the virtues of celebrity could be made available to all.

Harris established Pseudo along the now-familiar lines of social media corporations, with their breakout zones and cheerfully infantile, play-inducing furnishings. It was based in a loft at 600 Broadway, a space that a wry *New York Magazine* profile from 1999 described as being large enough to park a fleet of double-decker buses. Inside, Harris built himself a private apartment, making a personal enclave in what was otherwise a non-stop 24/7 zone of sociability, a frenetic combination of television studio and happening.

Pseudo was conceived and run as a participatory domain, though as with Warhol's Factory, it was always the same person who settled the bills. The door to the street was left open day

and night, and there were endless parties, many of them filmed and uploaded on the station, blurring the distinctions between work and play, meat and cyberspace. Gamers playing Doom, *The Matrix* projected on to a wall, a queue of models and pop stars snaking down the street: the stuff of dreams, assuming the dreamer had been a nerdy friendless kid in Ventura with his nose to the tube.

Towards the end of the 1990s, Harris's interest in Pseudo began to wane in favour of an ambitious new project, which might be described as a month-long party, a psychology experiment, an art installation, a durational performance, a hedonistic prison camp or a coercive human zoo. Quiet was conceived as an investigation into surveillance and group living: an experiment designed to test the effects of the oncoming collapse of boundaries between the public and the private that Harris was convinced the internet would bring about. 'Andy Warhol was wrong,' he informed a journalist. 'People don't want fifteen minutes of fame in their lifetime, they want it every night. The audience want to be the show.'

In the winter of 1999, he rented a dilapidated empty warehouse in Tribeca and set about transforming it into an Orwellian chamber of enchantment, helped by a team of artists, chefs, curators, designers and builders and backed by a seemingly unlimited budget of personal funds. The idea was that sixty people would spend the final month of the millennium living in a communal pod hotel he'd built in the basement. They would be unable to leave, though the public would be free to come and go, enjoying a bountiful libidinal playpen, in which all urges could be gratified,

be it guzzling unlimited liquor at the free bar, dancing in a nightclub called Hell or discharging one's aggression in a shooting range in the basement that was stocked with submachine guns and live ammo.

Like Pseudo, Quiet was open to all-comers. Over the month of December, the bunker was a honeypot for the *fin de siècle* downtown scene, drawing queues right down the block. The novelist Jonathan Ames was among the crowd and in his 'City Slicker' column for *New York Press* he described his adventures there. 'People,' he wrote, 'gathered night after night to drink, smoke pot, grab one another and see strange performances. It was like the Beat generation meets the Internet. Not the best combination perhaps, but amusing and unusually vital, though there was the sense of great waste; I think the Beat generation cultivated their madness on a much lower budget, which seems more virtuous, but that's only because I have a poor man's prejudice and snobbery when it comes to money.'

All the beds in the pod hotel were rapidly filled, despite the exacting conditions of entry, which included the necessity of dressing in grey shirts and orange trousers – a uniform that is now disturbingly reminiscent of Guantanamo Bay. The space in which the new citizens of Quiet were confined offered no privacy whatsoever. The bunks were crammed into a single subterranean dormitory, army style. There was only one shower. It had glass walls, and was situated in full view of the dining hall, where elaborate gourmet meals were served free of charge three times a day.

In fact, everything at Quiet was free. The price of entry into

the bunker wasn't money, but rather a willingness to surrender control over one's identity. There were surveillance cameras everywhere, even in the toilets, streaming to the web. Furthermore, each of the sleeping pods was fitted with a two-way audio-visual system, a camera plus television set. These devices converted Quiet into a panopticon and its citizens into both prisoners and jailers, at once the subject and the object of scrutiny.

They could look as much as they liked, flicking through the channels, settling on this or that pod, watching people eating or defecating or having sex. They could gorge themselves on feasts of the eye, but they couldn't hide. They could watch whatever face or body took their fancy, but they could not protect themselves from being regarded by the camera's unstinting gaze, though they could work to generate an audience, to acquire the glitter that comes from being regarded by multiple eyes, the high wattage sheen lent by mass attention. Quiet wasn't just a metaphor for the internet. It was the thing itself, enacted by real bodies in real rooms; its feedback loops of voyeurism and exposure.

Like the internet, what seemed transient was actually permanent, and what seemed free had already been bought. In his understanding of this, Harris was notably prescient, something that can be seen when one contrasts Quiet with an essay written the same year by the critic Bruce Benderson about cybersex and the effect of the internet on communities and cities, entitled 'Sex and Isolation'. In it, he writes: 'We are very much alone. Nothing leaves a mark. Today's texts and images may look like real carvings – but in the end they are erasable, only a temporary blockage of all-invasive light. No matter how long the words and pictures

stay on our screens, there will be no encrustation; all will be reversible.' This statement captures the anxieties of the web 1.0, its now painful innocence, and fails to foresee what Josh did: the grim permanence of the web to come, where data has consequences and nothing is ever lost, not arrest logs, not embarrassing photos, not Google searches, not the torture logs of entire nations.

On arrival, the citizens of Quiet signed away the rights to their own data, just as we do when we persist in treating corporate spaces of the web as private diaries or zones of conversation. Everything recorded was owned by Harris, including information gathered by way of increasingly brutal and intrusive interrogations, apparently carried out by a genuine former CIA operative. These interrogations form one of the most distressing aspects of the documentary *We Live in Public*. Over and over, clearly vulnerable people are grilled by uniformed guards about their sexual proclivities and mental health, with one weeping woman asked to demonstrate exactly how she'd cut her wrists, the speed and angle of the blade.

It sounds like hell, and the footage looks like hell, the uniformed people fucking in their kennels, as a rattled-sounding Josh says on camera: 'There's all these people around you at close quarters and the more you get to know each other the more alone you become. That's what this environment is doing to me.' And yet most people seem on balance to have relished their time in Quiet, or at least to have been glad they'd been through it, though they also attested to increasing fights, as drug use and proximity and lack of privacy ate away at the inmates.

The party came screeching to a halt in the early hours of the

new millennium, when Quiet was raided and shut down by the police and the Federal Emergency Management Agency, apparently because of concerns that it was a millennial cult (the noise of guns being discharged, audible from the street outside, cannot have helped). The bust was part of Mayor Rudy Giuliani's clamp down on licentiousness and crime, his attempt to clean and order the city by way of what was known euphemistically as the Quality of Life Task Force, the same mechanism responsible for the sanitisation and desexing of Times Square. As dawn broke over Manhattan, as the twenty-first century began, the citizens of Quiet were thrown out into the street, the machinery of closeness abruptly shut off.

The sadism that makes Quiet appalling as a viewing spectacle also clouds its purpose. It reveals people's greed for attention, yes, but the message of danger is diminished by the suspicion that a single person is manipulating the situation, ratcheting up the stakes. Watching the footage of interrogations, or of a group of orange-clad people ogling two strangers having athletic sex inside a shower, one has the sense that someone invisible is yanking the strings: someone who will do anything to generate effects, create drama, keep the viewer hooked. On some level, Harris must have grasped this, because his next project was simpler, more self-exposing and far more declarative.

In We Live in Public (the documentary takes its name from the work), Harris turned the cameras on himself and his girlfriend Tanya Corrin, a former employee and his first serious relationship. Having exposed people's desire for participation, their frantic need to be witnessed, he now wished to assess the cost of this kind of

surveillance, to see the human effects of collapsing whatever boundaries exist between the public and the private, the real and the virtual. Again, let me restate that this is in 2000, three years before MySpace was founded and four years before the launch of Facebook, when social media had not yet begun, let alone become entrenched enough to generate the kind of anxiety that is familiar today. The television show *Big Brother* had been on air since 1997, but that simply put people into a decreasingly comfortably appointed prison and let unseen viewers vote them out. What Harris wanted to do was open the channels, to let audience and show bleed into one.

That fall, he filled his apartment with sophisticated recording equipment, including dozens of automated cameras. For 100 days, he and Tanya would live entirely in public, come what may. The footage harvested was streamed on to the project's website, where it appeared on a split screen, the other half of which was dedicated to discussion by a shifting online community, who not only watched but also responded and engaged. At the project's height, thousands of people were logging on, watching Josh and Tanya eating, showering, sleeping, having sex.

At first, the relationship bloomed under these artificial lights, but as the scrutiny intensified cracks began to form. From the beginning, the watchers commented on what they saw, a relentless chorus, a talking mirror, by turns flattering and savage. What was being said? Better check, the two of them in separate rooms, assessing their feedback, comparing their popularity, tweaking their behaviour in accordance with demands. When they fought, the watchers took sides, generally Tanya's, advising her on ways

of handling Josh, telling her to make him sleep on the couch, telling her to force him to move out.

Under this kind of barrage, this seeping of the virtual into the actual, Josh became progressively more isolated and embittered, not helped by the fact that his fortune was leaking away, the millions vanishing as swiftly as they'd materialised. 2000: the year of the stock market crash, the bursting of the dotcom bubble. Eventually Tanya left, a humiliating public separation, and he stayed on in the loft alone with a hostile crowd of spectators, trapped in a malicious room of knowing ghosts. Then the audience too began to dwindle, and as they melted away Josh felt the elements of his personality disappearing with them. Without the attention, without the scrolling responses, did he even exist? An abstract question, Philosophy 101, until you look at the footage of him moving between rooms, spooked and bloated, something blank about his face, like a man who has suffered a blow to the head.

*

I first saw the documentary *We Live in Public* in a way that would have been unthinkable ten years before. A friend I knew from Twitter, Sherri Wasserman, inaugurated a film festival designed for the internet. At first, the idea was to watch films about isolation while physically isolated but technologically connected. Over time, the focus shifted to prisons both real and imagined, among them the two designed by Harris.

There were six of us at the first Co-Present festival, scattered

across America and Europe, watching on our laptops and talking via Gchat. We got to *We Live in Public* last, after a triple bill of *Into the Abyss*, *Escape from New York* and *Tokyo Drifter*, which is to say blindsided by images, by hours and hours spent immersed in the glowing innards of our computers. All those films were beautiful and disturbing, relevant in different ways, but *We Live in Public* felt like confronting something personal, something ugly and increasingly uncomfortable. Looking at the chatlog now, we all sound stunned. SW: *this increasingly looks like the cocky internet startup mogul's version of the Stanford Experiment*. ST: *I feel like I'm going crazy*. AS: *it's seriously fucked*.

I can't speak for the others, but I was frightened by what I saw, and frightened by what it meant for me. Somehow, I'd woken up in the future. I think we're all in Josh's room now. I think the salient point about the new world we've been drifting into is that all the walls are falling down, everything blurring into everyone else. In this atmosphere of perpetual contact, perpetual surveillance, intimacy falters. Hardly any wonder Josh fled the city the day after We Live in Public ended, spending the next few years hiding out on an apple farm upstate, recovering or recalibrating his sense of boundaries, drawing his self back into the outer casing of his skin.

Collapse, spread, merging, union: these things sound like the opposite of loneliness, and yet intimacy requires a solid sense of self to be successful and satisfying. In conversation after a screening of *We Live in Public* at the MoMA, the director Ondi Timoner said of Quiet that though it was in many ways a totalitarian space, 'it didn't matter . . . It was more important to get the attention

of the camera if at all possible, and there were 110 of them, so it was like a candy store for people who wanted to feel that they were part of something', adding emphatically: 'What I did not realise at the time was that this was what the internet would become.' She saw the film explicitly as a warning, saying: 'I think we have to be conscious of what we're after when we're posting our photo. I think we all have a desire not to feel alone and to feel connected and that's a basic desire, but in our society celebrity has become the golden lamb . . . if I can get that, I won't feel alone and will always feel loved.'

Love without risk. Love that is simply the dissemination of one's own face, its incessant replication. In the Errol Morris documentary *Harvesting Me*, Harris muses on his life in a way that implicitly conflates identity with the experience of being watched. 'My only friend was the tube . . . I'm a celebrity. There are people who watch me . . . I've got this Greek chorus watching me me me.' It's as if each extra set of eyes enlarges and reinforces the object of the gaze, that fragile, swollen *me*, though they are also capable of tearing it to pieces.

Once again, this recalls Warhol, who possessed a similarly intense desire to get inside the tube, using it as a way to broadcast himself, to seed his image throughout the world. Or, alternatively, to put other people in there, the better to enjoy them. All sorts of aspects of his work echo through Harris's projects, as they do through the internet at large. Take the so-called boring films, with their gratuitously lingering glances, their static, silvery regard of people engaged in the ordinary, quotidian activities of their titles: *Sleep* or *Haircut*, *Kiss* or *Eat*. They testify to the desire to watch a body

perform its rites: the same urge that is present in cruder form in Harris's endless recording of people defecating or washing, sleeping or having sex; an urge that has itself subsequently flowered out in vast profusion on the internet, that kingdom of self-portraiture, that enclave of the fetishised and the banal. Surveillance art, I suppose you could call it, made before the term was even in circulation.

The difference between Warhol and Harris, of course, is that Warhol was an artist, engaged in the production of something beautiful – a gleaming surface, an affectless mirror for the world – and not simply in social experiment and self-aggrandisement and what sometimes seems like unnecessarily cruel exposure. Though perhaps that last clause is not quite fair. Watching footage of Quiet, its sadism and manipulation, I was reminded more than once of Warhol's nastier films, the ones in which he and Ronnie Tavel provoke mania or nudge the doe-eyed participants into humiliating acts. Ondine slapping Rona Page, Mary Woronov torturing International Velvet in *Chelsea Girls*, beautiful Mario Montez in *Screen Test No. 2*, ecstatically mouthing the word *diar-rhoea*, his lovely face determined, anxious to please (at the beginning of the film, obsessively rearranging his luxuriant wig, the camera's eye upon him, he confesses dreamily, 'I feel like I'm in uh another world now. A world of fantasy.')

If there is a current animating Warhol's work, it is not sexual desire, not eros as we generally understand it, but rather desire for attention: the driving force of the modern age. What Warhol was looking at, what he was reproducing in paintings and sculptures and films and photographs, was simply whatever everyone

else was looking at, be it celebrities or cans of soup or photographs of disasters, of people crushed beneath cars and flung into trees. In gazing at these things, in rolling them out over curtains of colour, in reproducing them endlessly, what he was attempting to distil was the essence of attention itself, that elusive element that everyone hungers for. His study began with stars, with all those heavy-lidded, bee-stung divas, Jackie, Elvis, Marilyn, their faces vacant, stunned by camera lenses. But it didn't end there. Like Harris, Warhol could see that technology was going to make it possible for more and more people to achieve fame; intimacy's surrogate, its addictive supplanter.

At the Warhol Museum in Pittsburgh there is a room filled with dozens of televisions, all dangling from chains. Each one broadcasts a different episode of the two chat-shows he made in the 1980s, *Andy Warhol's T.V.* and *Andy Warhol's Fifteen Minutes.* Each set contains a miniature Andy, his false hair sprouting upwards, unhindered by gravity. Uneasy behind his glasses, but loving the broiling lights, directed on his face. Television was the medium he most desired entering into, the pinnacle of his ambitions. According to the curator Eva Meyer-Herman: 'The mass medium of television, which proliferates into every living room, is the utmost extreme of reproduction and repetition that he could imagine.' In *The Philosophy of Andy Warhol*, he reflected on the magical capacity of television, the way it makes you big no matter how small you feel.

If you were the star of the biggest show on television and took a walk down an average American street one

night while you were on the air, and if you looked through windows and saw yourself on television in everybody's living room, taking up some of their space, can you imagine how you would feel? No matter how small he is, he has all the space anyone could ever want, right there in the television box.

That's the dream of replication: infinite attention, infinite regard. The machinery of the internet has made it a democratic possibility, as television never could, since the audience in their living rooms necessarily far outnumbered the people who could be squeezed into the box. Not so with the internet, where anyone with access to a computer can participate, can become a minor deity of Tumblr or YouTube, commanding thousands with their make-up advice or ability to decorate a dining table, to bake the perfect cupcake. A prepubescent in a sweater with a knack for throwing shade can grip 1,379,750 subscribers, declaring *it's hard to explain myself so those are what my videos are for!!* And then you run the hashtag lonely through Twitter, *can't vibe with anybody lately #lonely*, seven favourites; *I love seeing people that I asked to do things with not reply to me and then do things without me. #lonely*, one favourite; *I'm having one of those nights. Too much thinking time #lonely I sound like a fucking sook with lots of cats. I wish I had a cat*, no favourites.

Meanwhile, what? Meanwhile, the life forms on the planet that we inhabit diminish by the hour. Meanwhile, everything becomes steadily more homogenised, more intolerant of difference. Meanwhile, teenagers kill themselves, leaving suicide notes

on Tumblr, against a backdrop of flinching, flickering Hello Kittys, *I was completely alone for 5 months. No friends, no support, no love. Just my parent's disappointment and the cruelty of loneliness.*

Something wasn't working. Somehow the spell of the replication machine had failed. Somehow where we'd got to wasn't all that desirable, all that habitable, all that swell. If I tore myself away from my computer and looked out of my window what I was confronted by instead were the screens of Times Square: a giant watch, Gordon Ramsay's craggy face, magnified to a hundred times the size of life.

Marooned inside this unnatural landscape, I could have been anywhere at all: London, Tokyo, Hong Kong, any of the technologically modified cities of the future, which seem increasingly to have been modelled on Ridley Scott's *Blade Runner*, with its floating adverts for Coca Cola and Off-World Colonies, its anxieties about the blurring between the artificial and the authentic.

Blade Runner portrays a world devoid of animals, a visionary precursor of the robotic moment that Sherry Turkle predicted. What is it that Sebastian says, the prematurely ancient man-child, living alone in the leaking, debris-strewn splendour of a deserted Bradbury Building in a futuristic, sodden L.A.? The replicant Pris asks him if he is lonely and he says no, as real people almost always do, telling her in his halting way: 'Not really. I make friends. They're toys. My friends are toys. I make them. It's a hobby. I'm a genetic designer.' So there's another room we're stuck inside, thronged with programmed companions, friends we invented and invested with life. Never mind emigrating off-world; what we have done is emigrate online.

I wonder, is it a coincidence that computers achieved their dominance at just the moment that life on earth became so cataclysmically imperilled? I wonder if that was a driver, if part of the urge to escape feeling, to plug the need for contact with the drug of perpetual attention, comes from the anxiety that we will one day be the last ones left, the last species surviving on this multifarious, flowered planet, drifting through empty space. That's the nightmare, isn't it, to be abandoned in perpetuity? Robinson Crusoe on his island, Frankenstein's monster disappearing on to the ice, *Solaris*, *Gravity*, *Alien*, a weeping Will Smith in *I am Legend* wandering the desolate, unpeopled, post-plague city of New York, begging a mannequin in an abandoned video store to *please say hello to me, please say hello to me*: all these horror stories revolve around the terror of solitude without prospect of cure, loneliness without the hope of alleviation or redemption.

I wonder too, if AIDS is part of what laid the ground for all this. In *Illness as Metaphor*, Susan Sontag makes a connection between the disease and the then-nascent world of computers, the way their metaphors rapidly became shared and entangled. The use of the word *virus*, for a start, migrating from an organism that attacks the body to programs that attack machines. AIDS colonised the imagination at the end of the last millennium, filling the atmosphere with dread, so that when the future rolled in it was thick with the fear of contamination, of sickening bodies and the shame of living inside them. A virtual world: why not, yes please, calling time on the tyranny of the physical, on the long rule of old age, sickness, loss and death.

Then too, as Sontag points out, AIDS exposed the alarming

realities of the global village, the world in which everything is in perpetual circulation, the goods and garbage, the plastic sucky-cup in London washing up in Japan, or trapped in the squalid gyre of the Pacific trash vortex, breaking down into pelagic plastics that are themselves eaten by sea turtles and albatross. Information, people, illnesses: everything is on the move. No one is separate, every element is constantly morphing into something else. 'But now,' Sontag writes at the close of her book, which was published in 1989:

> . . . that heightened modern interconnectedness in space, which is not only personal but social, structural, is the bearer of a health menace sometimes described as a threat to the species itself; and the fear of AIDS is of a piece with attention to other unfolding disasters that are the byproducts of advanced society, particularly those illustrating the degradation of the environment on a world scale. AIDS is one of the dystopian harbingers of the global village, that future which is already here and always before us, which no one knows how to refuse.

To which the twenty-first-century citizen might add #overit or #tl;dr, the same emotion of despair compressed into the micro-language we now seem compelled to confine ourselves inside.

<p style="text-align:center">★</p>

One night, walking home at 2.30 in the morning, I saw a carriage horse bolting down a deserted 43rd Street. Another evening, I

passed in the crowd on 42nd a man shouting to no one in particular *New York! We're drowning in colours!* In the elevator at the Times Square Hotel, I stepped in and out of conversations. Two women interrogating a man with greased-back hair about Louis Vuitton bags. *What colour you want? Black. When you going? She's going in an hour and a half.* There was a world outside, if I could make myself go into it, though it increasingly resembled the sanitised world inside the screen.

The same forces that have driven our migration online were also evident in the fabric of the neighbourhood itself. Every city is a place of disappearances, but Manhattan is an island, and to reinvent itself must literally bulldoze the past. The Times Square of Samuel Delany and Valerie Solanas and David Wojnarowicz, the Times Square of the Rimbaud photograph, the place where bodies could come together, had in the intervening decades undergone a drastic shift, a movement towards homogeneity. The great clean-up operation of gentrification: Giuliani and Bloomberg between them sweeping away the porn cinemas, the hookers and dancing girls, replacing them with corporate offices and high-end magazines.

It was the same fantasy of purification expressed by Travis Bickle in his famous monologue from *Taxi Driver*, the voice-over given as he drives through 1970s Times Square in his cab in the rain, past the green aquariums of the peepshows, the pink letters spelling out *FASCINATION*, the girls in their lemon hot-pants and plat-form heels, the headlights spilling red and white across wet tarmac. 'All the animals come out at night – whores, skunk pussies, buggers, queens, fairies, dopers, junkies. Sick, venal. Someday a real rain

will come and wash all this scum off the streets.' And now the rain had come. Now Times Square was populated by Disney characters and tourists and scaffolders and the police. Now the Victory, which in the Rimbaud photo was screening X-rated movies, was a gleamingly restored children's theatre, while the New Amsterdam had shown nothing but *Mary Poppins* since 2006.

It's ironic that Manhattan is becoming a kind of gated island for the super-rich, when one considers that in the 1970s it was closer to a gated prison for the poor, its reputation as a danger-zone exploited in the sci-fi film *Escape from New York*, the one we'd watched as part of the first Co-Present film festival. Back in that period, the building I was living in, the old art-deco liner of the Times Square Hotel, had been a welfare hotel, its empty rooms used to warehouse the overflow of homeless people from the city's teeming shelters. Valerie Solanas was a frequent incumbent of these places, and in *7 Miles A Second*, the graphic novel about his childhood, David Wojnarowicz remembered times when he was forced to stay in them, with their rotting mattresses and doors sawed two feet from the floor, so that any creep could crawl in while you slept. Even exhausted, he preferred the relative openness of the streets.

I don't know if he ever visited the Times Square itself, but as a kid he certainly turned tricks in places like it. He wrote about them later: the middle-aged men who'd pick him up, the grubby little rooms they'd take him to. One time, the john made him watch another couple through a peephole in the wall. When the woman turned around he saw that there were unhealed knife wounds all over her belly. In *7 Miles A Second*, there's a picture

of her torso, coloured in inked swatches of red and pink and brown. 'What really twisted my brain,' kid David says, 'was how that guy could fuck that woman' – a hooker he recognised from outside Port Authority – 'with those fresh wounds staring him in the face! Like he couldn't conceive of pain attached to the body he was fucking.'

This is what the Times Square Alliance was supposed to have erased: the panhandlers, the hustlers, the damaged and hungry bodies. And yet it's doubtful that the impulse was wholly human-itarian, driven by a wish to improve or make safe the lives of people on the margins. Safer cities, cleaner cities, richer cities, cities that grow ever more alike: what lurks behind the rhetoric of the Quality of Life Task Force is a profound fear of difference, a fear of dirt and contamination, an unwillingness to let other life-forms coexist. And what this means is that cities shift from places of contact, places where diverse people interact, to places that resemble isolation wards, the like penned with the like.

This is the subject of *Gentrification of the Mind*, Sarah Schulman's extraordinary polemic, which ties the physical process of gentri-fication to the losses of the AIDS crisis. Her book calls on us to realise that not only is it healthier to live in complex, dynamic, mixed communities than uniform ones, but also that happiness that depends on privilege and oppression cannot by any civilised terms be described as happiness at all. Or as Bruce Benderson, another denizen of the old Times Square, puts it in *Sex and Isolation*: 'The closing of the center city is loneliness for everyone. The abandonment of the body is isolation, the triumph of pure fantasy.'

There are consequences to physical environments, just as there are consequences to virtual worlds. During the period that I lived in Times Square, Wojnarowicz's phrase kept drifting through my head. *Like he couldn't conceive of pain attached to the body he was fucking. Like he couldn't conceive of pain attached to the body.* It's a statement about empathy, about the capacity to enter into the emotional reality of another human being, to recognise their independent existence, their difference; the necessary prelude to any act of intimacy.

In the fantasy world of *Blade Runner*, empathy is what distinguishes humans from replicants. In fact, the film opens with a replicant being forced to undertake the Voight-Kampff test, which uses a kind of polygraph machine to assess whether a suspect is truly human by measuring the degree of their empathic response to a series of questions, most of them about animals in distress. *The tortoise lays on its back, its belly baking in the hot sun, beating its legs trying to turn itself over, but it can't. Not without your help. But you're not helping . . . Why is that, Leon?*, a line of questioning that is abruptly terminated when Leon shoots the interrogator from beneath the desk.

The irony of the film is, of course, that it's the humans who are devoid of empathy, who fail to conceive of suffering on the part of the replicants, the stigmatised *skin jobs*, with their radically shortened life spans. It's only after the replicant Roy Batty nearly kills him — *Quite an experience to live in fear, isn't it?* — before saving his life that the Blade Runner Deckard, the hard-boiled detective, learns to empathise, dissolving with it some of the ice of his own pervasive loneliness, his isolation in the city.

I wonder now: is it fear of contact that is the real malaise of our age, underpinning the changes in both our physical and virtual lives. St Patrick's Day. In the morning Times Square was filled with drunken teenagers in green baseball caps, and I walked right down to Tompkins Square Park to escape them. By the time I turned for home it had begun to snow. The streets were almost deserted. At the top of Broadway I passed a man sitting in a doorway. He must have been in his forties, with cropped hair and big cracked hands. When I paused he started to speak unstintingly, saying that he had been sitting there for three days, saying that not a single person had stopped to talk to him. He told me about his kids – *I got three beautiful babies on Long Island* – and then a confusing story about work boots. He showed me a wound on his arm and said *I got stabbed yesterday. I'm like a piece of shit here. People throw pennies at me.*

It was snowing hard, the flakes whirling down. My hair was soaked already. After a while, I gave him five bucks and walked on. That night I watched the snow falling for a long time. The air was full of wet neon, sliding and smearing in the streets. What is it about the pain of others? Easier to pretend that it doesn't exist. Easier to refuse to make the effort of empathy, to believe instead that the stranger's body on the sidewalk is simply a render ghost, an accumulation of coloured pixels, which winks out of existence when we turn our head, changing the channel of our gaze.

STRANGE FRUIT

IT GOT COLDER AND THEN it got warmer, the fizz of pollen in the air. I left Times Square, moving instead to my friend Larry's temporarily vacant apartment on East 10th Street. It was good to be back in the East Village. I'd missed the neighbourhood, the community gardens decorated with fairy lights and scrap sculpture, the way you could hear a dozen languages a minute on Avenue A. Urbanity: providing, as Sarah Schulman puts it in *Gentrification of the Mind*, 'the daily affirmation that people from other experiences are real', though the old diversity of race and sexuality and income was palpably imperilled by the unstoppable rise of condos and fro-yo outlets, the escalating rents.

Larry's apartment was packed with an ecstatic clutter of Americana, a collection that included but was by no means limited to a lovingly assembled library of celebrity biographies – P for Dolly Parton, H for Keith Haring – alongside perhaps a hundred empty bottles of Jack Daniels, dozens of crocheted blankets, musical instruments and throw cushions, a bust of Elvis in sunglasses and a lanky blow-up alien embracing a bloated scarlet King Kong.

Arising from out of this joyful disorder were Larry's artworks, chief among them a cape he'd been working on for all the time I'd known him. This cape was patchworked from hundreds of discarded embroidery projects gathered in thrift stores and rummage sales over decades, many of them unfinished. After stitching them together, Larry had begun to embellish the empty spaces with millions of sequins, each one of them hand-sewn. Aeroplanes, butterflies, ducks, a train drawing behind it a skein of coloured smoke: all these endearing leavings, these absolute discards of culture and good taste, had been drawn together, alchemised into a celebration of the anonymous, the domestic and the homespun.

The cape was an imposing presence in the apartment. It was huge, for a start, perhaps the brightest, most intensely coloured object I'd ever laid eyes on. I liked living alongside it. It felt nourishing, somehow, a totem object of a kind of collaboration that had not involved actual contact, actual proximity, but that had nonetheless created links, drawing together a community of strangers, scattered through time. I liked the way it gestured too at the invisible presence of the body, partly because it was so obviously a garment, hanging in the empty space of Larry's studio, and partly because it had been made by dozens of human hands, attesting in every stitch to human labour, to the human desire to make things not because they are useful but because they are pleasing or consoling in some way.

Art that repairs, art that longs for connection, or that finds a way to make it possible. It was around this time that I came across Zoe Leonard's extraordinary work of mourning, *Strange Fruit (for*

David). *Strange Fruit* is an installation, completed in 1997 and now part of the Philadelphia Museum of Art's permanent collection. It's made from 302 oranges, bananas, grapefruits, lemons and avocados, their contents eaten and their torn skins dried before being sutured back together with red, white and yellow thread, embellished with zippers, buttons, sinew, stickers, plastic, wire and fabric. The results are exhibited sometimes together and sometimes in small groupings, laid in state across the gallery floor, where they continue on their implacable business of rotting or shrinking or mouldering away, until in time they will turn to dust and vanish altogether.

This piece, which is clearly part of the vanitas tradition in art, the practice of depicting matter as it passes from radiance to decomposition, was made in memory of David Wojnarowicz, who had been a close friend of Leonard's. They first met back in 1980, when they worked together at the nightclub Danceteria, the after-hours headquarters of the downtown New Wave scene. Later, they were both members of ACT UP, and were for a time also in the same affinity group, which is to say that they'd made art and talked about art and attended protests and been arrested together for over a decade.

David's death in 1992 coincided with a period in which ACT UP began to fragment and factionalise, its membership buckling under the strain of trying to transform entrenched and toxic systems while caring for and mourning beloved friends. Many people withdrew around that time, among them Leonard, who left New York, travelling to India before spending stints in off-season Provincetown and then in Alaska. *Strange Fruit* was made

during those years of solitude, arising if not in response to then certainly as a consequence of the mass losses of the AIDS years, the exhaustion of labouring to bring about political change.

In an interview in 1997 with her friend, the art historian Anna Blume, Leonard talked about how the first fruits came into being.

> It was sort of a way to sew myself back up. I didn't even realize I was making art when I started doing them . . . I was tired of wasting things. Throwing things out all the time. One morning I'd eaten these two oranges, and I just didn't want to throw the peels away, so absentmindedly I sewed them back up.

The results immediately recalled David's own stitched works, which recur in a variety of mediums, among them objects, photographs, performances and scenes in films. A cut loaf of bread, the two halves loosely darned back together, so that the space between them is filled with a cat's cradle of scarlet embroidery thread. A famous photograph of his own face, his lips stitched shut, the points where the needle has apparently entered marked with dots of what looks like blood. These are among the signature works of the AIDS crisis, pieces that attest to silencing and endurance; to the isolation of being denied a voice. Sometimes the sewing seems redemptive, but more often it is used to expose and draw attention to censorship and hidden violence, to the kind of sundering and shunning that was going on everywhere in David's world.

The fruit are recognisably objects from the same war. The title

picks up on the ugly slang word *fruit* for gay men, the strange produce, the outcasts of society. And it alludes too to Billie Holiday's song about lynching: hatred and discrimination enacted physically, with extreme violence, on the twisted and burned bodies hanging in the trees. Billie Holiday, who gave voice to loneliness both personal and institutional, who lived and died inside it, a life short on love and brutalised by racism. Billie Holiday, who was called *Blackie* to her face and made to take the back door even in venues where she was herself the headline act, wounds that she attempted to medicate with the poisonous ameliorators of alcohol and heroin. Billie Holiday, who in the summer of 1959 collapsed in her room on West 87th Street while eating custard and oatmeal, and who was taken first to the Knickerbocker and then to the Metropolitan Hospital in Harlem, where she was left – as so many AIDS patients would be in the years that followed, particularly if they too had black or brown skin – on a gurney in a corridor, just another dope case.

The worst thing about this act of dehumanisation and denial of care was that it had happened before, back in 1937, when a stranger telephoned to tell her that her father Clarence was dead and where should they ship the body, the blood still staining his white dress shirt. Pneumonia, she recorded in her autobiography, *Lady Sings the Blues*: 'And it wasn't the pneumonia that killed him, it was Dallas, Texas. That's where he was and where he walked around, going from hospital to hospital trying to get help. But none of them would even so much as take his temperature or take him in. That's the way it was.'

She sang the song 'Strange Fruit' in protest against his death,

its lyrics seeming 'to spell out all the things that had killed Pop'. And then all those same things killed her too. She never got out of the Metropolitan. She was put under arrest for possession of narcotics, and spent the final month of her life dying in a hospital room guarded by two policemen, the humiliations metered out to the stigmatised being apparently unlimited.

In its work, ACT UP attempted to address at least some of these things, to untangle and challenge the systemic forces that made some bodies matter less than others, that made the bodies of homosexuals and drug addicts and people of colour and the homeless seem expendable. In the late 1980s, it was agreed by the ACT UP floor that their work should broaden out beyond gay men, to become more inclusive and to address the needs of other populations, among them drug users and women, particularly prostitutes.

Leonard's own work, which she describes in the ACT UP Oral History Project, was centred around needle exchanges, then a radical way of preventing the spread of AIDS. Though needle exchanges had briefly been established in New York City by Mayor Koch, under the zero tolerance ethos of the Giuliani administration they had become illegal, as they were in many other places both in America and globally. Leonard helped to establish a project that provided clean works and AIDS education for addicts, an activity for which she was arrested, charged, tried and risked a lengthy jail sentence in order to challenge the legality of syringe possession laws.

Strange Fruit is needlework of a different kind. It isn't activism, not like attending a protest or willingly breaking the law, and yet it deals with some of the same forces. It takes the pain of exclusion and loss and isolation, and holds them, quietly. It is political,

yes, but it is also personal, attesting to experiences that are the inescapable consequence of embodiment. Speechless, *very silent*, the fruit convey in their smallness, their particularity, the pain of breakage, of vanishing, of longing for something beloved that has departed and will not come again.

Their entreaty survives even the translation to a computer screen. Looking at them as .jpgs – a sutured orange, a banana wound absurdly with string – it is hard not to feel a tug of emotion, both in response to the damage and to the inadequate, attentive, hopeful, stubborn work of mending that had been done to them, stitch by stitch, zipper by button.

I was not the only person to find the fruit affecting. In a monograph for *Frieze* about Zoe Leonard's work, the critic Jenni Sorkin describes seeing the installation for the first time while wandering irritably around the Philadelphia Museum of Art some time around the beginning of the millennium. 'From a distance,' she writes, 'it looked like detritus. Then I got closer and stopped being annoyed and instead became very sad and felt suddenly very alone – despair hit me like a truck. The sewn fruit was absurdly, inexplicably, intimate.'

Loss is a cousin of loneliness. They intersect and overlap, and so it's not surprising that a work of mourning might invoke a feeling of aloneness, of separation. Mortality is lonely. Physical existence is lonely by its nature, stuck in a body that's moving inexorably towards decay, shrinking, wastage and fracture. Then there's the loneliness of bereavement, the loneliness of lost or damaged love, of missing one or many specific people, the lone-liness of mourning.

All this, though, could be conveyed with dead fruit, with drying skins on a gallery floor. What makes *Strange Fruit* so deeply touching, so intensely painful, is the work of stitching, which makes legible another aspect of loneliness: its endless agonising hope. Loneliness as a desire for closeness, for joining up, joining in, joining together, for gathering what has otherwise been sundered, abandoned, broken or left in isolation. Loneliness as a longing for integration, for a sense of feeling whole.

It's a funny business, threading things together, patching them up with cotton or string. Practical, but also symbolic, a work of the hands and the psyche alike. One of the most thoughtful accounts of the meanings contained in activities of this kind is provided by the psychoanalyst and paediatrician D. W. Winnicott, an heir to the work of Melanie Klein. Winnicott began his psychoanalytic career treating evacuee children during the Second World War. He worked lifelong on attachment and separation, developing along the way the concept of the transitional object, of holding, and of false and real selves, and how they develop in response to environments of danger and of safety.

In *Playing and Reality*, he describes the case of a small boy whose mother repeatedly left him to go into hospital, first to have his baby sister and then to receive treatment for depression. In the wake of these experiences, the boy became obsessed with string, using it to tie the furniture in the house together, knotting tables to chairs, yoking cushions to the fireplace. On one alarming occasion, he even tied a string around the neck of his infant sister.

Winnicott thought these actions were not, as the parents feared, random, naughty or insane, but rather declarative, a way of commu-

nicating something inadmissible in language. He thought that what the boy was trying to express was both a terror of separation and a desire to regain the contact he experienced as imperilled, maybe lost for good. 'String,' Winnicott wrote, 'can be looked upon as an extension of all other techniques of communication. String joins, just as it also helps in the wrapping up of objects and in the holding of unintegrated material. In this respect, string has a symbolic meaning for everyone,' adding warningly: 'an exaggeration of the use of string can easily belong to the beginning of a sense of insecurity or the idea of a lack of communication'.

The fear of separation is a central tenet of Winnicott's work. Primarily an infantile experience, it is a horror that lives on in the older child and the adult too, returning forcibly in circumstances of vulnerability or isolation. At its most extreme, this state gives rise to the cataclysmic feelings he called *the fruits of privation*, which include:

1) going to pieces
2) falling for ever
3) complete isolation because of there being no means for communication
4) disunion of psyche and soma

This list reports from the heart of loneliness, its central court. Falling apart, falling forever, never resuming vitality, becoming locked in perpetuity into the cell of solitary confinement, in which a sense of reality, of boundedness, is rapidly eroded: these are the consequences of separation, its bitter fruit.

What the infant desires in these scenes of abandonment is to

be held, to be contained, to be soothed by the rhythms of the breath, the pumping heart, to be received back through the good mirror of the mother's smiling face. As for the older child, or the adult who was inadequately nurtured or has been cast backwards by loss into a primal experience of separation, these feelings often spark a need for transitional objects, for cathected, loved things that can help the self to gather and regroup.

One of the most interesting things about Winnicott's account of the small string-obsessed boy is that though he's at pains to insist the behaviour is not abnormal, he does perceive dangers associated with it. If contact was not renewed, he thought the individual could potentially topple from grief into despair, in which case the object play would become instead what he called *perverse*. In this unwelcome state of affairs, the function of the string would change 'into a *denial of separation*. As a denial of separation string becomes a thing in itself, something that has dangerous properties and must needs be mastered'.

When I first read that statement, I immediately recalled the big wicker bin in Henry Darger's room that I'd visited in Chicago. It was filled with the salvaged coils and snippets of string that he gathered from gutters and trash cans across the city. Back home, he spent hours each day unravelling them, smoothing out the strands before tying them together. It was an occupation that he found deeply emotional, to judge from his journal, in which he records not much more than attendance at mass and tangles and difficulties with cord and brown twine.

29 March 1968: 'Tantrums over tangles and tied knots slipping in twine. Threaten to throw ball at sacred images because of this

difficulty.' 1 April 1968: 'Over tanglement of twine, difficult to do. Some severe tantrums and swear words.' 14 April 1968: 'From 2 to Six P. M. undid tangle of white twine to wrap around ball. More tantrums because sometimes the two ends of twine won't stay tied together.' 16 April 1968: 'Had trouble again with twine. Mad enough to wish I was a bad tornado. Swore at God.' 18 April 1968: 'Lots of twine and cord. Not tough tangles this time. Did singing instead of tantrums and swearing.'

There is in this record such emotional intensity, such profound swells of anger and distress, that one gets a visceral sense of what it might be like to regard string as a dangerous material: to see it as something that must be subdued, something into which larger anxieties could be channelled, something that if handled wrongly could unleash an outpouring of overwhelming grief or rage.

But according to Winnicott, this kind of activity could do more than simply deny separation or displace feeling. The use of transitional objects like string could also be a way of acknowledging damage and healing wounds, binding up the self so that contact could be renewed. Art, Winnicott thought, was a place in which this kind of labour might be attempted, where one could move freely between integration and disintegration, doing the work of mending, the work of grief, preparing oneself for the dangerous, lovely business of intimacy.

★

It seems funny to think that healing or coming to terms with loneliness and loss, or with the damage accrued in scenes of

closeness, the inevitable wounds that occur whenever people become entangled with one another, might take place by means of objects. It seems funny, and yet the more I thought about it the more prevalent it was. People make things – make art or things that are akin to art – as a way of expressing their need for contact, or their fear of it; people make objects as a way of coming to terms with shame, with grief. People make objects to strip themselves down, to survey their scars, and people make objects to resist oppression, to create a space in which they can move freely. Art doesn't have to have a reparative function, any more than it has a duty to be beautiful or moral. All the same, there is art that gestures towards repair; that, like Wojnarowicz's stitched loaf of bread, traverses the fragile space between separation and connection.

In the final five years of his life, Andy Warhol also worked with stitching, sewing photographic images together to form 309 organic, homespun versions of the old multiples. One of the most beautiful in this series is a patchwork of nine black and white photographs of his friend Jean-Michel Basquiat. They have been made a little imperfect during their passage through the sewing machine: the edges crimped, uncut threads trailing from the margins.

In the photograph, Basquiat is eating, tucking into a fantastic spread. His eyes are closed and he's almost crouching at the table, propelling into a mouth so open you can see his molars a forkful of what looks to be French toast. Full flash, a blur or shadow at his jaw. He's dressed all in white, white light bouncing off his face. On the crammed table in front of him are piled plates,

which only slowly resolve into the classic components of a diner brunch. Fruit cup, chrome milk and coffee jug, salt and pepper cellars, a jar of paper twists of sugar and a foaming glass of liquid, maybe beer. The impression is of opulence, richness, plenitude: all the abstract qualities, in fact, that Basquiat craved in his headlong pursuit of the never enough, his insatiable hunger that neither money, drugs nor fame could fill, and which was partly about being a black man trying to achieve recognition in a society that continually rejected him even as he was lauded and encircled.

In both the shape and cause of his hunger, Basquiat was not unlike his hero Billie Holiday. Like her, he was dogged no matter how famous he became by racism: mistaken for a pimp; refused entry to smart parties; unable even to get a cab to stop on the street, but forced instead to hide while white girlfriends did the hailing. His exquisite, inscrutable, magical art was set against all that, formulating its own deliberate language of dissent, creating a spell of resistance, speaking out in a rebellious tongue against systems of power and of malice. No wonder he was haunted when he discovered that Holiday didn't have a gravestone, spending a consumed few days designing one to suit her: an object that would rightly mark the manner of her living and the manifest cruelty of her death.

Warhol may not have understood all this, though he certainly witnessed scenes in which Basquiat was humiliated and excluded, collaborating with him too on a portrait of Billie Holiday, reclining in red shoes over a blued-out Del Monte sign. All the same, despite their many differences, these two men became inseparable.

Warhol loved Basquiat, in the same way that he had once loved Ondine. They first met in 1980, when Jean-Michel, then a grubby young graffiti artist who went by the tag SAMO, Same Old Shit, came up to him in the street and hustled him into buying a painting he didn't want.

'One of those kids who drive me crazy,' reports the first diary entry to mention his name, 4 October 1982, but soon it is *went to meet Jean Michel at the office*, or *cabbed to meet Jean Michel*; soon they are working out at the gym together and having their nails done; soon Jean-Michel is calling at all hours, sometimes to gossip and sometimes to spill a circuitry of anxiety and paranoia, of which Warhol observes: 'But actually if he's even on the phone talking to me, he's okay.'

In some ways Warhol shared Basquiat's greed for sensation, though not when it came to sex or drugs. According to the evidence of the diaries, in which Basquiat appears on 113 of the 807 pages, his heroic consumption both fascinated and repelled Warhol. Describing Basquiat's lengthy holiday with a girlfriend, he asked querulously, 'I mean, how long can you suck dick,' a question that tripped him into a very rare statement of regret about his own withdrawal from the arena of the physical: 'Oh, I don't know. I guess I've missed out on a lot in life – never pickups on the street or anything like that. I feel life has passed me by.'

He worried over Basquiat, longed for his company, and fretted over his heroin use, the times he'd come up to the studio and slump over a painting, taking five minutes to tie his shoe, or curling up and falling asleep right there on the Factory floor. What he loved most was the creativity of their friendship, the

way they made work together, side by side or even on the same canvas, their lines merging as Warhol increasingly adopted Basquiat's vernacular, his fabulously distinctive style. Basquiat brought him back to painting, introducing him too to a more creative crowd, the kind he'd been surrounded by in the 1960s and had lost touch with over the course of his vacuum-packed, tinsel years.

Some of this ardency leaks into the photograph, along with a palpable concern about where appetite is going, what its final destination might be. It often seems that there is a body-snatching quality to Warhol's portraiture, something vampiric about his desire to snap other people's countenances, to store and reproduce and multiply their essences. But I sometimes wonder if what he was trying to do was snatch them out of danger, by which I mean the danger of death that lurks everywhere in his work, from the paintings of electric chairs to *Empire*, his slow-motion, single-shot eight hour and five minute film of the Empire State Building over the course of an entire night, that long steady look at time washing over the face of the world.

One thing to confront it in your art, quite another to do it in real life. Warhol was always jittery around illness or any sign of physical decay, still the little boy who'd hidden under his bed right through his father's wake. His terror of death drove the phobia of hospitals he shared with Billie Holiday. *The place*, he called them, demanding that cab drivers make detours so that he could avoid catching so much as a contaminating glimpse of their front doors. His friendship with Basquiat coincided precisely with the gathering AIDS crisis, the entries interleaving in his journal.

Death and disappearance everywhere; death and disappearance explicitly yoked to appetite, to eros and to the fleeting, unstoppable ecstasy of getting high.

Warhol must have felt an intimation of threat, some premonition of potential loss, watching his friend twisting on the hook of heroin, shuttling between paranoia and somnambulance. As it happens, though, death being perverse above all things, it was he who died first, slipping quietly away in the early hours of Sunday 22 February 1987 in a private room in New York Hospital while recovering from apparently uneventful emergency surgery to remove his damaged gallbladder, an operation he had tried desperately to evade. Unlikely as it might once have seemed, Basquiat outlived him by eighteen months before overdosing on heroin in the summer of 1988 in the building on Great Jones Street, in pre-gentrification Soho, that he rented from Andy.

In its obituary, the *New York Times* observed: 'Mr. Warhol's death last year removed one of the few reins on Mr. Basquiat's mercurial behavior and appetite for narcotics.' Perhaps Warhol's sense of being a rein on Basquiat, a tethering thread, is part of why the stitched portrait seems of a piece with the *Extinction* silkscreens he made in 1983, at the behest of environmental activists: a series which also communicates his anxiety about beloved creatures being lost or snatched away. Each one displays a species that was imperilled, that was running out of time, among them an African elephant, a black rhino and a bighorn ram, the sadness and gravity of their regard undiminished by the pop colours, the commercial cheer. Mementos from a time of disappearances, the first intimations of the uncountable losses with which we're now confronted,

the unimaginable loneliness of being left behind in the world we have despoiled.

Against this omnipresent, quickening threat of extinction, against the mounting risk of abandonment, Warhol summoned things, a ballast of objects, a way to check or trap or maybe even trick time altogether. Like many people, among them Henry Darger, he treated his separation anxiety, his fear of loss and loneliness, by hoarding and collecting, by shopping obsessively. This is the acquisitive Andy immortalised in the silver statue in Union Square, his Polaroid camera around his neck, a Bloomingdale's Medium Brown Bag in his right hand. This is the Andy who before taking the cab to hospital with what must have been an agonisingly painful infected gallbladder spent his last hours at home on East 66th Street stuffing his safe with valuables, the Andy whose house after his death was found to be crammed on every floor with hundreds and thousands of unopened packages and bags, containing everything from underwear and cosmetics to Art Deco antiques.

But like every ordinary activity in which he participated, Warhol also alchemised his hoarding into art. The largest and most extensive artwork he ever made was the Time Capsules, 610 sealed brown cardboard boxes filled over the last thirteen years of his life with all the varied detritus that flooded into the Factory: postcards, letters, newspapers, magazines, photographs, invoices, slices of pizza, a piece of chocolate cake, even a mummified human foot. He kept one on the go in his office at the Factory and one at home, moving them when full into a storage unit, though his intention was eventually to sell or exhibit them somehow. After his death they were transferred to the Warhol

Museum in Pittsburgh, where a team of curators have been working since the early 1990s to systematically catalogue their contents.

While I was living at Larry's, I decided I wanted to look at the Time Capsules, to see what it was that Warhol wanted to preserve. The project wasn't yet open to the public, and so once again I wrote a begging letter to the curator, who agreed that I could spend five days viewing but not touching some of the contents.

I'd never been to Pittsburgh before. My hotel was a few blocks from the Warhol, and each morning I walked to it on a street that ran parallel to the river, wishing I'd brought gloves. I fell in love with the museum at first sight. My favourite space was towards the top of the building: a maze of dimly lit, echoing rooms in which a dozen of Warhol's movies from the 1960s were being projected. I'd never seen them full-size before, flickering and granular, the colour of mercury or tarnished silver. All those lovely things his eye had eaten up. John Giorni's dreaming, somnolent body. The beautiful Mario Montez, resplendent in a white fur headdress, slowly and erotically consuming a banana. A naked, cavorting Taylor Mead, whose memorial service at St Mark's Church I went to the next year, wanting to pay my respects to the diminishing Warhol circle. Nico in *Chelsea Girls*; the sky behind the Empire State Building growing infinitesimally more light. Time in the room was running palpably slow, hanging heavy, because of the way the films were projected at half speed.

The Time Capsules themselves were kept on metal shelves in the archivists' lair on the fourth floor. At the end of the room, a

man inside a plastic tent was carrying out the delicate work of conservation, and at a table near the front a young woman with a magnifying glass was identifying people in Warhol's photographs. The artist Jeremy Deller was also visiting, resplendent in a Barbie pink Puffa jacket. He'd known Warhol in the 1980s and among the pile of pictures he found a couple of them hanging out together in Warhol's suite at a grand London hotel, Deller in a stripy blazer and Andy with a floppy, slightly foolish hat perched above his wig.

To view the Capsules, we had to don blue plastic gloves. The curator took down the boxes one by one, laying out each item on a protective sheet of paper. Time Capsule −27 was filled with Julia Warhola's clothes: her floral aprons and yellowing scarves, a black velour hat with a rhinestone pin, a letter that began *Dear Buba and Uncle Andy, Did Santa Clause come up there? Did you see TV?* Old satin flowers, a single earring, a dirty paper towel, many of them packed away in plastic carrot bags, a lasting record of Julia's eccentric storage solutions, her stubborn thrift.

In Time Capsule 522, there were remnants of Basquiat, including his birth certificate, which he had tagged, and a drawing he'd done of Andy all in blue, his arms wide open, holding a camera with the word *CAMERA* in block capitals beneath it. There was a letter from him too, on paper from the Royal Hawaiian hotel, three sparsely written pages, that started *HI SWEETHEART, HERE IN WAIKIKI.*

But alongside these seemingly precious relics were other boxes filled with hundreds of stamps, with hotel pyjamas still in their wrappers, with cigarette butts and pencils, with pages and pages of

jotted notes containing names for Superstars that never were. A used paintbrush, a ticket stub for the opera, a New York State Driver's Manual, a single brown suede glove. Candy wrappers, not quite empty bottles of Chloé and Ma Griffe, an inflatable birthday cake signed with a Sharpie, *Love Yoko & Co.*

What were the Capsules, really? Trash cans, coffins, vitrines, safes; ways of keeping the loved together, ways of never having to admit to loss or feel the pain of loneliness. Like Leonard's *Strange Fruit*, they have something of the feeling of an ontological investigation. What is left after the essence has departed? Rind and skin, things you want to throw away but somehow can't. What would Winnicott have made of them? Would he have used the word *perverse*, or would he have seen their tenderness, the way they work to arrest time, to prevent the quick and dead from slipping too far, too fast?

Andy's nephew Donald was giving a talk at the museum while I was there, as he did most weeks. One afternoon we sat down in the café together and he told me about his uncle, speaking slowly and distinctly into my little silver tape recorder. What he remembered most was Andy's kindness, how he liked to joke around with the kids, as his two beloved dachshunds, Amos and Archie, ran barking round the room. His apartment had been crammed from top to bottom with fascinating objects, and Donald remembered thinking even then that it was a microcosm of New York, the city that seemed so thrilling to him as a child.

Uncle Andy had a knack for listening, for getting whoever he was with to speak about their lives, even if they were children. 'I think he didn't like to talk about himself, because he just found

other people more interesting,' Donald said, adding later that he thought Warhol had found himself boring. Andrew Warhola, that is, the vulnerable human self still resident beneath the silvered wig and corset.

He touched on Warhol's Catholicism, something that he shared with both Darger and Wojnarowicz: how every Sunday was a holy day, on which he would invariably go to church. This information aligned with references in the diaries to spending repeated Christmas days doling out food in homeless shelters, an aspect of Warhol that tends to be eclipsed by tales of party-going and celebrity friends. He talked too about how much Andy had missed his mother after she died, how he had learned to live around the loss.

I asked him then if he thought that Warhol was happy and he said that Andy was at his happiest in his studio, a place that Donald described as his *playland*, adding that he thought Andy had sacrificed a great deal to become an artist, including the possibility of having a family of his own. Later, after I'd turned off the machine and we were walking out of the café, we began to chat about the Capsules, and he said musingly, *maybe they were a partner to him*.

Maybe they were, or at least a way of occupying the space a partner would have inhabited. Or maybe it was just reassuring to know that whatever happened, whoever vanished next, he had all the evidence in order, boxed and ready for the case against death.

<div align="center">★</div>

It's easy to forget that Warhol was a stitched work in his own right. On the last day that I was at the Museum, one of the curators showed me a box of the corsets Andy had no choice but to wear every day of his life after Solanas's bullet passed right through him, clipping organs, ricocheting through his interior and leaving him with a permanent hernia, a hole in his belly. *Bauer & Black, Abdominal Belt, Extra Small, Made in the USA*, the label read.

They were shockingly tiny, to fit his twenty-eight-inch waist. Many had been hand-dyed by his friend Brigid Berlin, also known as Brigid Polk and the Duchess, B to his A. She'd picked cheerful colours, tomato red and lettuce green, lavender, orange, lemon and a pretty bluish-grey. They looked like the sort of thing Marie Antoinette might wear – a post-punk Marie, anyway, off to Danceteria in a towering pink wig. 'She does a beautiful job on them,' Warhol told the Diary in 1981. 'The colors are so glamorous,' adding regretfully of his then crush: 'but it looks like no one will ever see them on me – things aren't progressing with Jon.'

The corsets made me more aware than anything of Warhol as a physical presence, a body that was always on the verge of falling apart. He spent so much of his life trying to stick himself together, an assemblage of purchased parts: the white and blond wigs, the big glasses, the cosmetics he used to conceal his patchy reddish skin, his ugly open pores. One of the most prevalent phrases in his diary is *glued myself together*, which is to say the nightly routine of taping on his wig, putting together the finished Andy, the public production, the camera-ready, professional version. Towards

the end of his life, he often spent evenings playing with cosmetics in front of his mirror, giving himself better and brighter faces, the same benevolent, flattering magic trick he'd performed for hundreds of celebrities and socialites, from Debbie Harry to Chairman Mao.

The glue only failed him once, on 30 October 1985, when he was signing copies of his photobook *America* at Rizzoli bookstore. In front of the queue, in front of the entire store, a pretty, well-dressed girl ran up and snatched his wig off, exposing his bald head, a signifier of shame, permanently concealed since he first began to lose his hair as a young man.

He didn't run away. He pulled up the hood of his Calvin Klein coat and carried on signing for the crowd. To his diary a few days later, he began by saying: 'Okay, let's get it over with. Wednesday. The day my biggest nightmare came true.' He described the experience as agonising. 'It was so shocking. It hurt. Physically. And it hurt because nobody had warned me.'

No wonder. Imagine being stripped, having the most excruciating portions of your body bared to hostile or amused witnesses. Back when he was a little boy, Andrew Warhola had once refused to go to school for a whole year because a girl in his class had kicked him. But this was worse; not just violence against his person, but rather having the pieces of himself torn apart, literally disarticulated.

There are very few images I can think of in which Warhol shows this aspect of himself willingly, divested of his uniform, exposing the same vulnerable human form that both the corsets and the Time Capsules protected him against. Back in New York, I hunted

out the series of black and white photographs taken by Richard Avedon in the summer of 1969, in which Warhol in a black leather jacket and black sweater flaunts his scarred abdomen, posing like St Sebastian, his arms akimbo.

The other portrait of undress was painted by Alice Neel in 1970 and is now owned by the Whitney. In it, Warhol is sitting on a couch, wearing brown trousers and gleaming brown shoes. He's strapped into his corset, but is otherwise naked to the waist, revealing a scarred and dented chest, marked by two deep intersecting purple gashes, which divide his ribcage into triangles. Running on either side of them is a ladder of quick white dashes that represent the ghosts of stitches. Neel's eye, Neel's brush lingers attentively on his ruined body, beautiful and damaged. She gets it all: the slender wrists, the bulging corseted belly, the delicate little breasts with their pink areolae.

I loved how Warhol looked in that picture, the careful reticent way he holds himself. His eyes are closed, his chin is up. Neel has done his face in a lovely muted palette of pale pinks and greys, with thin shadowy blue lines running along his jaw and hairline, giving him the exquisite pallor he'd always craved, and emphasising the remarkable fineness of his bones. What is the word for his expression? It's not exactly proud or ashamed; it is a creature tolerating inspection, at once exposed and withdrawn; an image of resilience as well as profound, unsettling vulnerability.

Strange, to see such an adept gazer submitting to someone else's scrutiny. 'He looks a bit like a woman, male and female in one,' the painter Marlene Dumas commented of the portrait.

'Warhol was also enigmatic; there is a total fake, artificial aspect, then there is the lonely aspect of an alienated character.'

Loneliness is not supposed to induce empathy, but like Wojnarowicz's diaries and Klaus Nomi's voice, that painting of Warhol was one of the things that most medicated my own feelings of loneliness, giving me a sense of the potential beauty present in a frank declaration that one is human and as such subject to need. So much of the pain of loneliness is to do with concealment, with feeling compelled to hide vulnerability, to tuck ugliness away, to cover up scars as if they are literally repulsive. But why hide? What's so shameful about wanting, about desire, about having failed to achieve satisfaction, about experiencing unhappiness? Why this need to constantly inhabit peak states, or to be comfortably sealed inside a unit of two, turned inward from the world at large?

In her discussion about *Strange Fruit*, Zoe Leonard made a statement about this business of imperfection, about the way life is made up of endless failures of intimacy, endless errors and separations, that anyway culminate only with loss. At first, she says, the sewing

> . . . was a way to think about David. I'd think about the things I'd like to repair and all the things I'd like to put back together, not only losing him in his death, but losing him in our friendship while he was still alive. After a while I began thinking about loss itself, the actual act of repairing. All the friends I'd lost, all the mistakes I've made. The inevitability of a scarred life. The attempt to sew it back

together . . . This mending cannot possibly mend any real wounds, but it provided something for me. Maybe just time, or the rhythm of sewing. I haven't been able to change anything in the past, or bring back any of the people I love who have died, but I've been able to experience my love and loss in a measured and continuous way; to remember.

There are so many things that art can't do. It can't bring the dead back to life, it can't mend arguments between friends, or cure AIDS, or halt the pace of climate change. All the same, it does have some extraordinary functions, some odd negotiating ability between people, including people who never meet and yet who infiltrate and enrich each other's lives. It does have a capacity to create intimacy; it does have a way of healing wounds, and better yet of making it apparent that not all wounds need healing and not all scars are ugly.

If I sound adamant it is because I am speaking from personal experience. When I came to New York I was in pieces, and though it sounds perverse, the way I recovered a sense of wholeness was not by meeting someone or by falling in love, but rather by handling the things that other people had made, slowly absorbing by way of this contact the fact that loneliness, longing, does not mean one has failed, but simply that one is alive.

There is a gentrification that is happening to cities, and there is a gentrification that is happening to the emotions too, with a similarly homogenising, whitening, deadening effect. Amidst the glossiness of late capitalism, we are fed the notion that all difficult

feelings – depression, anxiety, loneliness, rage – are simply a consequence of unsettled chemistry, a problem to be fixed, rather than a response to structural injustice or, on the other hand, to the native texture of embodiment, of doing time, as David Wojnarowicz memorably put it, in a rented body, with all the attendant grief and frustration that entails.

I don't believe the cure for loneliness is meeting someone, not necessarily. I think it's about two things: learning how to befriend yourself and understanding that many of the things that seem to afflict us as individuals are in fact a result of larger forces of stigma and exclusion, which can and should be resisted.

Loneliness is personal, and it is also political. Loneliness is collective; it is a city. As to how to inhabit it, there are no rules and nor is there any need to feel shame, only to remember that the pursuit of individual happiness does not trump or excuse our obligations to each another. We are in this together, this accumulation of scars, this world of objects, this physical and temporary heaven that so often takes on the countenance of hell. What matters is kindness; what matters is solidarity. What matters is staying alert, staying open, because if we know anything from what has gone before us, it is that the time for feeling will not last.

NOTES

BACKGROUND MATERIAL ABOUT DAVID WOJNAROWICZ'S life and work comes from the wonderfully rich David Wojnarowicz Papers (MSS 092) at Fales Library and Special Collections, New York University Libraries (hereafter Fales). Cynthia Carr's extraordinarily detailed, beautiful and acute Wojnarowicz biography, *Fire in the Belly* (Bloomsbury, 2012), was also indispensible.

The ACT UP Oral History Project, founded by Jim Hubbard and Sarah Schulman, was of great assistance in understanding both the progress of AIDS in New York City and the work of ACT UP. Transcripts of all interviews can be read at www.actuporalhistory.org, and footage can be viewed at Videotapes, Manuscripts and Archives Division, The New York Public Library.

Unpublished material about Darger's life is drawn from the Henry Darger Papers, American Folk Art Museum Archives, New York (hereafter HDP).

I'm particularly indebted to Gail Levin and Breanne Fahs, the biographers of Edward Hopper and Valerie Solanas respectively, whose meticulous biographies bring into print the remarkable

details of their subjects' lives, including many previously unpublished letters and interviews.

CHAPTER 1: THE LONELY CITY

4 '*a chronic disease without redeeming features* . . .': Robert Weiss, *Loneliness: The Experience of Emotional and Social Isolation* (MIT Press, 1975), p. 15.

4 '*If I could catch the feeling* . . .': Virginia Woolf, ed. Anne Olivier Bell, *The Diary of Virginia Woolf, Volume III 1925–1930* (Hogarth Press, 1980), p. 260.

8 '*Loneliness is a* . . .': Dennis Wilson, 'Thoughts of You', *Pacific Ocean Blue* (1977).

CHAPTER 2: WALLS OF GLASS

16 '*It's nothing accurate at all* . . .': Gail Levin, *Edward Hopper: An Intimate Biography* (Rizzoli, 2007), p. 493.

17 '*The loneliness thing is* . . .': Brian O'Doherty, *American Masters: The Voice and the Myth* (E. P. Dutton, 1982), p. 9.

17 '*Are your paintings reflective* . . .': *Hopper's Silence*, dir. Brian O'Doherty (1981).

17 '*certain kinds of spaces* . . .': Carter Foster, *Hopper's Drawings* (Whitney Museum/Yale University Press, 2013), p. 151.

20 '*our most poignant* . . .': Joyce Carol Oates, 'Nighthawk: A Memoir of Lost Time', *Yale Review*, Vol. 89, Issue 2, April 2001, pp. 56–72.

22 '*brilliant streak* . . .': Deborah Lyons, ed., *Edward Hopper: A Journal of His Work* (Whitney Museum of American Art/W. W. Norton, 1997), p. 63.

23 '*the exceedingly unpleasant* . . .': Harry Stack Sullivan, *The Interpersonal Theory of Psychiatry* (Routledge, 2001 [1953]), p. 290.

24 '*The writer who wishes* . . .': Frieda Fromm-Reichmann, 'On Loneliness',

in *Psychoanalysis and Psychotherapy: Selected Papers of Frieda Fromm-Reichmann,* ed. Dexter M. Bullard (University of Chicago Press, 1959), p. 325.

25 *'Loneliness, in its quintessential form . . .':* ibid., pp. 327–8.

26 *'I don't know why . . .':* ibid., pp. 330–31.

26 *'possessed . . .':* Robert Weiss, *Loneliness: The Experience of Emotional and Social Isolation,* pp. 11–13.

30 *'The man's the work . . .':* Katherine Kuh, *The Artist's Voice: Talks with Seventeen Artists* (Harper & Row, 1960), p. 131.

31 *'I'm being very biographic . . .':* Interview with Edward Hopper and Arlene Jacobowitz, April 29, 1966 from 'Listening to Pictures' program of the Brooklyn Museum. Gift of the Brooklyn Museum. Archives of American Art, Smithsonian Institution (housed at Edward and Josephine Hopper Research Collection; Whitney Museum of American Art, Frances Mulhall Achilles Library).

33 *'I'd heard of Gertrude Stein . . .':* Brian O'Doherty, 'Portrait: Edward Hopper', *Art in America,* Vol. 52, December 1964, p. 69.

33 *'It seemed awfully crude . . .':* ibid., p. 73.

34 *'They are not factual . . .':* Interview with Edward Hopper and Arlene Jacobowitz, April 29, 1966 from 'Listening to Pictures' program of the Brooklyn Museum. Gift of the Brooklyn Museum. Archives of American Art, Smithsonian Institution (housed at Edward and Josephine Hopper Research Collection; Whitney Museum of American Art, Frances Mulhall Achilles Library).

34 *'The interior itself . . .':* Gail Levin, *Edward Hopper,* p. 138.

37 *'without a stitch on . . .':* ibid., p. 335.

38 *'Any talk with me . . .':* ibid., p. 389.

39 *'Should be married . . .':* ibid., pp. 124–5.

40 *'the most exact transcription . . .':* Edward Hopper, 'Notes on Painting', in Alfred H. Barr, Jr, et al, *Edward Hopper: Retrospective Exhibition, November 1 – December 7, 1933* (MoMA, 1933), p. 17.

40 *'to force this unwilling medium . . .':* ibid., p. 17.

40 '*I find in working always . . .*': ibid., p. 17.

41 '*I haven't gone thru . . .*': Gail Levin, *Edward Hopper*, pp. 348–9.

43 '*seems to be the way . . .*': Katherine Kuh, *The Artist's Voice: Talks with Seventeen Artists*, pp. 134–5.

CHAPTER 3: MY HEART OPENS TO YOUR VOICE

48 '*The silent adjustments . . .*': Ludwig Wittgenstein, *Tractatus Logico-Philosophicus* (Harcourt, Brace & Co., 1922), p. 39.

51 '*I only know one language . . .*': Andy Warhol, *The Philosophy of Andy Warhol* (Penguin, 2007 [1975]), pp. 147–8.

52 '*To me good talkers . . .*': ibid., p. 62.

53 '*And my brother . . .*': Andy Warhol, *The Andy Warhol Diaries*, ed. Pat Hackett (Warner Books, 1991), p. 575.

55 '*"ats" for "that is" . . .*': Victor Bockris, *Warhol: The Biography* (Da Capo Press, 2003 [1989]), p. 60.

56 '*He had an enormous inferiority complex . . .*': ibid., p. 115.

56 '*just a hopeless born loser . . .*': ibid., p. 91.

59 '*all the Cokes . . .*': Andy Warhol, *The Philosophy of Andy Warhol*, p. 101.

59 '*If everybody's not a beauty . . .*': ibid., p. 62.

60 '*The reason I'm painting . . .*': Andy Warhol, interviewed by Gene Swenson, 'What Is Pop Art? Interviews with Eight Painters (Part 1)', *Art News*, Issue 62, November 1963.

61 '*He made a virtue . . .*': Victor Bockris, *Warhol: The Biography*, p. 137.

62 '*Machines have less problems . . .*': Andy Warhol, 'Pop Art: Cult of the Commonplace', *TIME*, Vol. 81, No. 18, 3 May 1963.

62 '*B is anybody . . .*': Andy Warhol, *The Philosophy of Andy Warhol*, p. 5.

63 '*I guess I wanted to be . . .*': ibid., p. 22.

63 '*At the times in my life . . .*': ibid., p. 21.

65 '*I need B because . . .*' ibid., p. 5.

65 '*finding it stunning and poignant . . .*': Stephen Shore, *The Velvet Years: Warhol's Factory 1965–67* (Pavilion Books, 1995) p. 23.

66 'He was a little bit franker . . .': ibid., p. 130.

67 'I didn't get married . . .': Andy Warhol, The Philosophy of Andy Warhol, p. 26.

68 'My guess is that it helped . . .': Stephen Shore, The Velvet Years, p. 22.

68 'I don't really feel . . .': Gretchen Berg, 'Andy Warhol: My True Story', in Kenneth Goldsmith, I'll Be Your Mirror: Selected Andy Warhol Interviews 1962–1987 (Da Capo Press, 2004), p. 91.

68 'Andy was the worst . . .': Mary Woronov, Swimming Underground: My Years in the Warhol Factory (Serpent's Tail, 2004), p. 121.

69 'confidence in the stability . . .': Rei Terada, 'Philosophical Self-Denial: Wittgenstein and the Fear of Public Language', Common Knowledge, Vol. 8, Issue 3, Fall 2002, pp. 464–81.

71 'pure Ondine . . .': Andy Warhol and Pat Hackett, POPism (Penguin, 2007 [1980]), p. 98.

71 'you have finished me off . . .' Andy Warhol, a, a novel (Virgin, 2005 [1968]), p. 280.

72 'The only way to talk . . .': ibid., p. 121.

73 'I'm making love to the tape recorder . . .': ibid., p. 445.

73 'No, oh Della, please . . .': ibid., p. 44.

73 'may I ask you . . .': ibid., p. 53.

73 'Don't you hate me . . .': ibid., p. 256.

73 'Please shut it off . . .': ibid., p. 264.

74 'The dialogue was straight . . .': Warhol, The Andy Warhol Diaries, p. 406.

74 'How old are you . . .': Andy Warhol, a: a novel, p. 342.

74 'SPF—Why do you avoid . . .': ibid., p. 344.

76 'Prussian tactics . . .': ibid., p. 389.

76 'Andy was the chief psychiatrist . . .': Stephen Shore, The Velvet Years, p. 155.

77 'something – work or a feeling . . .': Lynne Tillman, 'The Last Words are Andy Warhol', Grey Room, Vol. 21, Fall 2005, p. 40.

77 'Out of the garbage . . .': Andy Warhol, a, a novel, p. 451.

79 'dominant, secure, self-confident . . .':Valerie Solanas, *SCUM Manifesto* (Verso, 2004 [1971]), p. 70.

80 '*SCUM is against the entire system* . . .': ibid., p. 76.

81 '*Valerie Solanas was a loner* . . .': Avital Ronell, ibid., p. 9.

81 '*It is a product* . . .': Mary Harron, in Breanne Fahs, *Valerie Solanas* (The Feminist Press, 2014), p. 61.

81 '*SCUM Manifesto was* . . .': ibid., p. 71.

81 '*A true community* . . .':Valerie Solanas, *SCUM Manifesto*, p. 49.

82 '*to keep under your pillow* . . .': Breanne Fahs, *Valerie Solanas*, p. 99.

82 '*dead serious* . . .': ibid., p. 87.

82 '*Andy, will you* . . .': ibid., pp. 100–102.

85 '*Toad* . . .': ibid., pp. 121–2.

86 '*I felt horrible, horrible* . . .': Andy Warhol, *POPism*, pp. 343–5.

88 '*Read my manifesto* . . .': Howard Smith, 'The Shot That Shattered The Velvet Underground', *Village Voice*,Vol. XIII, No. 34, 6 June 1968.

88 '*I'm a writer* . . .': *Daily News*, 4 June 1968.

89 '*do it again* . . .': Andy Warhol, *POPism*, p. 361.

92 '*glued-together* . . .': Andy Warhol, ibid., p. 358.

92 '*It's too hard to care* . . .': Gretchen Berg, 'Andy Warhol: My True Story', in Kenneth Goldsmith, *I'll Be Your Mirror: Selected Andy Warhol Interviews 1962–1987*, p. 96.

92 '*What I never* . . .': Andy Warhol, *POPism*, p. 359.

CHAPTER 4: IN LOVING HIM

100 '*I've periodically* . . .': Cynthia Carr, *Fire in the Belly*, p. 133.

101 '*In my home one could not* . . .': David Wojnarowicz, *Close to the Knives: A Memoir of Disintegration* (Vintage, 1991), p. 152.

103 '*testing testing testing* . . .': ibid., p. 6.

105 '*I did what I could* . . .': Tom Rauffenbart, *Rimbaud in New York* (Andrew Roth, 2004), p. 3.

106 '*There was no way* . . .': David Wojnarowicz, Fales, Series 8A, 'David Wojnarowicz Interviewed by Keith Davis'.

106 '*I could barely speak* . . .': David Wojnarowicz, *Close to the Knives*, p. 228.

106 '*My queerness* . . .': David Wojnarowicz, Fales, Series 7A, Box 9, Folder 2, 'Biographical Dateline'.

107 '*the sound of it* . . .': David Wojnarowicz, *Close to the Knives*, p. 105.

109 '*things I'd always* . . .': David Wojnarowicz, ed. Amy Scholder, *In the Shadow of the American Dream* (Grove Press, 2000), p. 130.

109 '*I want to create* . . .': ibid., p. 219.

110 '*I found myself walking* . . .': ibid., p. 161.

110 '*Although the Rimbaud* . . .': Tom Rauffenbart, *Rimbaud in New York*, p. 3.

113 '*So simple, the appearance* . . .': David Wojnarowicz, *Close to the Knives*, p. 9.

114 '*the solitude of two persons* . . .': David Wojnarowicz, unpublished journal entry, Fales, Series 1, Box 1, Folder 4, 26 September 1977.

117 '*Our society is* . . .': Valerie Solanas, *SCUM Manifesto*, p. 48.

118 '*a space at a libidinal* . . .': Samuel Delany, *The Motion of Light on Water* (Paladin, 1990), p. 202.

119 '*What has happened* . . .': Samuel Delany, *Times Square Red, Times Square Blue* (New York University Press, 1999), p. 175.

120 '*Of course, not all* . . .': Maggie Nelson, *The Art of Cruelty* (W. W. Norton & Co., 2011), p. 183.

121 '*SCUM gets around* . . .': Valerie Solanas, *SCUM Manifesto*, p. 61.

122 '*When I stopped working* . . .': Charlotte Chandler, *Ingrid Bergman: A Personal Biography* (Simon & Schuster, 2007), p. 239.

122 '*Often I just go where* . . .': *People*, Vol. 33, No. 17, 30 April 1990.

123 '*Just the kind of thing* . . .': Andy Warhol, *The Andy Warhol Diaries*, p. 634.

123 '*A LONELY FORM* . . .': *Life*, Vol. 38, No. 24, 24 January 1955.

124 '*That's how I express* . . .': Barry Paris, *Garbo* (Sidgwick & Jackson, 1995), p. 539.

126 '*Scottie, what are you doing* . . .': *Vertigo*, dir. Alfred Hitchcock (1958).

128 'The instant of photographing . . .': Nan Goldin, The Ballad of Sexual Dependency (Aperture, 2012 [1986]), p. 6.

129 'third gender . . .': Nan Goldin, The Other Side 1972–1992 (Cornerhouse Publications, 1993), p. 5.

131 'I saw the role . . .': Nan Goldin, The Ballad of Sexual Dependency, p. 8.

131 'I decided as a young girl . . .': ibid., p. 145.

132 'I want to make somebody . . .': David Wojnarowicz, Brush Fires in the Social Landscape (Aperture, 2015), p. 160.

133 'I always consider myself . . .': David Wojnarowicz, Close to the Knives, p. 183.

133 'In loving him . . .': ibid., p. 17.

CHAPTER 5: THE REALMS OF THE UNREAL

All material from Henry Darger's memoir derives from Henry Darger, *The History of My Life,* Box 25, HDP.

155 'My dear friend Miss Catherine . . .': Henry Darger, letter to Catherine Schoeder (Katherine Schloeder), Folder 48:30, 1 June 1959, Folder 48:30, Box 48, HDP.

156 'Saturday April 12 . . .': Henry Darger, Journal 27 Feb 1965 – 1 Jan 1972, Folder 33:3, Box 33, HDP.

158 'The intention consisted . . .': Pierre Cabanne, Dialogues with Marcel Duchamp (Da Capo Press, 1988), p. 46.

164 'This endless stream . . .': John MacGregor, Henry Darger: In the Realms of the Unreal (Delano Greenidge Editions, 2002), p. 117.

165 'to play, to be happy . . .': ibid., p. 195.

170 'Grahams bank . . .': Henry Darger, Predictions June 1911 – December 1917, Folder 33:1, Box 33, HDP.

173 'the sense of being alone . . .': Melanie Klein, 'On the Sense of Loneliness', in Envy and Gratitude and Other Works 1946–1963 (The Hogarth Press, 1975), p. 300.

173 '*an unattainable perfect internal . . .*': ibid., p. 300.

174 '*It is generally supposed . . .*': ibid., p. 302.

CHAPTER 6: AT THE BEGINNING OF THE END OF THE WORLD

180 '*I might as well look . . .*': *The Nomi Song*, dir. Andrew Horn (2004).

182 '*I still get goose pimples . . .*': Steven Hager, *Art After Midnight: The East Village Scene* (St Martin's Press, 1986), p. 30.

182 '*Everyone was a freak . . .*': *The Nomi Song*, dir. Andrew Horn (2004).

182 '*you were witnessing one of . . .*': ibid.

184 '*He was always thin . . .*': Rupert Smith, *Attitude*, Vol. 1, No. 3, July 1994.

185 '*He began to look like a monster . . .*': ibid.

186 '*A lot of people took off . . .*': *The Nomi Song*, dir. Andrew Horn (2004).

186 '*I remember seeing him . . .*': ibid.

187 '*bodily signs designed to expose . . .*': Erving Goffman, *Stigma: Notes on the Management of Spoiled Identity* (Penguin, 1990 [1963]), p. 11.

187 '*reduced . . .*': ibid., p. 12.

188 References to Margaret Heckler and the White House press conference are drawn from Jon Cohen, *Shots in the Dark: The Wayward Search for an AIDS Vaccine* (W. W. Norton, 2001) pp. 3–6.

189 '*There is one, only one . . .*': Pat Buchanan, 'AIDS and moral bankruptcy', *New York Post*, 2 December 1987.

190 '*Then came the sledgehammer . . .*': Bruce Benderson, *Sex and Isolation* (University of Wisconsin Press, 2007), p. 167.

192 '*found herself frightened . . .*': Michael Daly, 'Aids Anxiety', *New York Magazine*, 20 June 1983.

192 '*a community of pariahs . . .*': Susan Sontag, *Illness as Metaphor and AIDS and Its Metaphors* (Penguin Modern Classics, 2002 [1978/1989]), p. 110.

192 '*I used my own . . .*': Andy Warhol, *The Andy Warhol Diaries*, p. 506.

192 '*I didn't want to be near . . .*': ibid., p. 429.

193 'The New York Times *had a big article . . .*': ibid., p. 442.

193 '*We went and watched . . .*': ibid., p. 583.

193 '*You know, I wouldn't be surprised . . .*': ibid., p. 692.

194 '*Then they picked me up . . .*': ibid., p. 800.

194 '*the other news from . . .*': ibid., p. 760.

195 '*risk-taking individuals . . .*': Sarah Schulman, *Gentrification of the Mind* (University of California Press, 2012), p. 38.

197 '*Peter was probably . . .*': Stephen Koch, interview with author, 9 September 2014.

198 '*You know why . . .*': David Wojnarowicz, *Close to the Knives*, p. 106.

198 '*the rabid strangers . . .*': ibid., p. 104.

198 '*If you want to stop AIDS . . .*': David Wojnarowicz, 7 *Miles A Second* (Fantagraphics, 2013), p. 47.

199 '*that beautiful hand . . .*': David Wojnarowicz, *Close to the Knives*, pp. 102–3.

200 '*The beginning of the end . . .*': Sarah Schulman, *People in Trouble* (Sheba Feminist Press, 1990), p. 1.

201 '*merge one's body . . .*': David Wojnarowicz, untitled manuscript, Fales, Series 3A, Box 5, Folder 160.

201 '*If I could attach . . .*': David Wojnarowicz, 7 *Miles A Second*, p. 61.

204 '*My rage is really about the fact . . .*': David Wojnarowicz, *Close to the Knives*, p. 114.

205 '*One day politicians . . .*': David Wojnarowicz, *Untitled (One day this kid)*, courtesy of the Estate of David Wojnarowicz and P.P.O.W. Gallery, 1990.

206 '*I use images of sexuality . . .*': David Wojnarowicz vs. The American Family Association and Reverend Donald E. Wildmon, 25 June 1990, in Bruce Selcraig, 'Reverend Wildmon's War on the Arts', *New York Times*, 2 December 1990.

207 '*I didn't want to ruin . . .*': David Wojnarowicz, *Memories That Smell Like Gasoline* (Artspace Books, 1992), p. 48.

209 '*He's loved* . . .': David Wojnarowicz, unpublished journal entry, Fales, Series 1, Box 2, Folder 35, 13 November 1987.

209 '*David has a problem . . .*': David Wojnarowicz, unpublished journal entry, Fales, Series 1, Box 2, Folder 30, '1991 or thereabouts'.

209 '*I am glass, clear empty glass . . .*': David Wojnarowicz, *Memories That Smell Like Gasoline*, pp. 60–61.

211 '*It was very much alive . . .*': David Wojnarowicz, unpublished audio journal, Fales, Series 8A, '1988 Journal, Nov/Dec'.

213 '*To place an object or writing . . .*': ibid., p. 156.

214 '*To make the private into . . .*': David Wojnarowicz, *Close to the Knives*, p. 121.

215 '*once this body drops . . .*': David Wojnarowicz, *Brush Fires in the Social Landscape* (Aperture, 2015), p. 160.

CHAPTER 7: RENDER GHOSTS

226 '*almost sleepy . . .*': Jennifer Egan, *A Visit from the Goon Squad* (Corsair, 2011), p. 317.

228 '*Likewise, at a screen . . .*': Sherry Turkle, *Alone Together: Why We Expect More from Technology and Less from Each Other* (Basic Books, 2011), p. 188.

231 '*If I'm in a certain mood . . .*': *We Live in Public*, dir. Ondi Timoner (2009).

232 '*I think that I love . . .*': ibid.

234 '*Andy Warhol was wrong . . .*': Richard Siklos, 'Pseudo's Josh Harris: The Warhol of Webcasting', *Businessweek*, 26 January 2000.

235 '*People gathered night after . . .*': Jonathan Ames, 'Jonathan Ames, RIP', *New York Press*, 18 January 2000.

236 '*We are very much alone . . .*': Bruce Benderson, *Sex and Isolation*, p. 7.

237 'There's all these people . . .': We Live in Public, dir. Ondi Timoner (2009).

241 'it didn't matter . . .': Ondi Timoner, MoMA screening of We Live in Public, 5 April 2009.

242 'My only friend was the tube . . .': First Person: Harvesting Me, dir. Errol Morris (2001).

243 'I feel like I'm in uh . . .': Mario Montez, Screen Test #2, dir. Andy Warhol (1965).

244 'The mass medium of television . . .': Benjamin Secher, 'Andy Warhol TV: maddening but intoxicating', Telegraph, 30 September 2008.

244 'If you were the star . . .': Andy Warhol, The Philosophy of Andy Warhol, pp. 146–7.

246 'Not really. I make friends . . .': Blade Runner, dir. Ridley Scott (1982).

248 'But now that heightened . . .': Susan Sontag, Illness as Metaphor and AIDS and Its Metaphors, p. 178.

249 'All the animals come out . . .': Taxi Driver, dir. Martin Scorsese (1976).

251 'What really twisted my brain . . .': David Wojnarowicz, 7 Miles A Second, p. 15.

251 'The closing of the center city . . .': Bruce Benderson, Sex and Isolation, p. 7.

252 'The tortoise lays on its back . . .': Blade Runner, dir. Ridley Scott (1982).

CHAPTER 8: STRANGE FRUIT

255 'the daily affirmation . . .': Sarah Schulman, Gentrification of the Mind, p. 27.

256 Larry Krone, Then and Now (Cape Collaboration).

258 'It was sort of a way . . .': Zoe Leonard, Secession (Wiener Secession, 1997), p. 17.

259 'And it wasn't the pneumonia . . .': Billie Holiday, with William Dufty, Lady Sings the Blues (Harlem Moon, 2006 [1956]), p. 77.

260 '*to spell out all the things . . .*': ibid., p. 94.

261 Zoe Leonard, ACT UP Oral History Project, Interview No. 106, 13 January 2010.

261 '*From a distance . . .*': Jenni Sorkin, 'Finding the Right Darkness', *Frieze*, Issue 113, March 2008.

263 '*String can be looked upon . . .*': D. W. Winnicott, *Playing and Reality* (Routledge, 1971), p. 19.

263 '*1) going to pieces . . .*': D. W. Winnicott, *Babies and Their Mothers* (Free Association Books, 1988), p. 99.

264 '*into a* denial . . .': D. W. Winnicott, *Playing and Reality*, p. 19.

264 '*Tantrums over tangles . . .*': Henry Darger, *Journal 27 Feb 1965 – 1 Jan 1972*, Folder 33:3, Box 33, HDP.

268 '*One of those kids . . .*': Andy Warhol, *The Andy Warhol Diaries*, p. 462.

268 '*But actually if he's . . .*': ibid., p. 584.

268 '*I mean, how long can you suck dick . . .*': ibid., p. 641.

270 '*Mr. Warhol's death . . .*': Michael Wines, 'Jean Michel Basquiat: Hazards of Sudden Success and Fame', *New York Times*, 27 August 1988.

273 '*Dear Buba and Uncle Andy . . .*': Andy Warhol, TC–27, Andy Warhol Museum.

273 '*HI SWEETHEART . . .*': Andy Warhol, TC522, Andy Warhol Museum.

274 '*I think he didn't . . .*': Donald Warhola, interview with author, 12 November 2013.

276 '*She does a beautiful job . . .*': Andy Warhol, *The Andy Warhol Diaries*, p. 421.

277 '*Okay, let's get it over . . .*': ibid., p. 689.

278 '*He looks a bit like a woman . . .*': Phoebe Hoban, 'Portraits: Alice Neel's Legacy of Realism', *New York Times*, 22 April 2010.

279 '*was a way to think about David . . .*': Zoe Leonard, *Secession*, p. 18.

BIBLIOGRAPHY

Als, Hilton, *White Girls* (McSweeney's, 2013)

— with Jonathan Lethem and Jeanette Winterson, *Andy Warhol at Christie's* (Christie's, 2012)

Angell, Callie, *Andy Warhol Screen Tests: the Films of Andy Warhol Catalogue Raisonné, Volume 1* (Abrams, in association with Whitney Museum of American Art, 2006)

Arbus, Diane, *Diane Arbus* (Aperture, 2011)

Arcade, Penny, *Bad Reputation: Performances, Essays, Interviews* (Semiotex(e)/MIT Press, 2009)

Aviv, Rachel, 'Netherland', *The New Yorker*, 10 December 2012

Barthes, Roland, *Roland Barthes* (University of California Press, 1977)

— *Mourning Diary* (Hill & Wang, 2010)

Bender, Thomas, *The Unfinished City: New York and the Metropolitan Idea* (The New Press, 2002)

Benderson, Bruce, *Sex and Isolation* (University of Wisconsin Press, 2007)

Benjamin, Walter, *One-way Street and Other Writings* (Penguin, 2009)

Berman, Marshall, *On the Town: One Hundred Years of Spectacle in Times Square* (Verso, 2006)

Bisenbach, Klaus, ed., *Henry Darger* (Prestel, 2009)

— *Henry Darger: Disasters of War* (KW Institute for Contemporary Art, 2003)

Bockris, Victor, *Warhol: The Biography* (Da Capo Press, 2003 [1989])

Bonesteel, Michael, *Henry Darger: Art and Selected Writings* (Rizzoli, 2000)

Bowlby, John, *Separation* (Basic Books, 1973)

Boym, Svetlana, *The Future of Nostalgia* (Basic Books, 2001)

Brown, Bill, 'Things', *Critical Inquiry*, Vol. 28, No. 1

Beaumont, Matthew and Gregory Dart, eds., *Restless Cities* (Verso, 2010)

Cacioppo, John T. and Patrick William, *Loneliness: Human Nature and the Need for Social Connection* (W. W. Norton, 2008)

— et al, 'The Anatomy of Loneliness', *Current Directions in Psychological Science*, Volume 12, No. 13, pp. 7–74, June 2003

Carr, Cynthia, *Fire in the Belly: The Life and Times of David Wojnarowicz* (Bloomsbury, 2012)

Chion, Michel, *The Voice in Cinema* (Columbia University Press, 1999)

Clements, Jennifer, *Widow Basquiat* (Payback Press, 2000)

Cohen, Jon, *Shots in the Dark: The Wayward Search for an AIDS Vaccine* (Norton, 2001)

Cole, Steve W., et al, 'Accelerated Course of Human Immunodeficiency Virus Infection in Gay Men Who Conceal Their Homosexuality', *Psychosomatic Medicine* 58, pp. 219–31 (1996)

Colacello, Bob, *Andy Warhol: Holy Terror* (Harper Collins, 1990)

Connor, Steve, *Dumbstruck: A Cultural History of Ventriloquism* (Oxford University Press, 2000)

Cooke, Lynne and Douglas Crimp, *Mixed Use, Manhattan* (MIT Press, 2010)

Danto, Arthur, *Andy Warhol* (Yale University Press, 2009)

Davis, Glynn, and Gary Needham, eds., *Warhol in Ten Takes* (British Film Institute/Palgrave Macmillan, 2013)

Delany, Samuel, *The Motion of Light on Water* (Paladin, 1990)

— *Times Square Red, Times Square Blue* (New York University Press, 1999)

Dillon, Brian, *Tormented Hope: Nine Hypochondriac Lives* (Penguin, 2009)

Dolar, Mladen, *A Voice and Nothing More* (MIT Press, 2006)

Dworkin, Craig, 'Whereof One Cannot Speak', *Grey Room*, Vol. 21, Fall 2005

Fahs, Breanne, *Valerie Solanas* (The Feminist Press, 2014)

Foster, Carter, *Hopper's Drawings* (Whitney Museum/Yale University Press, 2013)

Foucault, Michel, and Richard Sennett, 'Sexuality and Solitude', *London Review of Books*, Vol. 3, No. 9, 21 May 1981

Frei, George, Sally King-Nero, and Neil Printz, eds., *Andy Warhol Catalogue Raisonné Volume 1: Paintings and Sculpture 1961–1963* (Phaidon Press, 2002)

— *Andy Warhol Catalogue Raisonné Volumes 2A and 2B: Paintings and Sculptures 1964–1969* (Phaidon Press, 2004)

Freud, Anna, 'About Losing and Being Lost', *Indications for Child Analysis and Other Papers 1945–1956* (The Hogarth Press, 1969)

Friedberg, Anne, *The Virtual Window: From Alberti to Microsoft* (MIT Press, 2006)

Fromm-Reichmann, Frieda, *Principles of Intensive Psychotherapy* (Allen & Unwin, 1953)

— ed. Dexter M. Bullard, *Psychoanalysis and Psychotherapy: Selected Papers of Frieda Fromm-Reichmann* (University of Chicago Press, 1959)

Glembocki, Vicki, 'Are You Lonely?' *Research/Penn State* (Vol. 14, No. 3, September 1993)

Goffman, Erving, *Stigma: Notes on a Spoiled Identity* (Penguin, 1990 [1963])

Goldin, Nan, *The Ballad of Sexual Dependency* (Aperture, 2012 [1986])

— *The Other Side 1972–1992* (Cornerhouse Publications, 1993)

— *I'll Be Your Mirror* (Whitney Museum of Art, 1997)

Goldsmith, Kenneth, *I'll Be Your Mirror: The Selected Andy Warhol Interviews* (Da Capo Press, 2004)

Goodrich, Lloyd, *Edward Hopper* (H. N. Abrams, 1993)

Gould, Deborah B., *Moving Politics: Emotion and ACT UP's Fight against AIDS* (University of Chicago Press, 2009)

Griffin, Jo, *The Lonely Society?* (Mental Health Foundation, 2010)

Groy, Christian, et al, 'Loneliness and HIV-related stigma explain depression among older HIV-positive adults', *AIDS Care*, Vol. 22, No. 5, 2010

Hagberg, G. L., *Art as Language: Wittgenstein, Meaning, and Aesthetic Theory* (Cornell University Press, 1995)

Hager, Steven, *Art After Midnight: The East Village Scene* (St Martin's Press, 1986)

Hainley, Bruce, 'New York Conversation: Reading a: A Novel by Andy Warhol', *Frieze*, Issue 39, March–April 1998

Halperin, David M., and Valerie Traub, eds., *Gay Shame* (University of Chicago Press, 2009)

Haraway, Donna, *Cyborgs, Simians and Women: The Reinvention of Nature* (Free Association Books, 1991)

Harlow, Harry, and Clara Mears, *The Human Model: Primate Perspectives* (Wiley, 1979)

— and Stephen J. Suomi, 'Induced Depression in Monkeys', *Behavioral Biology*, Vol. 12, 1974

Herek, Gregory M., 'Illness, Stigma, and AIDS', in G. R. VandenBos, ed., *Psychological Aspects of Serious Illness* (American Psychological Association, 1990)

— ed., 'Aids and Stigma in the United States: A special issue of *American Behavioral Scientist*' (Sage Publications, 1999)

Holiday, Billie, with William Dufty, *Lady Sings the Blues* (Harlem Moon, 2006 [1956])

Howe, Marie, and Michael Klein, *In the Company of My Solitude: American Writing from the AIDS Pandemic* (Persea Books, 1995)

Hughes, Robert, *Ethics, Aesthetics, and the Beyond of Language* (State University of New York Press, 2010)

Hujar, Peter, *Portraits in Life and Death* (Da Capo Press, 1977)

— and Vince Aletti and Stephen Koch, *Love & Lust* (Fraenkel Gallery, 2014)

Huxley, Geralyn, and Matt Wrbican, *Andy Warhol Treasures* (Goodman Books, 2009)

Jarman, Derek, *Modern Nature* (Century, 1991)

— *At Your Own Risk: A Saint's Testament* (Hutchinson, 1992)

— *The Garden* (Thames & Hudson, 1995)

Julius, Anthony, *Transgressions: The Offences of Art* (Thames & Hudson, 2002)

Kasher, Steven, *Max's Kansas City* (Abrams Image, 2010)

Kirkpatrick, David, 'Suddenly Pseudo', *New York Magazine*, 22 December 1999

Klein, Melanie, *Love, Guilt and Reparation and Other Works 1921–1945* (Free Press, 1984 [1975])

— *Envy and Gratitude and Other Works 1946–1963* (The Hogarth Press, 1975)

Koch, Stephen, *Stargazer: The Life, World and Films of Andy Warhol* (Marion Boyars, 2000)

Koestenbaum, Wayne, *Humiliation* (Picador, 2011)

— *Andy Warhol: A Biography* (Phoenix, 2003)

— *My 1980s* (FSG, 2013)

Koolhaas, Rem, *Delirious New York: A Retroactive Manifesto for Manhattan* (Monacelli Press, 1994)

Kramer, Larry, *Faggots* (Minerva, 1990 [1978])

Kuh, Katharine, *The Artist's Voice: Talks with Seventeen Artists* (Harper & Row, 1960)

Lahr, John, *Prick Up Your Ears: The Biography of Joe Orton* (Penguin, 1980)

Leonard, Zoe, *Secession* (Wiener Secession, 1997)

Levin, Gail, *Hopper's Places* (Knopf, 1989)

— *Edward Hopper: An Intimate Biography* (Rizzoli, 2007)

— ed., *Silent Places: A Tribute to Edward Hopper* (Universe, 2000)

Lotringer, Sylvère, ed., *David Wojnarowicz: A definitive history of five or six years on the lower east side* (Semiotext(e), 2006)

Lyons, Deborah, ed., *Edward Hopper: A Journal of His Work* (Whitney Museum of American Art/W. W. Norton, 1997)

MacGregor, John, *Henry Darger: In the Realms of the Unreal* (Delano Greenidge Editions, 2002)

Masters, Christopher, *Windows in Art* (Merrell, 2011)

Malanga, Gerard, and Andy Warhol, *Screen Tests | A Diary* (Kulchur Press, 1967)

McNamara, Robert P., ed., *Sex, Scams and Streetlife: the Sociology of New York City's Times Square* (Praeger, 1995)

Mijuskovic, Ben Lazre, *Loneliness* (Associated Faculty Press, Inc., 1979)

— *Loneliness in Philosophy, Psychology and Literature* (Van Gorcum, Assen, 1979)

Modell, Arnold H., *The Private Self* (Harvard University Press, 1993)

Moore, Patrick, *Beyond Shame: Reclaiming the Abandoned History of Radical Gay Sexuality* (Beacon Press, 2005)

Moustakas, Clark, *Loneliness* (Jason Aranson Inc., 1996 [1961])

Mueller, Cookie, *Walking Through Clear Water in a Pool Painted Black* (Semiotext(e)/Native Agents, 1990)

Muñoz, José Esteban, *Cruising Utopia: The Then and There of Queer Futurity* (New York University Press, 2009)

Name, Billy, and John Cale, *The Silver Age: Black and White Photographs from Andy Warhol's Factory* (Reel Art Press, 2014)

Nelson, Maggie, *Bluets* (Wave Books, 2009)

— *The Art of Cruelty* (W. W. Norton & Co., 2011)

— *The Argonauts* (Graywolf Press, 2015)

O'Doherty, Brian, *American Masters: The Voice and the Myth* (E. P. Dutton, 1982)

Orton, Joe, ed. John Lahr, *The Orton Diaries* (Methuen, 1986)

Prinz, Neil, and Sally King-Nero, eds., *Andy Warhol Catalogue Raisonné Volume 3: Paintings and Sculpture 1970–74* (Phaidon Press, 2010)

— *Andy Warhol Catalogue Raisonné Volume 4: Paintings and Sculpture late 1974–76* (Phaidon Press, 2014)

Renner, Rolf G., *Edward Hopper* (Taschen, 2011)

Sanders, Charles L., 'Lady Didn't Always Sing the Blues', *Ebony*, Vol. 28, No. 3, January 1973

Sante, Luc, *Low Life* (Vintage Departures, 1992)

— 'My Lost City', *The New York Review of Books*, 6 November 2003

Scholder, Amy, ed., *Fever: The Art of David Wojnarowicz* (New Museum Books/Rizzoli, 1999)

Schulman, Sarah, *People in Trouble* (Sheba Feminist Press, 1990)

— *Girls, Visions and Everything* (Sheba Feminist Press, 1991)

— *My American History: Lesbian and Gay Life During the Reagan/Bush Years* (Routledge, 1994)

— *The Gentrification of the Mind: Witness to a Lost Imagination* (University of California Press, 2012)

Sedgwick, Eve Kosofsky, *Tendencies* (Duke University Press, 1994)

— *A Dialogue on Love* (Beacon Press, 2000)

Senior, Jennifer, 'Alone Together', *New York*, 23 November 2008

Serres, Michel, trans. Margaret Sankey and Peter Cowley, *The Five Senses: A Philosophy of Mingled Bodies* (Continuum, 2008)

Shafrazi, Tony, Carter Ratcliff, and Robert Rosenblum, *Andy Warhol: Portraits* (Phaidon Press, 2007)

Shilts, Randy, *And the Band Played On: Politics, People and the AIDS Epidemic* (St Martin's Press, 1987)

Shore, Stephen, and Lynne Tillman, *The Velvet Years: Warhol's Factory 1965-67* (Pavilion Books, 1995)

Shuleviz, Judith, 'The Lethality of Loneliness', *New Republic*, 13 May 2013

Smith, Andrew, *Totally Wired: On the Trail of the Great Dotcom Swindle* (Simon & Schuster, 2013)

Smith, Rupert, 'Klaus Nomi', *Attitude*, Vol. 1, No. 3, July 1994.

Solanas, Valerie, *SCUM Manifesto* (Verso, 2001 [1971])

Sontag, Susan, *Regarding the Pain of Others* (Penguin, 2004)

— *Against Interpretation and Other Essays* (Penguin Modern Classics, 2009 [1966])

— *Illness as Metaphor and Aids and Its Metaphors* (Penguin Modern Classics, 2002 [1978/1989])

Specter, Michael, 'Higher Risk', *The New Yorker*, 23 May 2005

Stimson, Blake, *Citizen Warhol* (Reaktion Books, 2014)

Sullivan, Harry Stack, *The Interpersonal Theory of Psychiatry* (Routledge, 2001 [1953])

Thomson, David, *The Big Screen: The Story of the Movies and What They Did To Us* (Allen Lane, 2012)

Taylor, Marvin, ed., *The Downtown Book: The New York Art Scene 1974–1984* (Princeton University Press, 2006)

— and Julie Ault, 'Active Recollection', in Julie Ault, *Afterlife: a constellation* (Whitney Museum of Art, 2014)

Tillman, Lynne, 'The Last Words Are Andy Warhol', *Grey Room*, Vol. 21, Fall 2005

Turkle, Sherry, *The Second Self: Computers and the Human Spirit* (Simon & Schuster, 1984)

— *Life on the Screen: Identity in the Age of the Internet* (Simon & Schuster, 1995)

— *Alone Together: Why We Expect More from Technology and Less from Each Other* (Basic Books, 2011)

Updike, John, *Still Looking: Essays on American Art* (Alfred A. Knopf, 2006)

Van der Horst, Frank C. P., and René Van der Veer, 'Loneliness in Infancy: Harry Harlow, John Bowlby and Issues of Separation', in *Integrative Psychological & Behavioral Science*, Vol. 42, Issue 4, 2008

Warhol, Andy, *a, a novel* (Virgin, 2005 [1968])

— *The Philosophy of Andy Warhol: From A to B and Back Again* (Penguin, 2007 [1975])

— *The Andy Warhol Diaries*, edited by Pat Hackett (Warner Books, 1989)

— and Gerard Malanga, *Screen Tests: A Diary* (Kulchur Press/ Citadel Press, 1967)

— and Pat Hackett, *POPism* (Penguin, 2007 [1980])

— and Udo Kittelmann, John W. Smith, and Matt Wrbican, *Andy Warhol's Time Capsule 21* (Dumont, 2004)

Weinberg, Jonathan, 'City-Condoned Anarchy', curatorial essay for 'The Piers: Art and Sex along the New York Waterfront', curated by Jonathan Weinberg with Darren Jones, Leslie

Lohman Museum of Gay and Lesbian Art, 4 April–10 May 2012

Weiss, R. S., *Loneliness: The Experience of Emotional and Social Isolation* (MIT Press, 1975)

Wells, Walter, *Silent Theater: The Art of Edward Hopper* (Phaidon, 2007)

Wilcox, John, and Christopher Trela, *The Autobiography and Sex Life of Andy Warhol* (Trela Media, 2010)

Winnicott, D. W., *Playing and Reality* (Routledge, 1971)

— *Babies and Their Mothers* (Free Association Books, 1988)

Wittgenstein, Ludwig, *Tractatus Logico-Philosophicus* (Harcourt, Brace & Co., 1922)

— *Philosophical Investigations*, translated by G. E. M. Anscombe (Basil Blackwell, 1986 [1958])

Wojnarowicz, David, *Close to the Knives: A Memoir of Disintegration* (Vintage, 1991)

— *Memories That Smell Like Gasoline* (Artspace Books, 1992)

— *The Waterfront Journals* (Grove Press, 1997)

— *Brush Fires in the Social Landscape* (Aperture, 2015 [1994])

— ed. Barry Blinderman, *Tongues of Flame* (Illinois State University/ Art Publishers, 1990)

— ed. Amy Scholder, *In the Shadow of the American Dream* (Grove Press, 2000)

— with Tom Rauffenbart, *Rimbaud in New York* (Andrew Roth, 2004)

— with James Romberger and Marguerite Van Cook, *7 Miles a Second* (Fantagraphics, 2013)

Wolf, Reva, *Andy Warhol, Poetry, and Gossip in the 1960s* (University of Chicago Press, 1997)

Woolf, Virginia, ed. Anne Olivier Bell, *The Diary of Virginia Woolf, Volume III 1925–1930* (The Hogarth Press, 1980)

Woronov, Mary, *Swimming Underground: My Years in the Warhol Factory* (Serpent's Tail, 2004)

Wrenn, Mike, ed., *Andy Warhol: In His Own Words* (Omnibus Press, 1991)

ACKNOWLEDGEMENTS

ONE MIGHT EXPECT WRITING A book about loneliness to be an isolating experience, but on the contrary it has been astonishingly connecting. I've been amazed at how many people have gone out of their way to support this project, and it underscores my sense that loneliness is something we share.

The first person I want to thank is my friend Matt Wolf, who introduced me to David Wojnarowicz's work, thereby setting this book in motion, and who has been an endless source of ideas and contacts ever since.

Huge thanks are due to those who made *The Lonely City* possible, a list that must start with my beloved agents at Janklow & Nesbit, the wonderful Rebecca Carter and P. J. Mark, dream readers both, as well as Claire Conrad and Kirsty Gordon. I also want to thank my terrific editors, Jenny Lord at Canongate and Stephen Morrison at Picador, for their insightful and considered feedback and support. I'm indebted to the Arts Council, who funded a research trip to various American archives, and to the Corporation of Yaddo, who provided me with the ideal place

to work. I'm also very grateful to the MacDowell Colony: this book really arose from friendships I made there.

Thanks too to all the teams at Canongate and Picador, especially Jamie Byng, Natasha Hodgson, Anna Frame, Annie Lee and Lorraine McCann on one side of the Atlantic, and P. J. Horoszko, Declan Taintor and James Meader on the other. And Nick Davies, too, who started it all rolling.

I've spent much of the last few years in artists' archives. I'm very grateful to all at Fales Library at New York University, home of the Downtown Collection and the David Wojnarowicz Papers and an intensely inspiring place in its own right. Particular thanks to Lisa Darms, Marvin Taylor, Nicholas Martin and Brent Phillips, and also to Tom Rauffenbart, the exceptionally generous executor of the estate of David Wojnarowicz. The staff at the American Folk Art Museum, home of the Henry Darger Papers, likewise provided very generous support. Thanks to Valérie Rousseau, Karl Miller, Ann-Marie Reilly and Mimi Lester. I'm also grateful to INTUIT in Chicago for letting me view the Darger room. At the Whitney Museum of American Art, I'd like to thank curator Carter Foster and Carol Rusk, Librarian at the Edward and Josephine Hopper Research Collection. And I'd like to say a huge thank you to all the staff at the Warhol Museum, whose kindness, generosity and help went well beyond the call of duty, particularly Matt Wrbican, Cindy Lisica, Geralyn Huxley, Greg Pierce and Greg Burchard.

While I was working on this book, I was lucky enough to be awarded a year's residency at the Eccles Centre for American Studies at the British Library. I'd like to express my deep gratitude

to Philip Davies, Catherine Eccles, Cara Rodway, Matthew Shaw and especially Carole Holden – it's every writer's dream to work with a curator who shares their interests and sensibilities and it was a joy to get such a passionate and knowledgeable guide to the BL's contents.

People who generously gave up their time to be interviewed or answer queries include John Cacioppo at the University of Chicago, Cynthia Carr, Stephen Koch at the Peter Hujar Archive (who also generously provided the beautiful Hujar portrait of Wojnarowicz on p. 94), and Donald Warhola. Thank you all. I'm also deeply grateful to Sarah Schulman, whose own work is such a constant source of education and inspiration.

Thank you to my exceptionally lovely writerly support team of Elizabeth Day and Francesca Segal, without whom it would take a lot longer and be much less fun. To Elizabeth Tinsley, whose thinking has been stimulating mine for decades now. To the artists, too: Sarah Wood and Sherri Wasserman, thank you. And a very special thanks to the magnificent Ian Patterson, who read and commented on a multitude of early drafts with vast intelligence and patience.

Then there are the friends and colleagues who've discussed, read, edited, encouraged, fed and housed me. In the UK: Nick Blackburn, Stuart Croll, Clare Davies, Jon Day, Robert Dickinson, John Gallagher, Tony Gammidge, John Griffiths, Tom de Grunwald, Christina McLeish, Helen Macdonald, Leo Mellor, Tricia Murphy, James Purdon, Sigrid Rausing and Jordan Savage. In the USA: David Adjmi, Liz Duffy Adams, Kyle de Camp, Deb Chachra, Jean Hannah Edelstein, Andrew Ginzel, Scott Guild,

Alex Halberstadt, Amber Hawk Swanson, Joseph Keckler, Larry Krone, Dan Levenson, Elizabeth McCracken, Jonathan Monaghan, John Pittman, the late Alastair Reid, Andrew Sempere, Daniel Smith, Schulyer Towne, Benjamen Walker and Carl Williamson.

For support with research materials: Brad Daly, Harko Kejzer, Heather Mallick, John Pittman, Cerys Matthews and Steven Abbott, Kio Stark and Eileen Storey, as well as several unknown but much appreciated benefactors.

Elements of this book first appeared in *Granta*, *Aeon*, *The Junket*, *Guardian* and *New Statesman*. Thanks too to all my editors there.

My deepest thanks go, as ever, to my family. My brilliant sister, Kitty Laing, who was on to some of the scenes on these pages long before me; my beloved father, Peter Laing; and my mother, Denise Laing, who has been reading since the beginning, and whose support I could not do without.

LIST OF ILLUSTRATIONS

Greta Garbo, 1955, by Lisa Larsen. Courtesy of The LIFE Picture Collection/ Getty Images.

Edward Hopper, 1941, by Arnold Newman. Courtesy of Getty Images.

Warhol on the phone, 1972, by Michael Ochs. Courtesy of the Michael Ochs Archives/Getty Images.

David Wojnarowicz with a Snake, 1981, by Peter Hujar. © 1987 The Peter Hujar Archive LLC. Courtesy Pace/MacGill Gallery NY and Fraenkel Gallery CA.

Henry Darger, 1971, by David Berglund.

Klaus Nomi, 1979, by William Coupon. Courtesy of William Coupon.

Scene from WE LIVE IN PUBLIC, 1999. Courtesy of Interloper Films.

Polaroid of Andy Warhol Posing for Alice Neel, 1970, by Brigid Berlin. Copyright Brigid Berlin. All Rights Reserved. Courtesy of Vincent Fremont Enterprises, Inc.

Arthur Rimbaud in New York (Times Square), 1978-79, by David Wojnarowicz (gelatin-silver print, 8 x 10 inches). Courtesy of the Estate of David Wojnarowicz and P.P.O.W. Gallery, New York.

A NOTE ON THE TYPE

This book is set in Bembo, a humanist serif typeface commissioned by Aldus Manutius and cut by Francesco Griffo, a Venetian goldsmith, in the late fifteenth century. This harmonious typeface has gone on to inspire generations of type founders, from Claude Garamond in the sixteenth century to Stanley Morison at the Monotype Corporation in the early twentieth century.

Jonathan Ring

OLIVIA LAING is a widely acclaimed writer and critic. She contributes to numerous publications, including *The Guardian, The Observer, New Statesman, Frieze,* and *The New York Times.* She's a Yaddo and MacDowell Fellow and was a 2014 Writer in Residence at the British Library. Her first book, *To the River,* was shortlisted for the Ondaatje Prize and the Dolman Travel Book of the Year. Her latest book, *The Trip to Echo Spring: On Writers and Drinking,* was shortlisted for the Costa Biography Award and the Gordon Burn Prize. It is also published by Picador.